Paint
with the
Impressionists

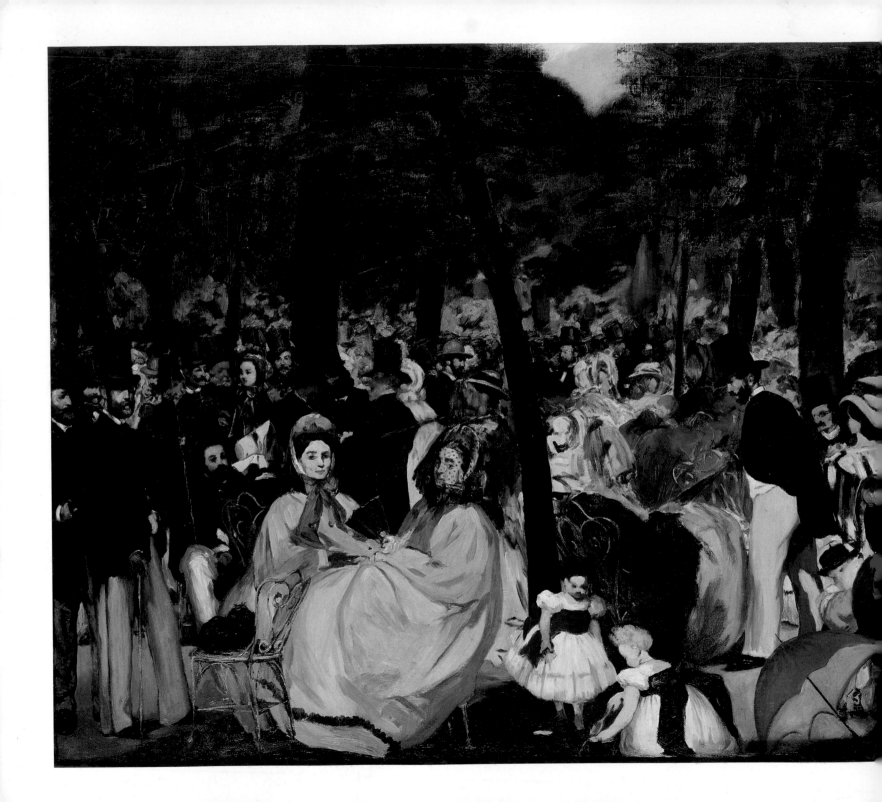

Jonathan Stephenson

Paint *with the* *Impressionists*

A step-by-step guide to their methods and materials for today's artists

A BULFINCH PRESS BOOK
LITTLE, BROWN AND COMPANY
BOSTON • NEW YORK • TORONTO • LONDON

For Tricia, Amy and Sophie

On the front cover:
Manet, *Claude Monet Working in his Boat at Argenteuil* (detail),
1874 (p. 20); original painting by Jonathan Stephenson

On the back cover:
Original paintings by Jonathan Stephenson; Pissarro, *The Artist's
Palette with a Landscape, c.* 1877–79 (pp. 28–29)

First United States Edition
ISBN 0-8212-2158-2

Library of Congress Catalog Card Number 94-79059

Bulfinch Press is an imprint and trademark of
Little, Brown and Company (Inc.)
Published simultaneously in Canada by
Little, Brown & Company (Canada) Limited

PRINTED IN SINGAPORE

CONTENTS

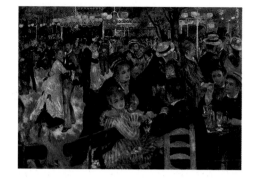

INTRODUCTION

FIRST IMPRESSIONS *Pages 7–14*

PART 1

MATERIALS *Pages 15–42*

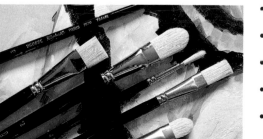

PART 2

TECHNIQUES

THE IMPRESSIONISTS AT WORK *Pages 43–57*

2.1 LANDSCAPE *Pages 58–75*

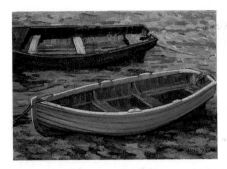

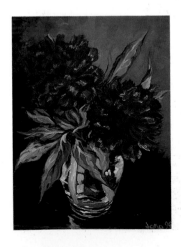

INTRODUCTION

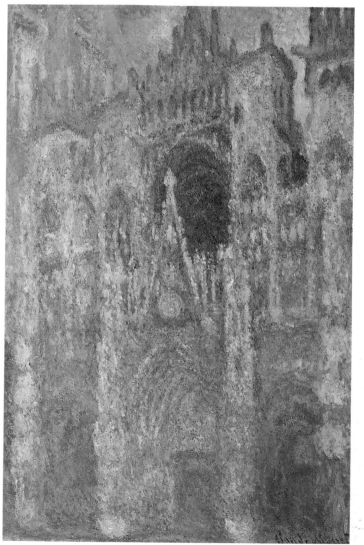

Monet, Rouen Cathedral,
the portal and the
Tour Saint-Romain, full
sunlight. Harmony in
blue and gold *(1893)*

FIRST *Impressions*

What is Impressionism?

The Impressionists and their friends

The Impressionist exhibitions

Rediscovering painting

Modern art

FIRST *Impressions*

If you want to follow the example of the original Impressionists and paint like them, you must learn to paint with them. In effect you have to imagine yourself next to them and repeat their actions – the only way to create real Impressionist paintings is to be a real Impressionist painter.

When you paint all you have to do is bring together a similar set of influences. This means you must first learn a few basic facts about the methods and materials of Impressionism that will allow you to reproduce the essential technical details. This is easy because the methods involved in Impressionist painting are very straightforward and simple and rely on modern materials. Its physical characteristics are easily achieved and the materials section of this book, together with the step-by-steps, provides you with all the information that you need to paint your own Impressionist paintings.

Impressionist painting, however, also involves hidden techniques and is more than the superficial imitation of popular Impressionist imagery. You must also develop an understanding of how this knowledge of methods and materials is put into practice in similar contexts to those that gave rise to the original Impressionists' paintings. This is easy enough to apply, although it is a more complex subject to explain. Impressionism depends on imposed conditions and patterns of behaviour, as well as other external influences. These affect how the finished works turn out, but do not show on them. It is this unseen area of Impressionist technique that accounts for some of Impressionism's most admired qualities.

Impressionist paintings happen because of a combination of four factors. Firstly, the choice of materials – this makes certain effects possible. Secondly, there are aspects of technique – the way the chosen materials are employed in simple, habitual and sometimes quite personal methods of application. Thirdly, the influence of circumstance – the consequences of the conditions under which the painting is done, how these affect what happens and the element of chance that they contribute. Arbitrary decision-making also introduces unpredictable results provoked by the last factor – the temperament of the painter. Ultimately this governs the progress of the painting and determines the relative importance of the other influences over the work of that particular individual.

Re-creating Impressionism is about re-creating all these elements. This book takes you through what actually happens when the materials and techniques of Impressionism are applied in real-life situations either painting out of doors, or in the studio.

What is Impressionism?

The myths around Impressionism may hinder your understanding of its techniques. Impressionism should not be thought of as a united movement with a common theory or practice; it was only defined in this way later by critics and art historians.

The methods and materials used by the Impressionists varied depending on the artist, on the year and from painting to painting. The term 'Impressionist techniques' broadly covers the methods of a wide group of talented individuals, including Monet, Renoir, Pissarro, Cézanne, Degas, Morisot, Manet and Sisley, and arguably Van Gogh, Gauguin, Toulouse-Lautrec, Seurat, Signac and many others. Impressionism represented the contemporary trends in French painting in the second half of the 19th century, and was focused on the activities of a particular group of artists whose most significant common factor was that they knew each other.

Monet is celebrated for his skilful use of colour as in *Field of Poppies, Giverny* (1885), which was partly the result of his very disciplined approach to painting. By looking at his subjects in a particular way, by choosing the time of day and by working for strictly limited periods, he was able to isolate spectacular colour effects and subtle harmonies from the ever-changing qualities of nature.

The Impressionists and their friends

In Manet's *Music in the Tuileries Gardens* (1860–62) (illustrated on the frontispiece) he has painted himself with the painters, poets and musicians who formed his circle, including his brother Eugène (who married Morisot in 1874), Fantin-Latour, Balleroy, Baudelaire, Théophile Gautier, Baron Taylor and Zacharie Astruc. The seated woman wearing the veil is the wife of Commandant Hippolyte Lejosne, who had introduced Manet to Baudelaire and Bazille.

Monet, Bazille, Renoir and Sisley were enrolled at Gleyre's studio and it was probably Bazille who introduced the others to Manet. Degas was also acquainted with Commandant Lejosne and was a good friend of Manet's – they first met in the Louvre in front of a Velazquez. Morisot and her sister were introduced to Manet by Fantin-Latour. Renoir, Monet and Bazille appear grouped around Manet in Fantin-Latour's painting shown right, *A Studio in the Batignolles Quarter* (1870). Degas was in the original sketch, but not in the finished painting. Zola is there – he was a friend of Cézanne who would have met Monet and Pissarro at the Académie Suisse in Paris.

In 1877 Gauguin met Pissarro and was invited by him and Degas to take part in the fourth Impressionist exhibition (1879). Gauguin was later an associate of Cézanne and Van Gogh, whom Pissarro met through Van Gogh's brother Théo. Pissarro knew Seurat and Signac, both of whom eventually exhibited with the Impressionists.

These links among the Impressionists extended to American artists. In 1874 Degas noticed Cassatt's painting at the Salon – she later helped to promote the Impressionists' works in America. John Singer Sargent also knew the Impressionists and painted Monet at work. The American-born Whistler was friendly with Manet, Degas and Monet and studied in Gleyre's studio.

Eva Gonzalès, Victorine Meurent and Suzanne Valadon modelled for the Impressionists and were artists in their own right.

Caillebotte

Caillebotte met Monet at Argenteuil through a mutual interest in the river and boats. Renoir, Manet and Sisley painted there in the company of Monet and became acquainted with Caillebotte, who was an early patron of the Impressionists, as well as an accomplished amateur painter.

Morisot

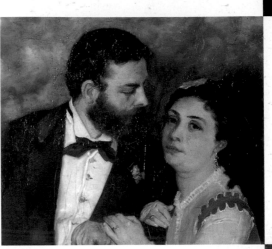

The Sisleys

Fantin-Latour's A Studio in the Batignolles Quarter (1870) (right) shows Renoir, Monet, Bazille and Zola grouped around Manet. Bazille could also afford a studio and sometimes let Monet, Renoir and Sisley work with him. The Batignolles area of Paris was very popular with many artists and writers.

Cézanne

Renoir, Monet, Bazille and Sisley all enrolled at Gleyre's studio. They left in 1863 and began painting out of doors in the forest of Fontainebleau, where Corot, Courbet and others were already active around the village of Barbizon.

Pissarro

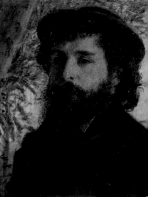

Monet

Cézanne, Monet and Pissarro attended the Académie Suisse in Paris. They could paint and draw at the Académie, but there was no teaching. Cézanne and Pissarro later worked together.

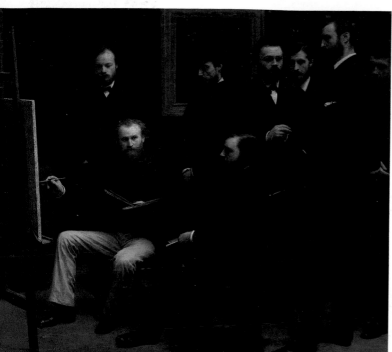

Courbet

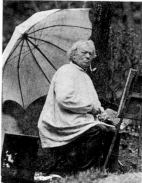

Corot

Boudin

The Realists and Barbizon painters of the previous generation were part of the extended circle. Monet knew Boudin from Le Havre and was inspired by Jongkind, while Courbet, Corot and Diaz were early influences and knew various members of the Impressionist group. Pissarro and Morisot considered themselves to be pupils of Corot, and Diaz is said to have helped Renoir by allowing him to buy paints on his account.

Gauguin

Degas

The fourth Impressionist exhibition took place in 1879. Gauguin was invited by Pissarro and Degas to take part. Gauguin later met Cézanne and Van Gogh as well. Pissarro was a friend of Van Gogh's brother and the Pointillists, Seurat and Signac, who exhibited with the Impressionists in 1886.

Van Gogh

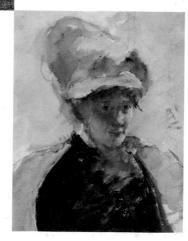

In 1874 Degas saw Cassatt's work at the Salon. She later helped to promote the Impressionists' work in America.

Cassatt

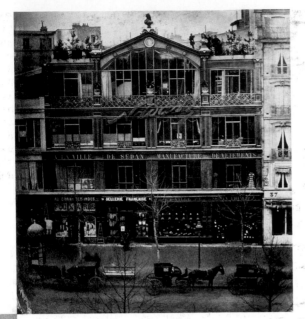

Nadar's studio, 35 boulevard des Capucines, where the first Impressionist exhibition was held in 1874.

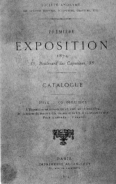

Catalogue of the first Impressionist exhibition, 1874.

The Impressionist exhibitions

The first group exhibition opened on 15 April 1874. There were only 3500 visitors, many of whom came to mock the paintings, including the press. In contrast, according to Emile Zola, soon afterwards 400,000 people visited the official Salon exhibition where art that satisfied popular and official taste was on show.

The 1874 exhibition was put on by the Société Anonyme des Artistes, literally a group with no name. Degas, Renoir, Monet, Pissarro, Morisot, Sisley and Cézanne were involved (all except Cézanne were founder members). However, they only represented a minority of the 30 contributors and their works accounted for less than a third of the exhibits. Manet, Fantin-Latour, Legros and Tissot, among others, refused to take part.

The catalogue was drawn up by Renoir's brother, who became exasperated by Monet's bland titles – when a vague view of Le Havre harbour had to be named, Monet told him to 'Put impression' and the painting subsequently appeared in the catalogue as *Impression, Sunrise*.

Renoir and Degas both wished to avoid the creation of a specific association that could be interpreted as a new school. The lack of a common aim, the arbitrary selection of the contributors by payment of a fee and their willingness to take part made it difficult to find a satisfactory name. But on 25 April the press obliged. A savagely satirical review of the exhibition by Louis Leroy appeared in *Le Charivari* with the title 'Exhibition of the Impressionists'.

The term 'Impressionist' was not intended to be complimentary and arose because Monet's painting had caused particular offence. 'Wallpaper in its embryonic state is more finished than that seascape', said the article. From that point on, the concept of Impressionism existed in the minds of the critics and the public.

Other group exhibitions took place – there were eight altogether between 1874 and 1886. It has been suggested that Impressionism was the art represented at those exhibitions and that the Impressionists were the artists whose work was shown at them. But, in fact, Degas, Pissarro, Cézanne, Monet, Renoir, Sisley and Morisot only exhibited together at two of the eight exhibitions and important figures such as Manet never participated. Furthermore, the art completed before and after these exhibitions was clearly part of the same trend.

Rediscovering painting

Renoir claimed that the artists who exhibited at the first Impressionist exhibition were reacting to a decline in painting that had brought about a situation where 'everybody was busy copying everybody else and nature was lost in the shuffle'. He believed they were responding to the injustice of the official Salon and the inadequacies of the schools. Their aim, he said, was to encourage other painters into 'relearning a forgotten craft'. Renoir later said they were turning away from Romantic and Classical ideals and were concentrating on painting without conforming to a set of rules, which he saw as a return to the values of the Old Masters.

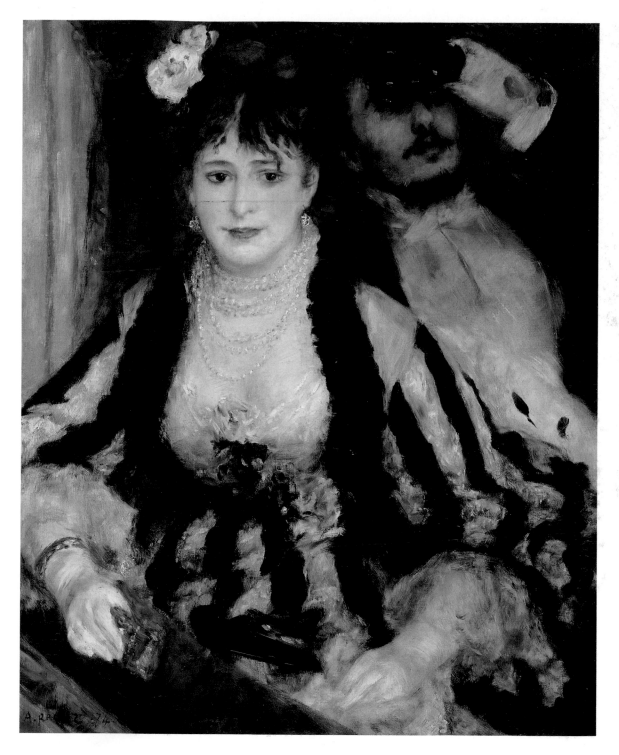

Renoir's early masterpiece La Loge (1874) was shown at the first Impressionist exhibition. Its contemporary subject and brilliantly handled loose brushwork would have seemed very modern at the time, but Renoir's technique here is probably based on a study of the 'Old Master' paintings of Rubens.

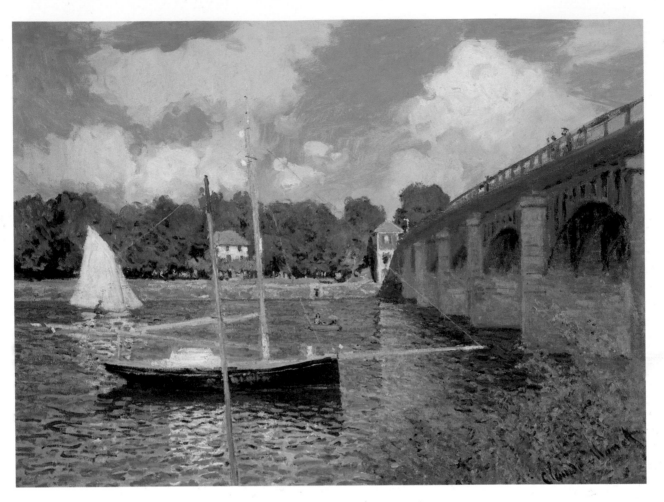

Monet's The Bridge at
Argenteuil *(1874) reflects
the social and economic
changes that influenced
the art of the time.*

Modern art

Art reflects and reacts to the circumstances
of its time. The 19th century brought changes
in artists' materials, the development of
photography, the building of railways and the
expansion of cities. There were social and
economic changes, increased leisure time,
growth in commerce and the development of
media and marketing activities. Art, too, became
modern. In Monet's painting *The Bridge at
Argenteuil* (1874) the bridge itself is a 19th-
century structure and is the product of an
advanced economy and of developed civil
engineering skills. The yacht is a pleasure craft,
not a fishing boat, and would have been used
by affluent Parisians who could reach the suburb
of Argenteuil by train.

As I have said, there is more to Impressionism
than mimicking its outward appearance. 'No
one is an artist', Monet said, 'unless he carries
his picture in his head before painting it, and is
sure of his method and composition. Techniques
vary, art stays the same – it is the transposition
of nature at once forceful and sensitive. ...
Pictures are not made out of doctrines. Since
the appearance of Impressionism, the official
salons, which used to be brown, have become
blue, green and red. ... But peppermint or
chocolate, they are still confections.'

PART 1

Impressionist painting

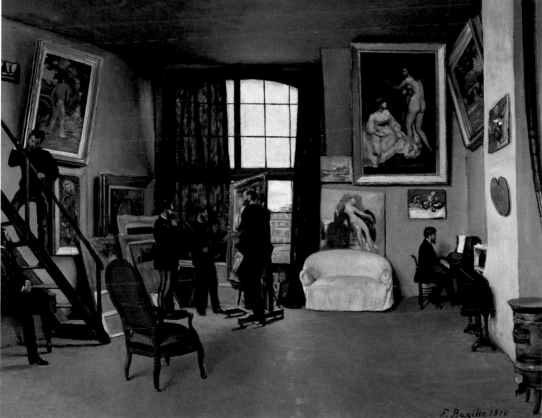

Bazille, The Artist's
Studio *(1870)*

THE 19TH CENTURY

Artists' materials have not changed a great deal since the second half of the 19th century when Impressionist painting began. The specific details of their composition and quality have certainly altered, but the essential character of many of them remains the same. The oil paints, canvases and brushes in use today are recognizably similar to those of the original Impressionists, as are the sketch boxes and easels used with them. Other important art materials, such as pastels and watercolours, are also almost the same now as they were then. This makes it relatively easy to re-create the Impressionists' methods with today's art materials.

This section of the book gives some general information about the materials that the Impressionists used and considers specific materials and equipment for use in Impressionist painting. By comparing what is available now with what was used in the 19th century, you will be helped to select suitable materials for your own Impressionist painting. You will also add to your understanding of the methods practised by the Impressionists.

At the beginning of the 19th century, painters still kept their colours as pigments – dry powders that have to be mixed with oil and then ground to a paste by hand to make paint. Alternatively, they purchased ready-made oil colours from an artists' colourman – a professional supplier of art materials – or had them made to order. These were produced by hand in exactly the same way and were wrapped in pieces of pig's

The engraved illustrations throughout this section are taken from the Winsor & Newton catalogue of 1886, the year of the last Impressionist exhibition. They show equipment typical of this period, which is similar to that shown in the 1888 catalogue of the French colourman Bourgeois.

Modern artists' materials are essentially the same as those that were available to the Impressionists.

bladder, tied with thread. Paint bladders were portable, but not very practical for painting out of doors.

By the middle of the 19th century, and certainly by the time of the Impressionist exhibitions in the 1870s and 1880s, materials had begun to change, coming to resemble those of the present day. The most significant developments had been: the introduction of mechanical grinding using paint mills, which allowed the mass production of artists' colours; a steady increase in the number of manufactured pigments available from the developing chemical industry, adding many bright colours to the palette; and the introduction of the collapsible metal tube as a container for paint, making oil paint much easier to store, dispense and carry about. Impressionism could not have happened if these changes had not taken place.

A new kind of painter

Remnants of earlier studio practices were still evident in the 19th century, but by then the technical knowledge of painters was in serious decline. The master painter's studio had been replaced by an academic system of teaching led by the Ecole des Beaux-Arts in Paris, which provided little or no practical training. A new kind of painter was emerging – enthusiastic, naturally gifted, but poorly trained and in many respects not very different from an amateur. Such artists tended to choose simple, direct and fairly obvious methods, preferring easy-to-use and readily available, commercially produced art materials. They began to experiment with the new brighter colours, trying out different effects and approaching painting without any preconceived ideas. This fusion of modern materials and modern painters produced Impressionist art.

Sources of supply

In 1800 supplying raw materials and making to order still formed a substantial part of the business of any artists' colourman, but by the

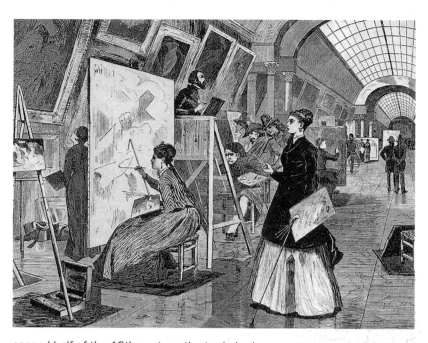

Art Students and Copyists in the Louvre Gallery *(1867)*

second half of the 19th century, the trade had expanded to serve an ever-increasing number of painters, most of whom had little practical knowledge and were largely amateur. The trade became a mechanized and commercially motivated industry of mass production rather than a small-scale specialized craft allied to the painter's studio.

By the time Impressionism began, the substantial manufacturing colourman with a retail shop, and a separate factory to supply it, was well established. The larger companies, such as Rowney, Winsor & Newton and (in France) the then separate firms of Lefranc and Bourgeois, supplied other retailers and exported. Small specialist businesses still existed, however, and there would have been a far greater choice of supplier and of products than there is today. The Impressionists seem to have favoured smaller suppliers and, when they could afford them, the specialist ones: for instance, the Ottoz family who were noted for their canvases; Mulard and Moisse, both famous for their oil colours; and, of course, Père Tanguy, the colourman who befriended the Impressionists.

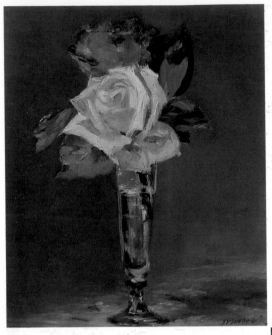

Roses in a Champagne Glass (c. 1882). This simple, but very effective, still life by Manet could have resulted from the use of thick, but fluid, handmade oil colours.

Machine-made paint

By the 1830s machines that ground colour between a row of rotating stone rollers had been devised and were adopted from the 1840s onwards. Triple-roller mills, as they are now known, are still employed to manufacture top-quality artists' colours; there are even some 19th-century machines still in use. The relative merits of hand and machine grinding have been disputed ever since.

Machine-made paints tend to have a stiff and buttery consistency which suits Impressionist techniques, as, unmodified, they work best with firm bristle brushes and are most easily applied in broad, heavy strokes. The consistency of modern brands varies – some manufacturers preferring to give their colours uniform characteristics by using additives, while others retain the individual properties of the pigments in simple formulations.

Hand-ground colour

Hand grinding is implied by the fluidity of Manet's and Morisot's oil colours and the specific requests made by Pissarro to his colourman and by Van Gogh to Père Tanguy. Tanguy trained with a colourman called Edouard, one of the best in Paris, whose business was subsequently bought by Mulard. Mulard originally employed Moisse. They all ground oil colours by hand, which Renoir was eventually to insist on. He and Monet purchased from Mulard and Moisse.

Hand-ground colours retain the character of each pigment and respond sympathetically to the brush. Impressionism clearly depends on art materials in their modern form and on oil colour being supplied as made-up paint in tubes, but you must not assume that satisfactory results can be obtained from any standard product. Several different manufacturers' paints have been used in the step-by-step demonstrations, but mostly the special quality artists' oil colours made by my own small colourman's business have been relied on. Their handling qualities, in my opinion, made the re-creation of the Impressionists' methods much easier.

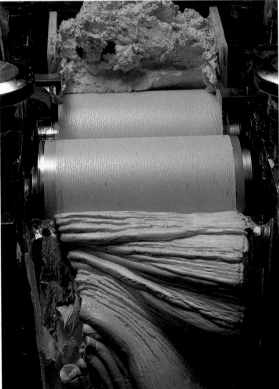

The triple-roller mill grinds the pigment, mixed with oil, between its rollers to make paint.

In the studio

The extent to which the Impressionists painted in studios has probably been underestimated. Degas worked exclusively in the studio and only left it to make preliminary sketches. Renoir eventually became dissatisfied with working out of doors and combined painting on site with reworking in the studio. Since still lifes and portraits are usually studio pieces, Cézanne, Manet and Morisot must have spent a significant amount of time painting indoors. In their later years Pissarro and Monet worked from studios very close to their subject; which makes painting more practical without necessarily excluding contact with nature. Pissarro often painted from windows and Monet took his subjects from his surrounding garden. Renoir was eventually confined to a wheelchair and so could not travel far.

The later studios of Renoir, Pissarro and Monet were classic in their design, having large window spaces which made them well lit. Monet and Renoir used translucent blinds or curtains to diffuse and control the light. This is precisely

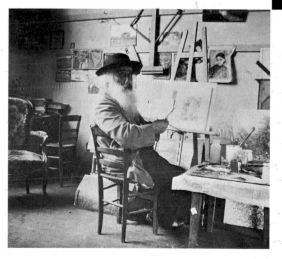

Pissarro photographed in his studio (c. 1897)

the kind of controlled studio environment that the Impressionists are supposed to have rejected.

Renoir's *Portrait of Frédéric Bazille Painting* (1867) shows Bazille working on his *Still Life with Heron*. Sisley must also have been present in the studio because he painted a version of the

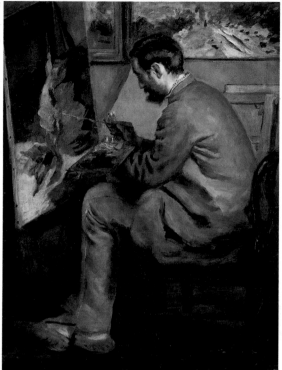

Renoir's Portrait of Frédéric Bazille Painting *(1867)*

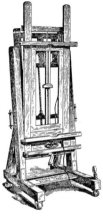

The studio easel (above) is very similar to the one Bazille is using in the Renoir portrait. An alternative late 19th-century design is also shown (far left).

same still life. Bazille let his friends, Monet, Sisley and Renoir, share his studio in rue Visconti during 1867.

In Renoir's painting of Bazille at work, his upright studio easel is just visible. This is of a type known in France at the time as an English easel. Similar easels appear in photographs of Renoir's and Monet's studios. In the photograph of Pissarro in his studio in around 1897 he is working at a less sophisticated, three-legged easel. A typically French version of this easel pattern, with an elegant lyre-shaped top, appears in photographs of Morisot's and Renoir's studios.

Bazille is shown holding an oblong palette with a double dipper on it and is painting with a flat brush. In later photographs Renoir and Pissarro have similar palettes and brushes. Bazille's canvas is tacked down at the edge of its stretcher and behind him is the wedged stretching frame of another canvas. These are both standard commercially prepared canvases.

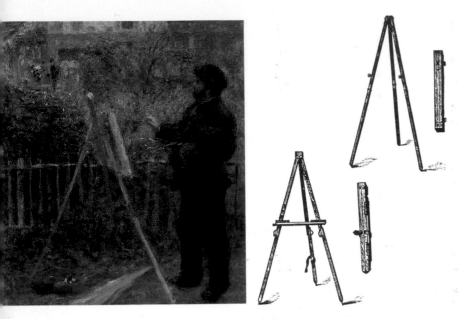

Renoir's Claude Monet Painting in his Garden at Argenteuil *(detail, 1873) shows Monet working at a lightweight, folding easel similar to the ones in the catalogue illustrations (above, centre and opposite, below).* Underneath the easel may be a sketching umbrella like the example from 1886 *(above, right).*

Painting out of doors

Before Impressionism there was already a long-established practice of making sketches in the open – finished paintings were then worked up from them in the studio. Valenciennes recommended this method to landscape painters in 1800. The generation before the Impressionists went a step nearer to completing a work on location; Corot, Courbet and Diaz worked in the Fontainebleau Forest around Barbizon and, with painters such as Boudin, Jongkind and Daubigny, established the fundamental concept of Impressionism – the idea of working directly from nature – and some of its methods. For example, before 1860 Daubigny had a floating studio in order to paint river scenes. Monet was to do the same later and was painted working from his boat by Manet.

Portable equipment was essential to these developments and was widely available by the mid-19th century when the ideas and practices of Impressionism began to evolve. Much of it was aimed at the amateur painter who enjoyed sketching out of doors as a leisure activity. It was also well suited to Impressionist methods since in many respects Impressionism is just an elevated form of sketching.

In *Claude Monet Painting in his Garden at Argenteuil*, Renoir shows Monet using a lightweight tripod easel. It is almost certainly a folding one – the brushmark part way down one of the front legs probably indicates a joint. A very similar easel appears in the surrounding catalogue illustrations together with two alternative patterns. It would appear that Monet was using the simplest and probably the cheapest type. Beneath his easel is an open sketch box of paints and possibly a folded umbrella. His palette and brushes would have been packed away into the sketching box for carrying from place to place. Umbrellas were used to shade the work area, diffusing strong light, so the painter could assess colours and tonal values more accurately. Monet's canvas is on a heavy wooden stretcher – a dot of colour near the top corner may represent a wedge and we can see that the grey or white primed canvas overlaps its edge and is neatly trimmed off. This is a typical ready-made stretched canvas.

The small easel in Manet's painting of *Claude Monet Working in his Boat at Argenteuil* (1874)

Claude Monet Working in his Boat at Argenteuil *(1874) by Manet. Monet's floating studio allowed him to get close to river subjects and gave him an unusual viewpoint.*

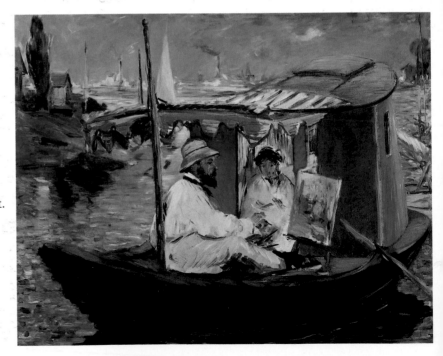

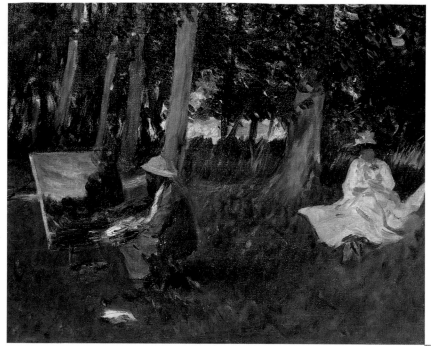

Monet Painting at the Edge of a Wood *(c. 1887) by Sargent depicts equipment typically used for painting out of doors.*

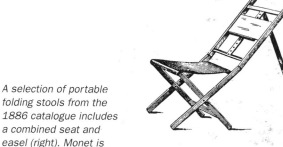

A selection of portable folding stools from the 1886 catalogue includes a combined seat and easel (right). Monet is seated on a stool in Sargent's painting.

is probably an ordinary sketching easel with the legs folded down. The boat's cabin is in effect a portable studio – its canopy serves the same purpose as a sketching umbrella. Monet is also wearing a hat, as he is in Sargent's oil painting *Monet Painting at the Edge of a Wood* (c. 1887), which shades the painter's eyes as well as protecting the head from the sun. He is sitting on a folding sketching stool, holding the palette and brushes as before, and the sketch box is again placed beneath the easel. The canvas has a primed turned edge, once more indicating that it is a standard commercial product.

Combination easel boxes were available to the Impressionists, but they do not appear to have used them. Cézanne may, however, be carrying one in the photograph on the right, which shows the standard practice of carrying sketching equipment as a backpack with straps. Most landscape destinations had to be reached on foot, but the development of the railway system from the mid-19th century made the countryside much more accessible to the Impressionists.

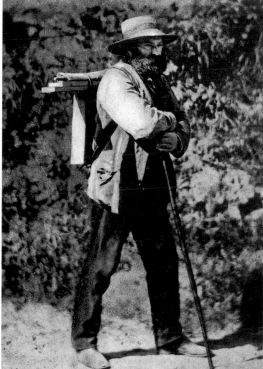

Cézanne photographed in Auvers (c. 1874) as he sets off on foot to paint, carrying his materials in a backpack.

OIL COLOURS

Paint bladders were used to store oil colour from the 17th century onwards. First metal and then glass syringes were tried as an alternative, but the collapsible metal tube was the first really practical portable container for oil paints. Invented in 1841 by John Goffe Rand, an American portrait painter living in Britain, it was first marketed by Thomas Brown, an artists' colourman operating from 163 High Holborn, London.

Rand's patent was bought in 1842 by William Winsor of Winsor & Newton, who perfected the design by adding a screw cap. This simple invention was essential to the development of Impressionism. As well as being portable, the tube facilitated mass production as it could be filled quickly and easily by the manufacturer in sizeable production runs using a piece of bench-mounted equipment.

Modern oil colours

Modern oil colours are still supplied in tubes, although now they are made of lacquered aluminium instead of lead. In theory, the best of today's oil colours should be similar, if not actually identical, to the oil paints used during the latter part of the 19th century. Those described as 'artists' oil colours', or 'extra-fine artists' oil colours' are most likely to offer the general aspects of quality that the original Impressionists would have been familiar with – simplicity of manufacture, and purity and strength of colour.

Paint of this quality from any reputable manufacturer should give good results with Impressionist methods. Brands do vary greatly, however, and there are very few oil paint ranges capable of performing equally well when applying all Impressionist techniques. The handling quality of oil colours is very important and you may have to experiment with several different ranges to find one that suits you and the techniques you wish to employ.

Satisfying results can be obtained from the cheaper oil paint ranges meant for students and leisure painters, and if you are a beginner you may feel more comfortable using them, but you will always get better results from artists' quality colours. A typical Impressionist palette does not involve many colours and the cost of buying good paint is amply repaid by its performance and the pleasure you will derive from using it.

Paint in boxes

Artists have always used studio chests – large, but movable, boxes or cabinets containing a substantial quantity of art materials and acting as a compact store for the painter's studio. The oil painter's sketch box, which is smaller and more portable, can be traced to the 17th century. The earliest version involved carrying a pre-laid palette of wet paint inside the box. Transporting paint bladders may have been an improvement on this, but both were potentially messy and neither was completely practical. The introduction of paint in tubes overcame these problems and from the late 1840s sketching out of doors in oil colours became

Present-day artists' oil colours (clockwise from top left) supplied by Grumbacher (America), Lefranc & Bourgeois (France), Talens (Holland), Maimeri (Italy), Rowney (Britain), Winsor & Newton (Britain), J P Stephenson (Britain) and Sennelier (France).

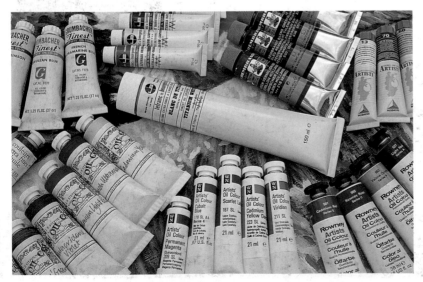

Studio chests and sketch boxes appear in photographs of Monet, Morisot and Pissarro at work. Modern oil painters' boxes have changed very little since the 19th century and still resemble those used by the Impressionists. The modern 'luxury' boxes in the photograph are by Winsor & Newton – on the left is a studio chest and on the right a portable sketch box. For Impressionist painting it is best to purchase an empty, well-made sketch box that you can fit with the materials that you definitely need. However, boxes are expensive and it is not essential to have one to enjoy painting.

Monet's painting Corner of a Studio (1861) shows his modest sketch box. It is very like the simple box shown in the 1886 engraving (below), although the French box is wooden, while the English one is made of metal.

The 1886 catalogue offered this elaborate sketch box of japanned tin (left). The photograph (below) shows modern 'luxury' boxes: on the left a studio chest and on the right a portable sketch box.

increasingly popular. The artists' colourmen developed sketch boxes like the ones shown in the engravings. Some were elaborately designed, frequently containing unnecessarily large, but immensely appealing, selections of colours and were marketed primarily for amateurs. Serious painters only need a modest sketch box, like the one in Monet's painting *Corner of a Studio* (1861).

Monet's sketch box is a typical example, consisting of a shallow tray with a hinged lid that closes to make a slim case for carrying. The tray in such boxes is partitioned off and, depending on the design, can accommodate a range of oil paints in tubes; bottles of oil, turpentine or painting medium; a selection of brushes; a palette knife; paint rags; a dipper; probably some charcoal or a pencil; and an oblong palette which can usually be fitted neatly into the lid.

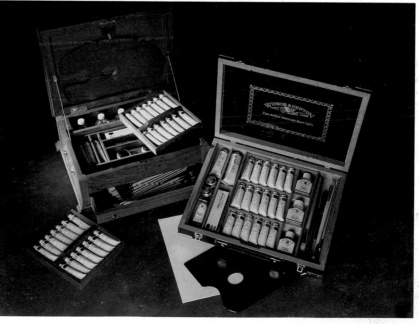

THE IMPRESSIONIST PALETTE

During the 19th century ideas were put forward by scientists, philosophers and artists on the subject of colour theory. Some of these were attempts to deepen the understanding of the science of colour that had first been investigated by Sir Isaac Newton in 1666, while other theories tried to explain the use of colour in art according to a set of aesthetic principles, or simply offered practical systems for amateur painters that showed how they might mix colours. In 1852 Hermann Von Helmholtz, in effect, demonstrated that these scientific and artistic theories had little relation to each other by determining that mixing coloured light and mixing pigments produced different results. Even today, few painters grasp the full significance of this, so the notion that the artistic use of colour may be fully governed by theory remains popular.

In France Michel Eugène Chevreul, a chemist and Director of dyeing at the Gobelins Tapestry Works, advanced scientific colour theory significantly with a major work on colour classification that established the 'laws of the contrast of colours'. His findings were published in 1864. Chevreul's theories were specifically referred to by the Pointillists: Seurat, Signac and, for a time, Pissarro, and were the justification for their methods of painting.

Many commentaries on Impressionism have insisted that Chevreul's work was also a great influence on the Impressionists' use of colour and that it explains their methods. In fact, this is simply part of the ill-informed intellectual theory that became attached to Impressionism and that so annoyed Renoir in his old age. It is true that some colour theory terminology drifted into general use and a second-hand knowledge of Chevreul's work began to circulate among artists, but Impressionism was already well under way by the time Monet was acknowledging his use of complementary contrasts and Pissarro was becoming involved in Pointillism.

Colour theory is not the origin of any Impressionist technique – confusion arises because Impressionist methods are quite likely to give results that coincide with colour theory. For example, in strong light and at certain times of the day, you will probably see a hint of colour that according to scientific theory is complementary to the one that you are looking at. As an Impressionist you simply paint the colours you see and represent such observations in your work, so effects that correspond to theory are put in, although not intentionally.

You will have a better understanding of the Impressionists' use of colour if you become familiar with the typical Impressionist palette. Renoir is credited with the introduction of the so-called rainbow palette, which concentrated on a series of bright colour values, mostly those that had been introduced during the first half of the 19th century and were newly discovered pigments.

The Impressionists' use of colour is usually easy to explain in terms of an instinctive or habitual use of the Impressionist palette and a deliberate policy of observing the subject in terms of its colour. Earlier painters such as Delacroix and Turner probably influenced the young Impressionists more than colour theory in the way that they employed colour. Generally speaking, if you adopt a modern version of this palette then you will be much more likely to become an Impressionist painter than if you study colour theory.

Chevreul's colour circle from his book, published in 1864, on colour classification and contrasts.

1 MATERIALS

24

Rainbow colours

Below is a selection of colours that could be used in modern versions of the Impressionists' rainbow palette. More than half of these were actually used by the Impressionists, the remainder are present-day alternatives that have either directly replaced colours no longer in use or are acceptable substitutes for them. Not all of the colours that you might use are shown here. Essentially the Impressionist palette contains bright values of blue, yellow, red and green, plus a Red Lake and White (I will explain the last two separately).

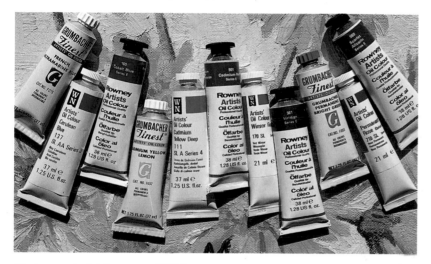

The Impressionists' palette can be reproduced with modern paints, but it is important to have the true pigments. In cheap paint ranges Viridian, Cerulean Blue, Cobalt Blue, Cadmium Yellow and Cadmium Red are likely to be substituted.

Blues

French Ultramarine is a synthetic version of the traditional pigment, also called Ultramarine, which was made from the semi-precious stone lapis lazuli. Artificial Ultramarine became widely available in France after 1828 when a prize was offered and won for the discovery of a method to produce a less costly pigment. Typically, French Ultramarine is a strong mid-blue and was used a great deal by the Impressionists.

Cerulean Blue – a delicate greenish blue – was first used by Rowney in 1860 as a watercolour and can be seen as an oil colour in French Impressionist paintings from the 1870s onwards (particularly in the work of Monet, Morisot and Manet).

Cobalt Blue was discovered in 1802 and was introduced soon afterwards. The Impressionists used it a great deal. It is also a rich mid-blue and has shade variants that come close to Ultramarine, but it often tends towards green and makes the most beautiful tints with White. Cobalt Blue is especially valuable as an oil colour because it dries well. It should nearly always be on your palette, but you must have the real Cobalt Blue and not an imitation of it.

Yellows

Cadmium Yellow is shown in lemon and deep yellow versions. It is also available as a mid-yellow variant and is closely related to Cadmium Orange. The Impressionists initially used the Chrome Yellows because they could be produced cheaply and with many shade variants. They were slow to adopt the Cadmiums, which became available in the 1840s, possibly because they were expensive and less popular with French colourmakers, but from the late 1870s the Cadmiums displaced the Chromes.

The Chrome Yellows are still available, but the Cadmium pigments are much better. The mid and deep yellow values of Cadmium Yellow that tend slightly towards orange are generally the most valuable ones to have on the palette. The Impressionists had an opaque Lemon Yellow with a greenish tinge, but none of the pigments used for this value are still available. Hansa Yellow Pale (not shown here) is a reasonable substitute and occurs in most oil paint ranges, but is often marketed under a brand name.

Reds

Vermilion was the only useful and reliable bright red that was available to the Impressionists. It has since been replaced by Cadmium Red, a colour with very similar properties. You should use one of the lighter, brighter values such as Cadmium Light Red, Cadmium Scarlet or Cadmium Vermilion. Several modern organic pigments now offer possible alternative bright reds, but the Cadmiums are generally more reliable.

Greens

I have shown three greens in the illustration on the previous page. The one in the middle is Viridian – the transparent emerald green version of Oxide of Chromium that featured on the original Impressionists' palettes. They also used Chrome Green and a very vivid Emerald Green that the French called Véronèse Green. The colour name still exists, but the original highly toxic pigment does not. It can be imitated with a mixture of Hansa Yellow Pale and Phthalocyanine Green. There are numerous other modern blended greens to choose from, for example, the Permanent Bright Green shown next to Viridian. Mixed greens can be useful, but they are not strictly necessary.

Phthalocyanine Green is usually sold under a brand name like the example shown. It is worth having on the palette even though it is fairly close to Viridian. Both are transparent emerald greens, but Phthalocyanine Green is sharper, more intense and more transparent. It is useful in mixtures.

Other important colours

The last two colours shown on the right on the previous page are examples of Red Lakes. You may also want to use other colours such as the Cobalt and Manganese Violets which were available to the original Impressionists and must have been used by Monet and Renoir. Both colours remain in use. Dioxazine Violet, a modern colour sold under brand names, is a possible alternative. Then there are the earth colours and Black that, contrary to popular opinion, do feature on the Impressionist palette. Invariably the Impressionists used Ivory Black, the least powerful and most transparent of the Blacks, but Lamp Black is as good. Yellow Ochre, Red Ochre, Raw Sienna and Burnt Sienna are more likely to be of use than the Umbers, but even they are occasionally worth having.

Red Lake

Throughout this book the term Red Lake, qualified as Deep or Rose, is used to refer to a

group of colours that occupies a range of values roughly between red and purple which are richly coloured and transparent. The original pigments in this group were Rose Madder, Carmine and Indian Lake. They were extracted from plants or insects and could be produced in many shade variants – 30 different Red Lakes were offered as oil colours by the French colourman Lefranc, alone, during the 1870s.

At about this time, synthetic dyes such as Alizarin also started to be used in Red Lake pigments. The different Red Lakes are not easily distinguished in paintings and so it is difficult to determine the Impressionists' preferences, but what matters most, in any event, is the function they served and which of today's Red Lakes would be suitable choices.

The valuable Red Lakes are colours ranging from a brilliant rose pink through crimson to a deep purple red. Dark shades of red violet or crimson tinged with brown may also work well. The rose pink to crimson varieties give beautiful tints with White which might be used for painting flowers, or the delicate complexions of young women, or children. Used in their pure forms the deep Red Lakes provide a dark shadow tone for strongly lit landscapes, but the most important function of any Red Lake on the Impressionist palette is its contribution to colour mixtures.

These six modern Red Lake colours are based alternately on Alizarin and Quinacridone pigments. The Quinacridone Pink (second from the left) and Murray Lake (far right) are usually the Red Lake (Rose) and the Red Lake (Deep), respectively, referred to in the step-by-step demonstrations in oils. In one case, though, the Red Lake (Deep) was a dark Quinacridone Violet.

Red Lake mixed with blue makes purple. Added to green, it darkens and dulls the colour, eventually producing an approximation to Black, or if White or yellow are present it gives broken greens with muted values. With a large amount of White, Red Lake plus blue or green, or both, in varying proportions, gives coloured greys. The greying effect of such combinations also helps to produce impure colours for use as intermediate values. So yellow and Red Lake might give an orange that when mixed with White and a tiny amount of blue becomes more like a Yellow Ochre or Raw Sienna. Adding green instead of, or as well as, blue, produces a different version of this shade.

Red Lake is almost always the mixing red on the Impressionists' palette. A brighter red, such as Cadmium Red, produces dull, flat and often dirty-looking mixtures and is generally used only as a pure red, or in a pink. There are, however, two things to take account of: firstly, you must use Red Lake judiciously or you will end up with very dirty colours, and secondly, with one exception, Red Lakes become less and less permanent as they are reduced in mixtures.

Six modern Red Lake colours are illustrated opposite. From the left, these are alternately based on Alizarin and Quinacridone pigments. Alizarin is a synthetic version of one of the components of Madder, an important traditional source of Red Lake. Alizarin pigments probably occur in the original Impressionists' paintings and are still widely used. They are cheap and commonly employed, though, in fact, at the low levels used in this type of colour mixing – where a small addition is used to 'break' another colour – they are not permanent. The more recently introduced Quinacridone pigments are more expensive, but are a better choice.

Quinacridones usually appear under brand names, or are called Permanent Rose or Permanent Magenta. Quinacridone colours were used for the Red Lake of the Impressionist palette throughout the step-by-step demonstrations. A more permanent version of Alizarin Crimson has recently been introduced and might also prove suitable.

Whites

Lead White or Flake White was established as an artists' colour long before Impressionism. Because this pigment is a compound of lead it accelerates the drying of oil. White Lead on its own, or any colour mixed with it, will be almost dry in two days even when thickly applied. In summer, it will certainly be dry by the third day.

This rapid drying is of obvious value in Impressionist painting, since heavy impasto effects – thickly applied paint, usually with deeply scored brushmarks – dry quickly and permit a crusty surface texture to be built up in a relatively short time. A short interval between painting

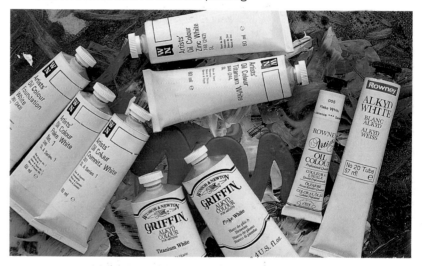

sessions will mean that you are actually working on a dry lower layer which is a completely different experience from attempting to add colour to thickly applied paint that is still very wet. Painting on to dry, or into semi-dry, colour is more practical.

This property of Flake White makes it very suitable for Impressionist methods in oil. Only where the paint is laid once and never touched again, or where a substantial time elapses between painting sessions, can a slower drying White be substituted. The Impressionists had access to the less opaque Zinc White, but did not employ it much, although they may have used it inadvertently as an ingredient in some

Lead White, or Flake White, was particularly useful to the Impressionists because of its fast-drying properties and is still available today. Modern Alkyd Whites also dry quickly. Titanium White is usually a better alternative than Zinc White to Flake White.

premixed pale colours. Pissarro actively sought such colours which he may have become familiar with in Britain.

These days Titanium White is also used. It is more opaque and usually whiter than Lead White. Titanium White takes longer to dry than Flake White in oil, but much less time than Zinc White, which is a slow dryer – useful for prolonging wet-in-wet working time. Titanium White is a better pigment than Flake White and can sometimes replace it in Impressionist techniques. For example, it was used in all of the portrait demonstrations in oil.

The Impressionists would have used the best Lead White paints ('Blanc d'Argent' and 'Blanc de Krems' or 'Blanc de Cremnitz'). Several versions of Lead White are still offered by manufacturers such as Winsor & Newton, Rowney and Lefranc & Bourgeois, even though it is considered an old-fashioned pigment and is sometimes avoided because of its toxicity. You may find significant differences between the available Lead Whites – they may even vary from tube to tube. A heavy, but easily workable, consistency is best.

Alkyd White is a modern fast-drying formulation made with an oil-modified alkyd resin in place of oil. It can be mixed with ordinary oil colours and speeds up the drying. But, the pigment loading of alkyds is lower than that of good oil colours.

Whichever White you use, you may sometimes need to alter its handling qualities. It is said that the Impressionists took excess oil from their colours by standing them on blotting paper prior to use, but an immobile White can be worse than an oily one. The Impressionists' Whites, incidentally, were probably mostly ground in poppy oil, which initially yellows less than linseed, but in the long term can promote cracking. It also tends to give paint a soft buttery consistency, so the Impressionists' Whites were probably thick, but easily spread.

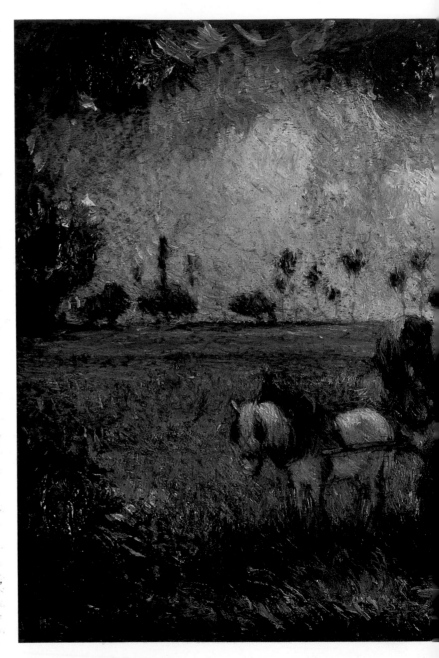

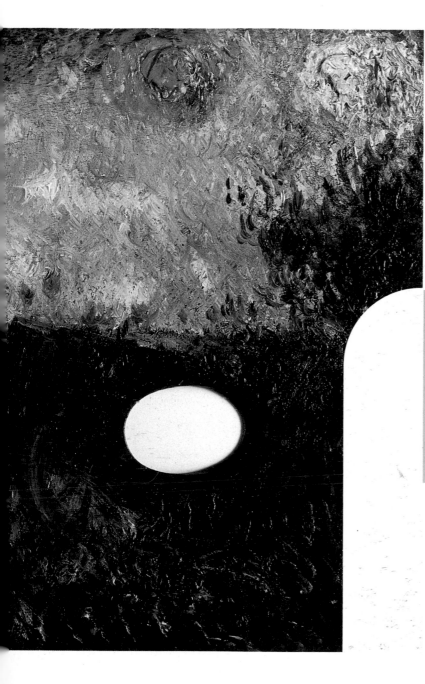

Palettes

The Impressionists' sketch boxes would have carried oblong palettes like these modern examples shown below. Dark, warm-coloured mahogany palettes are most suitable for painting on dark grounds. It is easier to judge colours when working off a light-toned palette, such as the birch-ply example on the right, if you are painting on to a white or pale-coloured canvas ground. Also illustrated are two tear-off palette pads – a convenience product for modern painters. You simply rip off the top sheet after it has been used and lay a fresh palette when needed on the clean sheet beneath it.

Pissarro painted this landscape on his palette (c. 1877–79) (left) presumably as a demonstration of how a limited selection of bright colours could be used – you can see his paints around the edge. The shape is very similar to the modern examples (above).

BRUSHES

Brushes with tin mounts were available before the 19th century, but it can safely be assumed that the metal ferrule was not in widespread use before then. This allowed brushes to be made with a flat section which meant that a different type of brushmark was possible and probably encouraged the use of bold strokes and broadly handled areas of colour.

Manet would have adopted such brushes in order to imitate the brushwork that he admired in the paintings of Velazquez and Hals. Following his example, the use of the *tache* – a distinctive brushmark – became popular, eventually becoming a facet of much Impressionist painting. The square-ended, flat-sectioned brush easily produces a firmly shaped brushmark and so lends itself to this mannerism. Flat brushes can also cover a canvas quickly which is an

Short flats, or 'brights', were available in the 19th century. They are less versatile than long flats as they are stiffer with a shorter bristle.

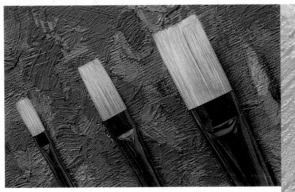

Long flats like these modern examples are versatile and very suitable for Impressionist methods.

Long flat and round hog hair (bristle) brushes from the 19th century.

advantage when painting using Impressionist techniques.

Flat brushes were made and are still supplied in two styles – the long flat and the short flat, also known as a 'bright'. I consider that the long flat brush is more important, judging from the paintings of the original Impressionists and from my experience of re-creating their methods. Its bristle extends well out of the ferrule, making the head long and flexible, so lending itself to very varied brushwork. A long flat can deliver long, short and manipulated strokes and can handle either thick heavy colour, or free flowing paint. It is therefore very versatile.

The short flat is a stubbier, stiffer brush with a shorter length of bristle extending from the ferrule. It can manipulate thick paint and performs best when used to dab colour into place, or make short strokes.

Flat brushes were not the only ones that were commonly used. Renoir, in particular, seems to have had a preference for the round, and in the work of Van Gogh and Degas the mixed use of round and flat brushes seems probable. Rounds have not changed since the 19th century. They have long, flexible bristles and because they are round in section they come to a blunt point. These brushes can deliver strokes that are either long and linear, short and narrow, or that spread in the middle and then tail away as the brush flexes in response to the rise and fall of pressure from the painter's hand as the strokes are made.

It is likely that the Impressionists relied almost entirely on bristle brushes, but Renoir, Manet, Morisot and Cézanne may have used a particular type. The French brush maker, Raphaël, continues a traditional French practice when making its 'Paris' brush range. This involves boiling the bristles twice during preparation – the softer and more flexible result may explain certain characteristics that can be observed in some Impressionist handling.

Modern examples of short flats, or 'brights'. This type of brush can be used for Impressionist painting.

Hog hair brushes (below).

Rounds have not changed since the 19th century. These are appropriate for some Impressionist techniques and for briefly indicating detail.

These 'Paris' brushes (right) are made with softened bristle which spreads in use, giving a slightly rounded brushstroke. The dome-shaped 'filbert' and shorter 'cat's tongue' do not appear to have been used by the Impressionists, but well-worn flat brushes take on this shape. Most modern brushes use interlocked bristle which is firmer and delivers a fairly even stroke. Both types can be used for Impressionist techniques.

Brush sizes

The sizes and shapes of brushes employed in Impressionist paintings can be roughly gauged from the sizes and shapes of the brushmarks. In the step-by-step demonstrations of Impressionist techniques in the section that follows, I have based my choice of brushes on such observations. There are perhaps some instances where the brush sizes have been dictated partly by the size of the canvas being painted on, but otherwise I have tried to employ the brushes that I believe the painter, whose methods are being re-created, would have used.

This has resulted in a fairly consistent use of two brush shapes and one hair type, the round and the long flat in bristle, across a fairly narrow range of sizes. The brushes shown here are life size so that you can see what was used in the step-by-steps. The French Impressionists,

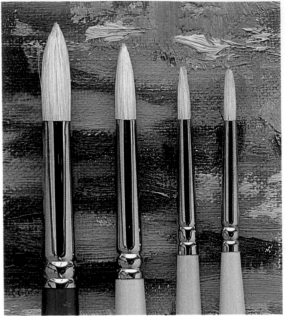

Round bristle brushes in English sizes 6, 4, 2 and 1 (left to right) are shown life size.

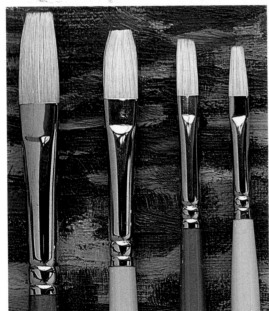

These long flats are shown life size and are the English sizes 6, 4, 2 and 1 (left to right).

of course, used French brushes which are sized differently from English ones. English brush sizes are given in the text. By comparing your brushes to these illustrations any ambiguity will be removed.

The brushes shown on the left are long flats in sizes 6, 4, 2 and 1. The sizes 4 and 1 are from a top-quality range, while the sizes 6 and 2 are of good quality that would suit most painters and perform well with Impressionist methods. The better brushes have a slightly whiter and neater bristle, but the real difference shows in their durability. Even though Impressionist painting does not demand great accuracy from the brush, you may still have to throw away ordinary quality brushes, particularly the small sizes, after they have been used a few times and have become worn.

Illustrated above are rounds in sizes 6, 4, 2 and 1. The largest-sized brushes I had occasion to use are shown opposite. They are long flat bristle brushes in sizes 12 and 10. Most of the brushwork in the paintings of the Impressionists and in my examples is, however, done with smaller brushes.

Soft-haired brushes hardly feature at all in Impressionist painting, although sometimes there are traces of an initial drawing beneath heavily applied paint that looks as though it has been sketched with a small round-pointed

sable brush. The overdrawing of finishing details, such as foreground figures in Boudin's paintings, must also have involved small fine brushes and they would have been used for some of the more delicate brush drawing in Degas's mixed media pieces.

The brushes shown right are sable-haired equivalents of the short and long flat brush styles discussed on the previous pages. Next to them are two fine-pointed rounds in sable. The long-handled sable rigger is the traditional version of this brush used in oil painting. It has been suggested that Renoir employed such soft-haired brushes and a drawing of three sable rounds, together with two bristle flats, appears in a list of materials made by him in 1879. However, the use of a rich painting medium is more likely to account for the smooth finish and softened strokes that are apparent in some of his paintings.

The three brushes illustrated below, right are of the modern synthetic-haired type, which can be used as an alternative to both bristle and sable brushes, although they do not always perform in exactly the same way. Synthetic-haired

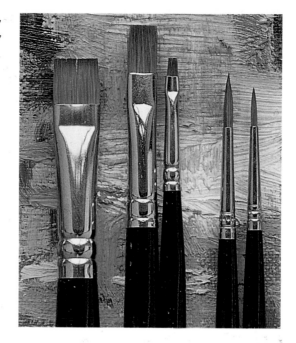

Sable-haired equivalents of the short flat, long flat and round brush styles, shown life size. Rounds like these, or larger, are good for drawing.

brushes can be recommended for use with modern acrylic paints, partly because their filament strength is gauged to suit the less substantial character of acrylic paint and partly because they can endure long standing in water, a necessary feature of painting with fast-drying acrylics.

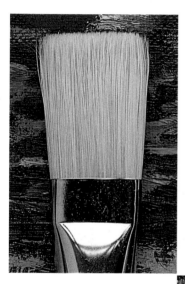

Long flat bristle brushes in English sizes 12 and 10, life size.

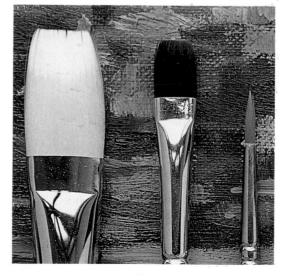

Modern synthetic-haired brushes are particularly recommended for use with acrylics.

Palette knives

Crank-handled, or crank-bladed, palette knives, like these modern examples shown below, were a standard piece of painter's equipment at the time of the Impressionists. Their shape allows the knife blade to be placed against the palette or a canvas without the artist's hand being in the way.

Courbet, the Realist painter and member of the Barbizon Group that foreshadowed the Impressionists, often applied paint with a palette knife and this may have made its use popular with the younger generation of painters. Pissarro and Cézanne experimented with knife painting, but it did not develop as an important technique of Impressionism. Knifed-on paint occurs in early works by Monet and sometimes Manet appears to have used a palette knife in the underlying *ébauche* – or lay-in – of his paintings.

The canvas weave can be seen showing through the exceptionally thin paint in the hair in Manet's 'Au Bal' (detail, c. 1875), suggesting that he scraped off the colour with a palette knife and then defined the remaining traces with a few dashing strokes.

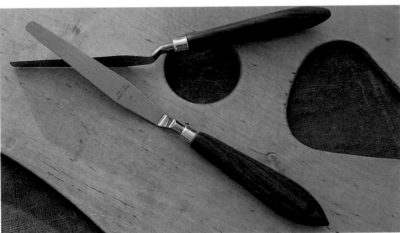

Palette knives like these modern crank-handled examples were used by the Impressionists mainly as a corrective tool.

In Impressionism the palette knife is more useful as a corrective tool, to remove unsuccessful layers of paint while they are still wet. Manet and Whistler developed this use of the knife and incorporated it into their techniques. Manet scraped off work that he did not like, using a palette knife, and would repaint the same area several times, always ending up with something that looked fresh and spontaneous. He also used thin passages of paint that had been scraped down as a subtle foundation for briefly indicated subjects. In '*Au Bal*' (*c.* 1875) the hair may have been painted once, scraped off to leave a thin layer of blurred colour, and then worked into and around with a few defining touches. Whistler is said to have repeatedly painted and scraped down when, for example, he was attempting a delicate portrayal of a face.

Media and thinners

Monet, Pissarro, Sisley and Van Gogh used oil paint as it came from the tubes without modifying it, except for the occasional use of a thinner such as turpentine in the early stages of some paintings and in difficult circumstances, for example, on a cold day, when the paint would not behave as they wished. Renoir and Cézanne adjusted their paint with a medium and Morisot and Manet must have done so sometimes.

Painting mediums were carried – as they are today – in small metal cups called dippers that

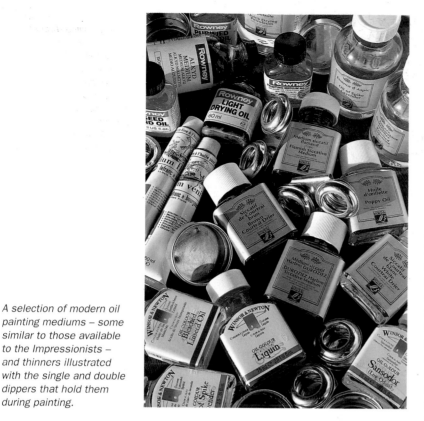

A selection of modern oil painting mediums – some similar to those available to the Impressionists – and thinners illustrated with the single and double dippers that hold them during painting.

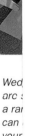

a wrinkling of the surface. Poppy oil was popular during the 19th century; it is slower drying than linseed oil and initially yellows and darkens less than linseed as it ages. It was used in the manufacture of Whites and blues since these colours are easily affected by the yellowing of oil and was considered desirable because it imparts a buttery consistency to paint made with it. Today safflower oil is employed as an alternative to poppy oil – both can be used in the same manner as linseed.

Prepared oils and mediums

Sun-thickened oil, stand oil and cooked oils are known as fat oils. They are prepared by various means and are thicker and richer than plain drying oils. Sun-thickened oil and stand oil have a syrupy consistency and are too thick to use without thinning. Cooked oils may contain resins and siccatives – metallic dryers – which accelerate the drying rate of the oil. All these materials impart a rich enamel-like finish to oil colour and cause the paint to flow. Copal oil medium was popular in the 19th century – the nearest modern equivalent to it would be an alkyd medium. Painting mediums based on linseed stand oil are generally considered to be reliable.

clipped on to the palette and from which the medium was added to the paint on the palette as needed. There are two types – single and double dippers – as shown in the 19th-century catalogue illustration on the right and the illustration above. A single dipper is used with a prepared painting medium that contains a mixture of a drying oil and a thinner and possibly other additives. A double dipper carries the drying oil, or painting medium, in one cup and the diluent in the other.

Diluents

Distilled turpentine and oil of spike lavender – which evaporates more slowly than turpentine – are the traditional thinners of oil painting. Today white spirit, various petroleum distillates and low odour thinners are available as alternatives.

Drying oils

Linseed oil is the most commonly used binding medium for oil colours; it is also employed as a very simple painting medium by working small extra quantities of it into the paint before it is applied. Usually a thinner is combined with it to avoid the excess use of oil, which may cause defects during ageing – darkening, cracking, or

Dippers and double dippers from 1886.

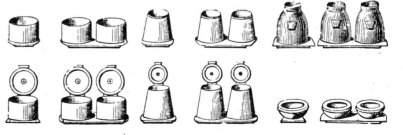

demonstrations have colour-tinted grounds. Note raw cloth for his works in a variety of media.

example, Pissarro and Morisot where traces of their use are clearly visible.

Canvas carrying pins should still be available and today there are also canvas carrying grips with handles. These are more sophisticated, but follow the same basic principle.

Canvas boards and painting papers

Canvas covered boards are popular with today's leisure painters – partly because they are much cheaper to buy than stretched canvases. There are oil paintings by Gwen John and Toulouse-Lautrec that were done on to card, but the modern canvas board cannot really be associated with Impressionism. Nevertheless, canvas boards are suitable for the beginner

Canvas carrying pins, double-ended spikes passed through a piece of wood, cork or plastic, make it possible to carry two wet canvases of the same size without their surfaces touching.

Canvas carrying pins

Canvas carrying pins allow you to transport an unfinished wet oil painting to and from the site where it is being painted. These are basically double-ended spikes protruding from a piece of wood, cork or plastic. One is fitted to each corner of the canvas and is pressed through the cloth and into the stretcher. Another canvas of exactly the same size can then be mounted face down on top of it by pressing it on to the upward pointing spikes. Two wet canvases can be carried in this way without their surfaces touching. When the paintings are finished off, the marks left by the pins are painted over, but there are works by, for

The modern canvas board at the front has been re-primed with a tint of acrylic colour.

and since they are also supplied with a white acrylic priming, it is just as easy to alter them to a suitable tint as it is to change a modern acrylic-primed canvas. The canvas board, shown face up above, has been prepared in this way and the ones seen from the back show their original white grounds at the turnover margins.

The page from the Winsor & Newton catalogue of 1886 refers to 'Academy Boards', the 19th-century equivalent of today's canvas board and shows samples of oil sketching papers, one with

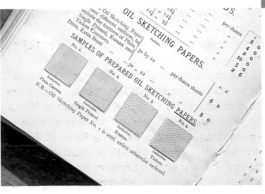

Samples of oil sketching papers in 1886.

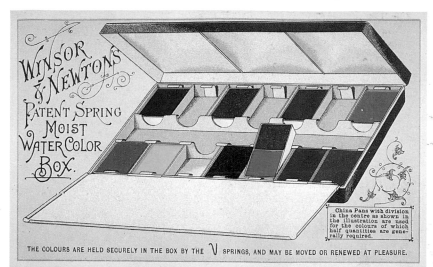

This watercolour pocket box shown in the Winsor & Newton catalogue over a hundred years ago uses paints in 'pans' that clip into place.

a plain surface and the others embossed to resemble canvas grains. The off-white colouring is a white oil-priming, somewhat discoloured by ageing and also probably by the glue used to stick the samples into the book. Some of Cézanne's paintings are on cream-tinted oil-primed sketching paper. His preference was for a plain surface textured only by the marks of the roller used to apply the ground. You can buy oil sketching paper now, but there is also an acrylic-primed version of this product made by Rowney which has a white ground that can easily be tinted.

WATERCOLOURS

Many of the Impressionists made use of watercolours. Morisot used them for preliminary sketches, Cézanne painted large still lifes in watercolours and some of Pissarro's works are in watercolour and gouache – watercolour rendered opaque by an addition of White. Van Gogh also painted with them and Boudin used watercolour washes over pencil drawings to record figure groups for his beach scenes.

The classic watercolour pocket box has changed little since the time of the Impressionists. Modern examples are almost the same as they were over a hundred years

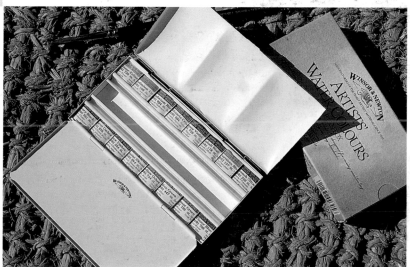

ago. Elegant wooden watercolour boxes are also a feature of the 19th century and Rowney still produce a beautifully presented studio box of this type.

Traditional watercolour brushes of kazan squirrel hair, bound in quill and wire mounts, are suggested by effects seen in paintings by Morisot and Cézanne. These are still made by several French manufacturers, including Raphaël. Fine-pointed kolinsky sable brushes would also have been used at the time. Some of you may find less expensive modern alternatives acceptable.

This modern example of the classic watercolour pocket box design is very similar to the one in the 1886 catalogue illustration (above, left).

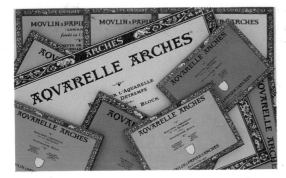

Aquarelle Arches (left) is a top-quality 100% cotton, gelatine-sized watercolour paper.

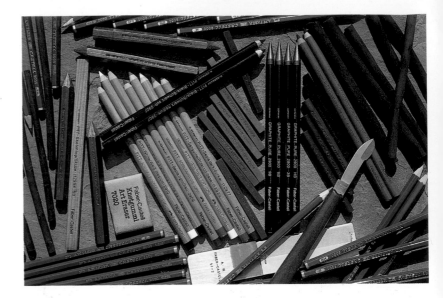

PAPERS

There are plenty of good artists' papers available. Watercolour papers can be used with watercolour, gouache, acrylic and even oil colour in Impressionist techniques. Top-quality 100% cotton watercolour papers are best, such as the Aquarelle Arches. Coloured papers are ideal for pastel – the Mi-Teintes range is also available as a card-backed 'artboard' that is suitable for large-scale works in pastel. Both these ranges are from France where there is a long-established tradition of papermaking. A honey-combed surface texture like that of Mi-Teintes appears in some works by Degas. There are many other good ranges to choose from; for example, Bockingford tinted watercolour paper is suitable for Impressionist methods, using pastel, gouache or thinned oil colour.

Coloured papers, such as the Mi-Teintes range, also available as a card-backed 'artboard', are ideal for pastel.

PASTELS AND PENCILS

Impressionism is primarily about painting, but it also involves drawing. The rejection of academic principles by the original Impressionists is often misinterpreted as a rejection of drawing, but Degas's work depended on it and Renoir eventually recognized its importance. The draughtsmanship of Cassatt, Manet, Morisot and Toulouse-Lautrec also confirms the ability of the Impressionists to draw. It can be assumed that the Impressionists' paintings occasionally began with a light pencil drawing, as Pissarro's *Bath Road, London* (1877) did.

In the 19th century pencils were the same as they are today, but softer broad-handling materials such as charcoal, black or red chalk, and probably Conté crayons, were more popular with the Impressionists. Conté crayons are firmer than chalk and are slightly greasy. There are faint, loosely sketched guidelines on canvases by Manet and Degas that could easily have been done with Conté crayons, but it seems more likely that black chalk was used for many of the Impressionists' drawings. Conté crayons are still being made. Smooth-drawing soft chalks now feature in the PITT range of drawing products manufactured by Faber Castell.

Drawing materials from the Faber Castell range.

Late 19th-century pencils.

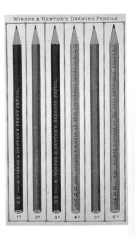

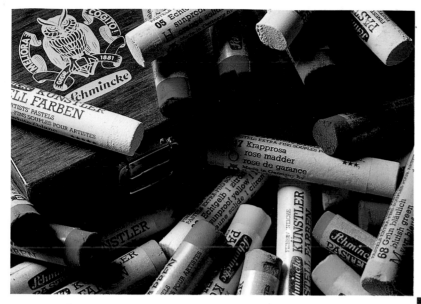

century and is perhaps of the quality used by the Impressionists. They are still made by hand and are exceptionally soft and smooth – able, for example, to produce the effects found in Manet's fluid works. This is a specialist range of over 500 colours. The German manufacturer, Schmincke, offers a comparable range.

The Talens Rembrandt Soft Pastel range, the Rowney Artists' Soft Pastels and the Quentin de la Tour Pastels from Lefranc & Bourgeois are mass market ranges that may be easier to obtain. These are all true soft pastels, which typically offer a smooth delivery and put down heavy deposits of dry pigment easily. These are the correct type of pastel to use in Impressionist techniques. There is also a slimmer, firmer, crayon-style pastel in use now that is less suitable for that purpose.

The German colourman, Schmincke, offers an extensive range of superior soft pastels (left).

The exceptionally soft Sennelier pastels (below) have been made by hand in France since the late 19th century and offer over 500 colours.

Pastels

Degas is well known for his use of pastels, but he was not the only Impressionist to work with them; Toulouse-Lautrec, Cassatt, Monet, Morisot and Manet also worked in pastels.

The Sennelier range of soft pastels 'A L'Ecu' has been made in France since the late 19th

The Rembrandt soft pastel range (below) is widely available and is generally suitable for Impressionist techniques.

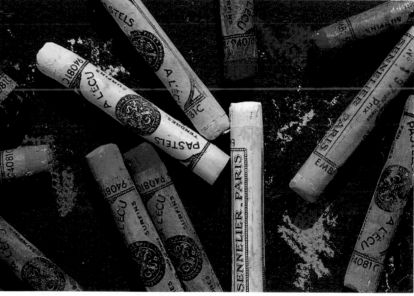

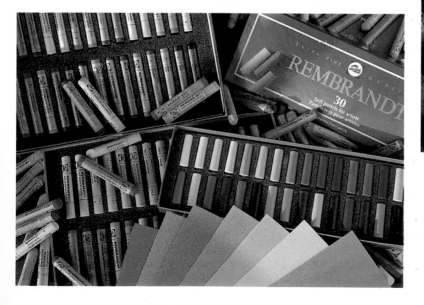

The Impressionists did not have the pastel pencils that are available today. The Rexel pastel pencil genuinely resembles the original soft pastel and offers the possibility of working using the same methods, but on a smaller scale. Modern pastel fixatives are an improvement on those that were available to the Impressionists.

Modern gouache paints are available ready-made, but you can also mix white into ordinary watercolours for the gouache technique.

ACRYLICS

Artists' acrylics were first introduced in the 1950s and are increasingly popular with today's painters. They are conveniently thinned with water and are quick drying. Acrylic paints are also versatile and can superficially imitate the effects of other media. Used at tube consistency, for example, they will deliver impasto effects similar to those obtained from oil colour. They are increasingly chosen, especially by amateur painters, in preference to oil paints. So, even though they are not associated with the Impressionists, I have translated some of the oil painting methods into acrylic techniques in the step-by-step demonstrations.

You will find all the essential colours of the Impressionist palette in acrylic paint ranges, but many of them will be based on modern organic pigments. Because the Impressionists' use of paint was relatively straightforward many of their methods translate easily from oil to acrylic, but you must not expect exactly the same results from acrylics as from oils.

Impressionist methods can be adapted for use with modern acrylic paints.

GOUACHE

Gouache is opaque watercolour. It was used by Degas and Toulouse-Lautrec, usually combined with pastel, and occasionally by Pissarro as an alternative to oil colour. It dries quickly and is mostly used on paper, although Degas also employed it on canvas. It has a soft, reflective colour quality and can be delivered in solid strokes that superficially resemble oil paint, but it cannot give impasto effects. Pissarro may have liked gouache because of his preference for the light tonal values of *peinture claire* to which gouache lends itself.

Prepared gouache may have been available in 19th-century France. Modern gouache paints vary enormously in quality. Many, aimed primarily at designers, do not offer the permanence that fine artists require. Schmincke and the French colour maker Lefranc & Bourgeois both enjoy good reputations for their gouache paints.

Impressionist methods can be applied to acrylic painting, but this is not quite the same as re-creating them and you must accept the differences caused by the lack of substance and short working time of acrylic paint.

PART 2

TECHNIQUES

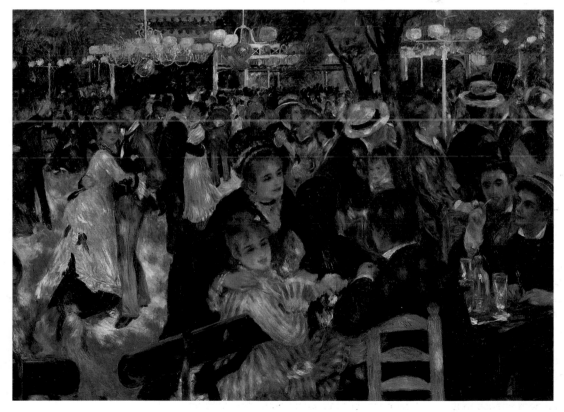

Renoir, Dancing at the
Moulin de la Galette
(1876)

COROT

The concept of Impressionism

Corot painted landscapes directly from nature as early as 1826 before any of the Impressionists were born and almost 50 years before the first Impressionist exhibition. For instance, he painted *The Colosseum seen from the Farnese Gardens on the Palatine* (1826) – one of three paintings completed in March of that year during fifteen on-site painting sessions. It is quite small and is on paper mounted on canvas, suggesting that it was originally intended as a sketch, but it represents the place at that moment in time so completely that it cannot be regarded as a mere visual note, or a preliminary stage towards another work. Corot recognized the controversial nature of the concept behind this work and did not exhibit it publicly until 1849.

By the 1860s, Corot's methods had already established the principles and ideas from which Impressionism would develop. In his notebooks he wrote: 'While trying for conscientious imitation, I never for a single instant lose the emotion which first seized me.' Corot recommended painting in the morning and evening, when the light is of a different quality and the subject is simplified by it into essential shapes and harmonious colours.

Corot was a master of 'peinture claire', the subtle use of values – the tonal aspects of the colouring – to create gentle harmonies. This is done with medium and pale tints without the use of strong contrasts. Corot arrived at his effects by establishing the extremes of the tonal range and then identifying and positioning each colour between them. This amounts to a study of the subject in terms of the light falling on it.

Corot specifically influenced Pissarro and Morisot, but his methods may be seen as the origin of most Impressionist techniques.

The Colosseum seen from the Farnese Gardens on the Palatine *(1826)*

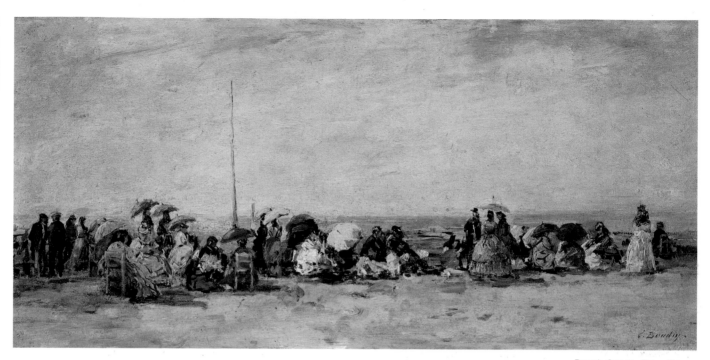

Beach Scene, Trouville
(1870–74)

BOUDIN

Towards Impressionism

Boudin painted marine and coastal scenes, which made him acutely aware of the fleeting effects of light and weather conditions and also of the rich colours that brilliant clear coastal light can reveal. In April 1866 he wrote: 'Tones must be clear and fresh, brilliant if possible.' Boudin's passion for capturing such transient effects out of doors encouraged him to handle paint both rapidly and broadly. He sought to suggest the sensations of an instant in time by simple, but skilful, brushwork and exaggerated essential colouring. As *Beach Scene, Trouville* (1870–74) shows, he also 'Dared to put into paint the things and people of our times...', saying in a letter: 'These middle-class men and women, walking on the pier towards the setting sun, have they no right to be fixed on canvas, to be brought to light?'

During the 1860s, Boudin accentuated the immediacy of his work, contributing to the development of Impressionism by intensifying his colouring, making his brushwork more vigorous and identifying his proper subject matter, the modern world – the realities of the painter's lifetime. He shared his ideas and enthusiasms with his friends and acquaintances, notably Jongkind, Courbet and the young Monet.

Boudin's paintings show considerable awareness of the sky as the source of light and as an indicator of space, as well as of weather conditions. His works often appear to have been broadly handled and are a spontaneous-looking representation of the land, sea and sky, with the detail of human activity added afterwards. Boudin used watercolour sketches to develop this method. This is a practical way of applying Impressionist techniques to lively and varied subjects.

Boudin contributed to the first Impressionist exhibition in 1874 to support the efforts of the younger artists, including Monet whom he knew from Le Havre.

MANET

Direct and spontaneous effects

Manet's style was based on those of Velazquez, Goya and Hals – particularly, on their brief, expressive brushwork. His imitation of it was probably responsible for the introduction of the 'tache', or distinctive brushmark, into Impressionist painting.

George Moore, an Irishman who socialized with the Impressionists at the Café de la Nouvelle-Athènes during the 1870s, gave an informative account of Manet at work. 'I think I see the well-known palette, I think I see again the quick grey eye raised from the paint box, the hand pausing among the tubes ... and, tense with desire, the fingers squeezed out the few simple colours that instinct dictated. A palette abundantly spread with Ivory Black, Flake White, Venetian Red, Vermillion, Madder, Yellow Ochre, Raw Sienna, Terre Verte, Ultramarine. I think I see the prompt agile hand sweeping over the canvas acknowledging no formula, an instinctive art seeking almost unconsciously its own gratification.'

Manet's obsession with perfect brushwork and his way of achieving it are revealed when Moore states: 'I have seen Manet paint a head of yellow hair six or seven times and the last painting was as fresh and as bright as the first, but how the miracle came about he was as incapable of explaining as I am. I know that before each painting he scraped the canvas smooth and then with brushes filled full of Yellow Ochre, White and Umber he laid on a fresh set of curls regardless of those of yesterday.'

Morisot gives a similar account of Manet at work on his *Portrait of Eva Gonzalès* (1870): 'He has begun her portrait over again for the twenty-fifth time. She poses every day, and every night the head is washed out with soft soap.' When he painted Morisot's own portrait around 1870 he used seven or eight white canvases in succession, making repeated attempts until he achieved a result that pleased him.

His friend Degas also acknowledged Manet's skill with the brush and alluded to another of his traits, that of borrowing from other painters, when he said: 'Manet drew inspiration from everywhere, from Monet, Pissarro, even from me. But with what marvellous handling of the brush did he not make something new of it! He had no initiative ... and did not do anything without thinking of Velazquez and Hals.' Under the influence of Monet, he adopted a more colourful palette during the 1870s, but as Renoir noted: 'Manet was surer of himself with Black and White than with high key colours.'

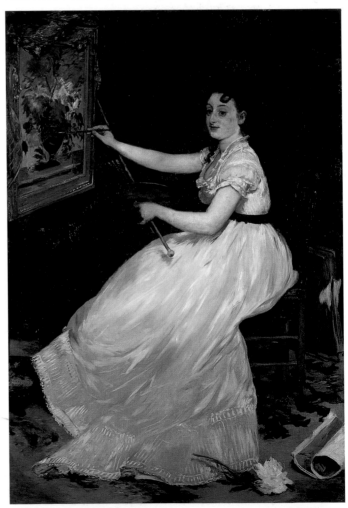

Portrait of Eva Gonzalès *(1870)*

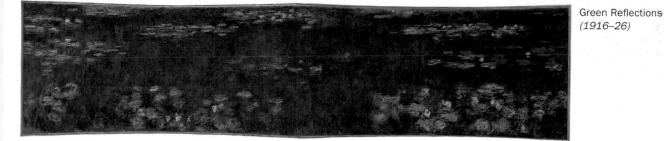

Green Reflections
(1916–26)

MONET

Impressions of nature

Monet's explanation of his methods was: 'Do as I do; work and experiment.' He told Maurice Guillemot: 'I'd like to keep anyone from knowing how it's done.' In fact, Monet's use of paint was straightforward: his real methods lay in his techniques for capturing an impression; and once you understand these they are easy to follow.

Monet's subject was the immediate experience of his senses. He did not paint the factual details of the scene – he painted his perceptions of its component parts to represent his impression of being there. 'I have no other wish than a close fusion with nature', he wrote, 'and no other fate is my desire ... than to have lived and worked in harmony with her laws. Beside nature's grandeur, her power and her immortality, the human creature seems but a miserable atom.'

Looking for colour

Monet responded to his friend Georges Clemenceau's remarks on the subject of colour by agreeing with him, but offering no further explanation: 'When I look at a tree I see only a tree', said Clemenceau, 'but you, you look through half-closed eyes and think "How many shades of how many colours are there within the nuances of light in this simple tree trunk?" Then you set about breaking down those values in order to rebuild and develop the ultimate harmony of the whole.' 'You cannot know', replied Monet, 'how close you are to the truth.

What you describe is the obsession, the joy, the torment of my days.'

In fact, Monet simply disciplined himself to look beyond the obvious. He saw his subject as patches of colour because he analysed it in those terms. Monet explained this to the American painter Lilla Cabot Perry as follows: 'When you go out to paint, try to forget what objects you have before you, a tree, a house, a field or whatever. Merely think here is a little square of blue, here an oblong of pink, here a streak of yellow, and paint it just as it looks to you, the exact colour and shape, until it gives you your own naive impression of the scene before you.'

Playing for time

When you try to paint an immediate impression of your experiences you soon realize how transient they are. In landscape painting the subject is changing constantly as the atmospheric effects come and go and the lighting of the scene alters with the movement of the sun. Painting becomes a race against time and a gamble against unpredictable elements beyond the painter's control. Monet dealt with these difficulties by limiting his goal and by applying a methodical approach to the time factor.

Before Impressionism the solution to these problems was to make a rapid sketch on site that could then be worked on, or from, in the studio, but was not itself treated as a finished work.

Monet extended the concept of this type of sketch, known in French as a *pochade*, until the distinction between it and a finished painting, or *tableau*, became blurred. He painted larger, more complicated sketches and treated them as the equal of studio paintings. Monet's works thus retained the speed of a sketch as they were being done. This was absolutely necessary as he had to work quickly in order to capture the impression while it was actually there.

However, very few Impressionist paintings are completed in one session and Monet's certainly were not. As Louis Vauxcelles wrote: 'With some of his canvases one could swear that they had been dashed off in a single afternoon, whereas in reality the Master has sometimes worked on them for several years.'

The systematic arrangement of a series of painting sessions is another aspect of Monet's technique. He applied a rather doubtful theory that in practice only works some of the time. His theory was that nature repeats itself and so the same momentary experience occurs again and again. Each time it may only last a short time, but these moments can be added together to make an extended period that the painter can use to observe and paint in. The skill is knowing when to stop the painting session. Monet admitted that this was difficult.

According to Monet's theory, if you return to the scene of your work another day when the conditions are broadly similar and paint between the same hours, you will again experience an identical 'impression' of the scene and will be able to continue with your painting. You should do this as many times as necessary in order to finish it.

It is apparent, however, that Monet completed works in the studio that had been started out of doors. This seems to be confirmed by a letter to Gustave Geffroy written from Giverny in France, in which Monet discussed working on paintings of London. 'You asked me when the exhibition of my poor old London pictures is due to begin. I promised it would be ready by early May, but I am afraid they will all be ruined by then. You tell me calmly to frame them and exhibit them as

they are. That I won't. It would be stupid to invite people to look at sketches which are far too incomplete. Where I went wrong was to insist upon adding finishing touches to them. A good impression is lost so quickly. I very much regret it and it sickens me because it shows how powerless I am. If I had left them as they were and had not planned to sell them, people could have done what they liked with them after my death. Then these essays, these preliminary studies could be shown as they are. Now that I have a go at every single one of them, I have to see them through, for better, for worse, to some kind of conclusion, but you have no idea what a state of nerves and despair I am in!'

Bathers at La Grenouillère
(1869)

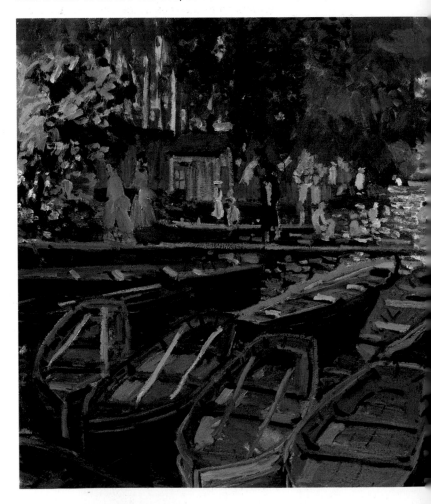

Seizing opportunities

One of Monet's practical solutions to the constantly changing nature of his subject was to have slotted boxes containing a large number of canvases. (He had them stationed about his garden at Giverny and carried them in his boat.) This meant that he could paint on each canvas in succession for a limited period of time, while the impression he sought to record remained, before moving on to the next one and working on that for a short time. The following day, or when the conditions were similar, he would go through the same sequence and gradually the paintings progressed towards completion. Each of them shows a precise moment in time. Monet claimed to work on as many as sixteen at once, but his series rarely had that many paintings in – he must have edited out the weaker images and failures, probably burning them.

The *Japanese Bridge* (1899–1900) and *Waterlily* (1903–26) paintings are based on this idea of painting a subject over and over again at different times of the day. Monet considered that it was impossible to paint for more than half an hour at a time and stated that the effect he was trying to capture in one of the *Poplars* series (1890–91) only lasted for seven minutes. He gauged the end of his working time by when the sun left a particular leaf.

At the beginning and end of the day, when you are more likely to encounter interesting effects and unusually rich colouring because of the low position of the sun, the time that you have to paint in does not last long. In the hour or so immediately before dusk, in summer at any rate, the half-hour that Monet refers to seems to be right. As the sun rises in the morning there are some very dramatic, but only fleeting, effects that would also explain the *Poplars* story, showing that Monet was evidently painting at the extremes of the day. This is confirmed by Maurice Guillemot in an account that begins: 'The crack of dawn in August 3.30 am' and goes on to describe Monet working on a series of fourteen canvases from his boat.

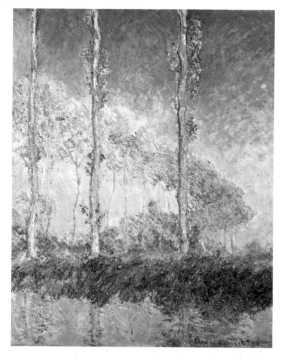

Poplars *(1891)*

Monet's materials

Monet's palette is easy to identify. He made no secret of it and was well aware that it was not itself responsible for his paintings. 'As for the paints I use, is it really as interesting as all that? I don't think so, considering that one could do something even more luminous and better with other palettes. The point is to know how to use the colours, the choice of which is, when all said and done, a matter of habit. Anyway I use Flake White, Cadmium Yellow, Vermillion, Deep Madder, Cobalt Blue, Emerald Green and that's all.'

These are indeed the essential values that he worked from and were probably the only colours that he used late in life. But, in fact, other colours do sometimes appear on his palette, including Black and earth colours.

The American collector William Henry Fuller observed that Monet's canvases were 'very white and very smooth'. This may be true of his late works, but for much of his life Monet favoured pale coloured grounds, cream, grey, beige and an odd grey-violet tint, possibly of his own making, although his choice was often erratic.

RENOIR

The reluctant Impressionist

Renoir started out as a porcelain painter. This early experience may have given him a taste for bright, luminous colours and the rich, glossy finish which are so often features of his work.

There is always a sense of life in Renoir's paintings – people enjoying themselves, a breeze blowing, water rippling by, the sun beating down, or the nearby sound of laughter – rather than a mere impression of the place. Monet and Renoir were aware of different aspects of a scene, as is apparent in works where they have painted the same subject together.

Renoir was never convinced that the methods of Impressionism worked perfectly, so he applied himself to painting directly from nature in a much more relaxed way. The following remark is typical of him: 'Out of doors, one uses colours one would never think of in weaker studio light. But landscape painting is a thankless job. You waste half the day for the sake of one hour's painting. You only finish one picture out of ten, because the weather keeps changing. You start to work on a sunlight effect, and it comes on to rain – or you have a few clouds in the sky and the wind blows them away. It's always the same story!'

Renoir was even more specific in a conversation with Ambroise Vollard: 'I finally realized that it [Impressionism] was too complicated an affair, a kind of painting that made you constantly compromise with yourself. Out of doors there is a greater variety of light than in the studio, where, to all intents and purposes it is constant; but, for just that reason, light plays too great a part outdoors; you have no time to work out the composition; you can't see what you are doing. I remember a white wall which reflected on my canvas one day while I was painting; I keyed down the colour to no purpose – everything I put on was too light; when I took it back to the studio, the picture looked black. ... Another time I was painting in Brittany, in a grove of chestnut trees. It was autumn. Everything I put on the canvas, even the blacks and blues, was magnificent. But it was the golden luminosity of the trees that was making the picture; once in the studio, with a normal light, it was a frightful mess. ... If the painter works directly from nature, he ultimately looks for nothing but momentary effects; he does not try to compose, and soon he gets monotonous. I once asked a friend, who was exhibiting a series of *Village Streets*, why they were all deserted. "Because", he replied, "the streets were empty whilst I was at work."'

Renoir made these remarks after he had turned away from Impressionism, but his words clearly recount his experiences while pursuing its ideals. It is likely that you will have these same difficulties. His solution, according to his son Jean, was to alternate sessions of working out of doors with corrective sessions in the studio. 'You go out and work, and you come back and work', he quotes him as saying, 'and finally your picture begins to look like something.' He had a realistic view of Impressionist landscape painting: 'Out of doors', he once said, 'one is always cheating.'

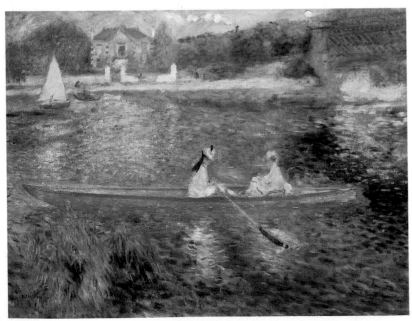

Boating on the Seine
(La Yole) *(1879)*

Relearning a forgotten craft

Renoir wanted to learn about the craftsmanship involved in painting and he had little sympathy for the academic teaching that had failed him. 'The bad system begins in the schools. I was in all of them and all were bad. The professors were ignorant men; they did not teach us our trade. Even today I do not know whether my pictures will last. Where I have noticed them yellowing I have tried to find out the cause. I have changed the colours on my palette ten times and I cannot be certain yet that I have arrived at a choice that will yield a permanent result. Now this was not always so; it is only since the Revolution that the principles of the Old Masters have been swept away. ... The Old

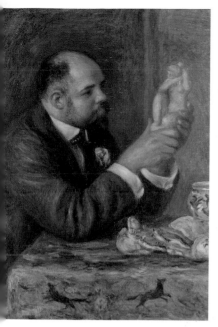

Portrait of M. Ambroise
Vollard (1908)

Masters were taught each step of their trade, from the making of a brush and the grinding of a colour. They stayed with their teachers until they had learnt well the ancient traditions of the craft. And the tradition has never been an obstacle to originality. Raphael was a pupil of Perugino; but that did not prevent his becoming the Divine Raphael.'

Renoir's methods remained instinctive. In later life he said: 'I arrange my subject as I want it, then I go ahead and paint it, like a child. I want a red to be sonorous, to sound like a bell; if it does not turn out that way, I put more reds or other colours till I get it. I am no cleverer than that. I have no rules and no methods; anyone can look over my material or watch how I paint – he will see that I have no secrets. I look at a nude; there are myriads of tiny tints. I must find the ones that will make the flesh on my canvas live and quiver.' Nowhere had he found techniques that overcame the instinctiveness of the painting process: 'The truth is that in painting as in the other arts there is not a single process, no matter how insignificant, which can reasonably be made into a formula. For instance, I tried long ago to measure out once and for all the amount of oil which I put into my colour. I simply could not do it. I have to judge the amount necessary with each dip of the brush. The "scientific" artists thought they had discovered a truth once they had learned that the juxtaposition of yellow and blue gives violet shadows. But even when you know that, you still do not know anything. There is something in painting which cannot be explained and that something is the essential. You come to nature with your theories and she knocks them all flat.'

Renoir's colours

Renoir responded to the brilliant colours of nature with brilliant colours of his own. Colour combinations that he obviously liked appear often in his paintings. The same feature will be treated the same way in different works. Water, for example, is usually rendered in blue and White dashes; foliage in little strokes of emerald green, shaded with blue and highlighted with a pale tint of the same emerald green and White, or with yellow. For Renoir colour combinations are important, such as red and blue, or blue and orange, or all three together. Areas of White are also significant and he has no reservations about using Black. He tended to use the colours of his palette in a very pure state.

Renoir's methods

Renoir was constantly experimenting so his methods and materials vary from painting to painting. In one of his portraits of Vollard the turpentine ran. The run was stopped by a dash of richer, oilier paint that represented the pattern on a table cloth. Vollard said: 'Renoir always attacked the canvas without the slightest apparent plan. Patches would appear at first, then more patches, then suddenly a few strokes of the brush and the subject "came out". Even with his stiffened fingers, he could do a head in one sitting as easily as when he was young.'

Throughout his life the simple pleasure of applying paint appealed to him. As he told Gleyre: 'If it didn't amuse me, I beg you to believe that I wouldn't do it.' The enjoyment of painting was part of his method.

Pissarro 1830–1903

An enthusiastic, if inconsistent, supporter of new ideas. Pissarro took part in all of the Impressionist exhibitions and was also responsible for introducing Gauguin, Seurat and Signac as exhibitors.

PISSARRO

The theorist

Pissarro was interested in theories – artistic, scientific and political – which he applied with varying degrees of success in his painting. It is difficult to appreciate how convinced he was of their importance, or to fully understand the role that he felt they occupied in art in general and particularly in his art. He believed obstinately in the existence of definite answers to the problems of painting and continued to search for them in the face of hardship and criticism.

The following extract from a letter to the dealer Durand-Ruel shows an instance of how Pissarro convinced himself that he had found a perfect solution: 'THEORY: Seek for the modern synthesis with scientifically based means which will be founded on the theory of colours discovered by M. Chevreul and in accordance with the experiments of Maxwell and the measurements of O. N. Rood. Substitute optical mixture for the mixture of pigments. In other words: break down tones into their constituent elements because optical mixture creates much more intense light effects than the mixture of pigments. As for execution, we regard it as inconsequential, of very little importance: art has nothing to do with it; originality consists only in the quality of drawing and the vision particular to each artist.'

Pissarro is referring to Neo-Impressionism, or Pointillism. In a letter to his son, Lucien, he said of the same subject: 'I am totally convinced of the progressive nature of this art, and certain that in time it will yield extraordinary results. I do not accept the snobbish judgments of romantic Impressionists in whose interests it is to fight against new tendencies.' Pissarro did, in fact, abandon this theory within about five years, but it is an interesting illustration of the deeply held beliefs that shaped his paintings at certain stages.

Pissarro's progress

Pissarro made abrupt changes of direction several times during his career. His different techniques stem from an ability to adopt and interpret the theories of others. He started out painting like Corot, using the established methods of Realism. These foreshadowed Impressionism and introduced Pissarro to ideas that he would repeat and develop throughout his life. For instance, his repeated use of subjects that we now regard as simple pastoral images, such as the inclusion of peasants and their everyday activities in his paintings, had political meaning. He intended them to be a display of radical political thought – he clearly felt this was an aspect of his work at all times. 'I firmly believe that our anarchist philosophy is linked to our work and therefore disagreeable to current thought', he wrote while involved with the Neo-Impressionists, Seurat and Signac.

Pissarro's style changed due to contact with Monet and with the works of the British artists, Turner and Constable, during the Franco-Prussian War, which increased his awareness of colour and light. His first period of Impressionism was

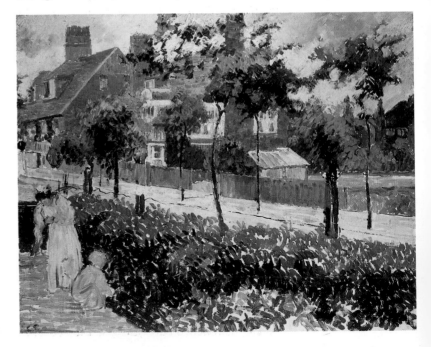

Bath Road, London *(1897)*

followed by a temporary Pointillist or Divisionist period. At the end of his life he returned to a version of Impressionism made richer by his experiences, experiments and wanderings in search of something he once described as artistic 'unity'.

Pissarro's methods

Despite considerable differences in the outward appearance of his paintings, there are a surprising number of constant technical features. These personal traits include a definite preference for white canvases, the likely use of a light pencil sketch on to the canvas to begin with and, typically, the employment of light tonal values with a restricted range of tone across the painting as a whole. He may have used colours with a Zinc White base in order to obtain such values more easily and had some made to order 'on a base of zinc' by a colourman called Contet.

Pissarro also seems to have been drawn to colour combinations involving red and green, a fascination that extended to his colour mixing, as well as to the colour schemes of his painting. A reworking of the painting's surface in several layers was also a common trait – one of his most interesting contributions to Impressionist methods. The surfaces of Pissarro's paintings are sometimes magnificently structured.

Pissarro gave this advice to a young painter, Louis Le Bail: 'Look for the kind of nature that suits your temperament. The motif should be observed more for shape and colour than for drawing. There is no need to tighten the form which can be obtained without that. Precise drawing is dry and hampers the impression of the whole; it destroys all sensations. Do not define too closely the outlines of things; it is the brushstroke of the right value and colour which should produce the drawing. In a mass, the greatest difficulty is not to give the contour in detail, but to paint what is within. Paint the essential character of things, try to convey it by any means whatsoever, without bothering about techniques. When painting, make a choice of subject, see what is lying at the right and at the left, then work on everything simultaneously.

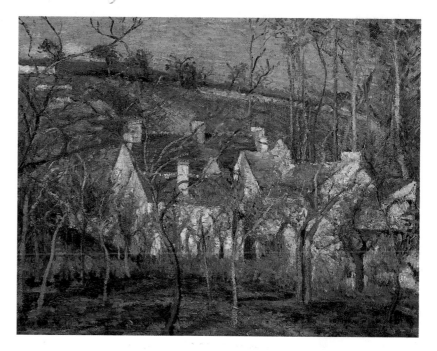

Don't work bit by bit, but paint everything at once by placing tones everywhere, with brushstrokes of the right colour and value, while noticing what is alongside. Use small brushstrokes and try to put down your perceptions immediately. The eye should not be fixed on one point, but should take in everything, while observing the reflections which the colours produce of their surroundings. Work at the same time upon the sky, water, branches, ground, keeping everything going on an equal basis and unceasingly rework until you have got it. Cover the canvas at the first go, then work at it until you can see nothing more to add. Observe the aerial perspective well, from the foreground to the horizon, the reflections of sky, of foliage. Don't be afraid of putting on colour, refine the work little by little. Don't proceed according to rules and principles, but paint what you observe and feel. Paint generously and unhesitatingly, for it is best not to lose the first impression. Don't be timid in front of nature: one must be bold, at the risk of being deceived and making mistakes. One must have only one master – nature; she is the one always to be consulted.'

The Red Roofs, Corner of the Village, Winter (1877)

Sisley 1839–99
Sisley was influenced by Monet, but made a unique and personal contribution to Impressionism. He was disinterested in self-publicity and lived in poverty for most of his career. He was recognized only shortly before his death.

SISLEY

The quiet Impressionist

Sisley excelled as a painter of scenes involving water and snow. He depicted tranquil, atmospheric images, very often conveying an impression of the mood created by the climatic conditions. He is the only Impressionist painter who successfully represented fog, mist or air when it is so heavy and cold that you *know* it is about to snow.

My understanding of his methods is based on studying his paintings. As Sisley died in extreme poverty, having been neglected in his lifetime, this is the only evidence, apart from a letter that he wrote to a friend explaining his ideas about painting, that has survived.

Sisley could be sensitive and skilful. There is a sense of his painting quickly – of a slightly frantic race against time – in the dancing brushwork of many of his paintings. This suggests a hand skimming rapidly over the canvas, dashing down the colour from the brush with twists, flicks and nods of the wrist as the arm continues to move.

Sisley painted instinctively, but also drew simultaneously on his experience. He is confronted by fleeting impressions of nature and the urgency of his painting – attempting to capture them in passing – reveals their transience. His method of painting conveys part of his impression, which is what he seemed to describe in a letter when he said: 'And though the artist must remain master of his craft, the surface, at times raised to the highest pitch of liveliness, should transmit to the beholder the sensation which possessed the artist.'

Sisley's rapid working meant that he was the only Impressionist landscape painter, with the possible exception of Morisot, who regularly achieved all or most of the intended painting in a single session. Since he could not achieve perfection this way, he retouched his paintings in the studio afterwards, but the immediate, essential impression of his subject remained.

To work like this, you have to take a deep breath, then do everything at the same time, filling the canvas rapidly as you gather the general sense of the scene from those elements within it

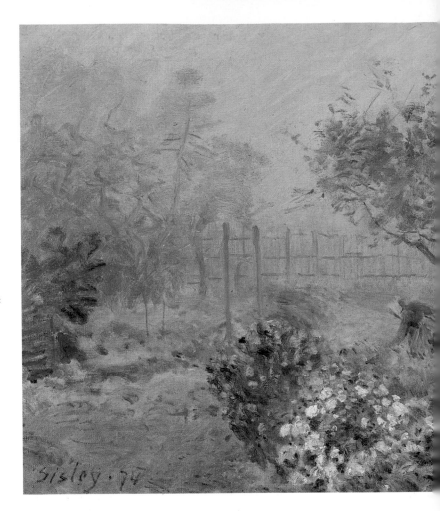

that impress themselves upon you most. As Sisley put it: 'The animation of the canvas is one of the hardest problems of painting. To give life to the work of art is certainly one of the most necessary tasks of the true artist. Everything must serve this end; form, colour, surface. The artist's impression is the life-giving factor, and only this impression can free that of the spectator.'

Obviously, you cannot attempt too much and you must simplify the image because of the lack of time, but Sisley knew that this could be an advantage. 'The subject, the motif, must always be set down in a simple way, easily understood and grasped by the beholder. By the elimination

Misty Morning *(1874)*

of superfluous detail the spectator should be led along the road that the painter indicates to him, and from the first be made to notice what the artist himself has felt.'

Sisley's use of materials

Sisley frequently made use of the ground, scrubbing paint thinly across it or leaving patches exposed. He used cream and pinky beige grounds and possibly pale grey ones. The quality of his paint, as well as his brushwork, may vary across a single painting, probably because he added turpentine to his colours in the early stages and also sporadically while painting, as well as using them stiffly without dilution.

Occasionally, the fluidity of a particular stroke suggests the addition of oil as well as turpentine, but this could be accounted for by the differential oil content of certain colours. In Sisley's time, the colourman would have been less likely to disguise this feature than today. In any event, Sisley's use of a medium is restricted to the purpose of allowing the paint to flow. By adjusting the handling quality of the paint, he is looking for contrasts between the ways used to show different effects.

Sisley refers to something of this sort in his letter: 'You see that I am in favour of a variation of surface in the same picture. This does not correspond to customary opinion, but I believe it to be correct, particularly when it is a question of rendering a light effect because when the sun lets certain parts of a landscape appear soft, it lifts others into sharp relief. These effects of light, which have an almost material expression in nature, must be rendered in material fashion on the canvas.'

In his snow scenes, Sisley seems to have used only a few colours. This may have been for financial reasons – he also used cheap canvases – but as they suit the subtle harmonies of his favourite subject, I think it more likely that they were a deliberate choice. For other scenes his colour range was wider, but it always seems to centre around a collection of bright colours, supported by Black and White, with one earth value, a Yellow or Brown Ochre.

There are several other things that distinguish Sisley's work. He had a tendency to use more distinct strokes in the foreground to encourage a sense of space, but it is his painting of skies, even non-descript ones, that shows his genius. He often used sloping strokes that give the idea of the sky gently rising above you. Sisley understood the importance of the sky in a landscape impression: 'The means will be the sky (the sky can never be merely a background). Not only does it give the picture depth through its successive planes (for the sky, like the ground, has its planes), but through its form, and through its relations with the whole effect or with the composition of the picture, it gives it movement. ... I emphasize this part of the landscape because I would like to make you understand the importance I attach to it. An indication of this: I always begin a picture with the sky.'

The accurate observation of trees, including a very subtle treatment of distant woodland, and the occasional use of a sideways squiggle to represent a branch, also strike me as being particular to him.

Boats on the Seine
(c. 1877)

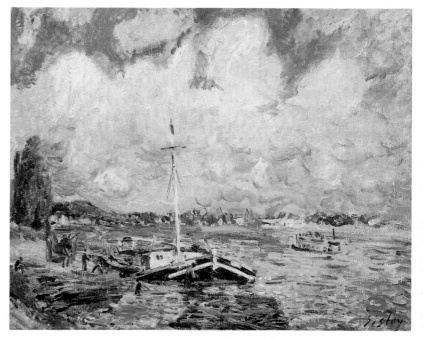

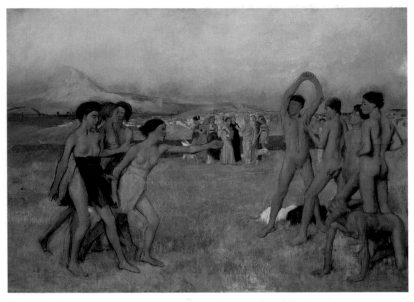

Young Spartans
(c. 1860–61)

DEGAS

The great draughtsman

Like Renoir, Degas did not want to be part of a new school and was in many ways distant from Impressionism. He was an admirer of the painter Jean-Auguste-Dominique Ingres, whose rigid insistence on the supremacy of drawing and the classical ideal was largely responsible for the stagnating academic practices that the Impressionists were reacting against.

Degas was himself a superb draughtsman, his art continuing from where that of Ingres left off. He was interested in line and composition, drawing before colour, and he worked only in the privacy of his studio. George Moore wrote a marvellous description: 'One morning in May a friend tried the door of Degas's studio. It is always strictly fastened and when shaken vigorously a voice calls from some loophole; if the visitor be an intimate friend a string is pulled and he is allowed to stumble his way up the corkscrew staircase into the studio. There are neither Turkish carpets nor Japanese screens, nor, indeed, any of those signs whereby we know the dwelling of the modern artist, only at the further end where the artist works is there daylight. In perennial gloom and dust the vast canvases of his youth are piled up in formidable barricades. Great wheels belonging to lithographic presses – lithography was for a time one of Degas's avocations – suggest a printing office. There is much decaying sculpture – dancing-girls modelled in red wax, some dressed in muslin skirts, strange dolls – dolls if you will but dolls modelled by a man of genius.'

Degas's drawings often incorporate intersecting horizontal and vertical lines, showing how he was fascinated by the geometry of his work. These lines appear to be points of reference that he relates the subject to, either as structural guides to a surrounding space, or as an analysis of what has been drawn. *Dancer Curtsying: Study of Arm* (c. 1885) actually has a geometric grid laid over the figure. It presents the contradictory image of a soft sensual drawing incisively dissected by analytical thought. Degas's dependence on drawing is confirmed by Moore: 'He makes numerous drawings and paints from them; but he never paints direct from life.'

In other instances, Degas has squared up his drawings using a grid of horizontal and vertical lines so that he can transfer and enlarge them, creating another work based on them. This is a traditional procedure that forms part of a considered and methodical approach. It has nothing to do with the supposed spontaneity of Impressionism as Degas confirmed when he said: 'I assure you no art was ever less spontaneous than mine. What I do is the result of reflection and study of the Great Masters; of inspiration, spontaneity, temperament – temperament is the word – I know nothing.' Degas's struggle to create and perhaps also his feeling of isolation within the privacy of his studio is conveyed when he said: 'It is very difficult to be great as the Old Masters were great. In the great ages you were great or you did not exist at all, but in these days everything conspires to support the feeble.'

In the case of Degas's painting *Miss La La at the Cirque Fernando* (1879) the original drawing squared for transfer still exists, showing a method of working within Impressionism that

Dancer Curtsying: Study of Arm (c. 1885)

is contrary to its supposed ideals. The subject reveals Degas's fascination with the world created by man rather than the world of nature that was Monet's inspiration.

Repetition and progression

Degas often repeated and redeveloped his themes, using varied techniques to examine the same image in different ways. He took counterproofs of drawings by pressing wet paper against them and made monotypes that reversed his images.

Degas and photography

The extent of the Impressionists' use of photography is difficult to determine, although its influence on their imagery is apparent. Degas, Manet and Fantin-Latour developed an interest in it during the 1860s and significantly a large number of photographs was found in Corot's studio after his death. The long exposures needed for early photographs would have produced blurred images that might have influenced Corot. Similarly the simplification of tone found in paintings, such as Manet's *Olympia* (1863–65), could suggest familiarity with the effects of early flash photography.

In the case of Degas, there is a more definite example of a link between photography and his art. The Getty Museum has a bromide photograph, thought to have been taken by Degas, known as *After the Bath* (1896). Two drawings and two oil paintings all show the same rather awkward and unusual pose. One of the drawings can definitely be dated to 1896 and all of the works are presumed to date from between 1895 and 1900.

Degas's different versions of this theme show a certain elongation of the form and the kind of distortions that might naturally be introduced by the gesture of an artist's hand seeking not only to record the subject, but also to create a composition. He also made definite and deliberate alterations to the setting. In all cases, the figure is lit from the left and the fall of light and shade across the body in the drawing in the Belgrade Museum is almost identical to that seen in the photograph. Any of these works could as easily have been taken from the photograph as from each other, or another drawing, or from life.

Certainly it would have been strange if Degas had repeated the pose, arguably less gracefully, in a photograph taken subsequently. As photography was still in its infancy, it also seems unlikely that Degas could have deliberately matched the lighting of the Belgrade drawing so successfully. The inevitable conclusion must be that the photograph came first.

Probably all the works are related to the photograph, but there is an element of doubt because of Degas's tendency to re-use themes and there is no certain proof that the photograph is by him. Degas had trouble with his eyes as he got older so it would not be surprising if he chose to supplement his drawing by taking photographs. The influence of photography is evident in his 'broken-frame' compositions and Degas was obviously familiar with Edward Muybridge's photographs of movement, which became available in 1878.

Miss La La at the Cirque Fernando *(1879)*

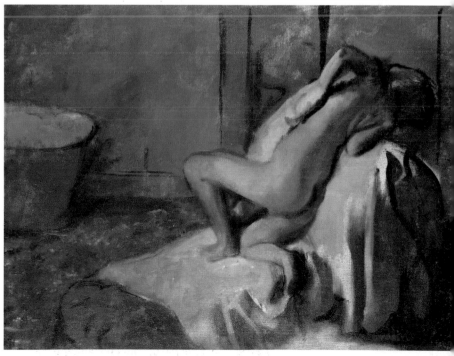

After the Bath *(1896)*

2.1 LANDSCAPE

Linseed fields near Drakeholes using the methods of Monet

MATERIALS

Canvas

A non-standard canvas prepared in the studio with a pale greenish grey ground composed of White, Yellow Ochre and Black. I have used a coarse flax cloth, but typically Monet's canvases are finer than this. Size 24" x 20" (61 cm x 51 cm).

Paint

Artists' oil colours from a restricted palette.

Cadmium Yellow
Cobalt Blue
Flake White
Phthalocyanine Green
Red Lake (Deep)

The same colours were laid out for the second session of painting, but I also added Cobalt Violet.

A dipper of turpentine was used with the colours (but only at the very beginning) which made the paint thin and fluid, allowing me to sketch in the scene rapidly.

Brushes

Size 6 long flat bristle brushes.

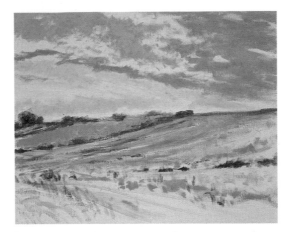

1

2

3

FIRST SESSION

Monet sometimes began with an *ébauche*, a rapid laying-in of colour that establishes the key features of the image quickly. With a subject that is constantly changing and is unlikely to remain the same between painting sessions, even though the conditions may be similar, it allows you to fix the image that you intend to depict.

1–2 I painted for an hour, attempting to capture the essence of the scene. I used Cobalt Blue and White for the open sky and a dull purple made from Cobalt Blue, Red Lake and White for the darker underside of the cloud formation. The greenish grey ground was left exposed as an indication of both the mid-toned and of the light areas of cloud. At this stage I intended to paint these in later. The ground also showed through the irregular and vigorous brushwork, creating an overall effect that harmonized the colouring while variously modifying the apparent values of each colour.

3 The landscape greens were achieved by mixing Cadmium Yellow, Phthalocyanine Green and Red Lake (Deep) in varying proportions. A soft olive green was made by adding White to one of the mixtures.

SECOND SESSION

4–6 This session took place the next day at exactly the same time and also lasted for an hour. The weather conditions were broadly similar and I was able to continue by using nature as it presented itself then as a reference that allowed me to add to the sketch – the *ébauche* – done previously.

Applying thicker paint than before I continued to work on the sky, highlighting the clouds with White and paying greater attention to the colours and details of the sky immediately above the horizon. While doing this, I also corrected the skyline which had only been hastily drawn in to begin with.

dabs of Cobalt Blue, also used as a tint, in an attempt to imitate the indeterminate colour quality of linseed in flower. My assessment was that it looked like blue tinged with pink so that is how I painted it.

Ideally, I would have continued painting on a third day, but the weather changed, the flowering of the linseed came to an end and the conditions clearly would not have repeated themselves for at least another year, if ever. A painting that has reached this stage could be completed in the studio, but those two brief outdoor sessions had created a spontaneous freshness that might have been spoilt – as it stands it is a valid impression of the scene, so it might as well be considered finished.

4

5

Next I turned my attention to the fields and assessed what colours to use on the basis of my immediate impression. For example, looking at the ripening field in the distance, I decided that it was an orange brown and, deliberately concentrating on the high-key element, painted it a strong tint of orange.

Similarly, looking down at the linseed field, I observed round, newly formed seed pods in a pale yellowish green. I translated this into the pale yellow dots spread across the lower right-hand side of the canvas.

Short strokes of different greens were swept across the middle and foreground to imply the curving slope of the land. A pinkish tint of Cobalt Violet was then placed among the

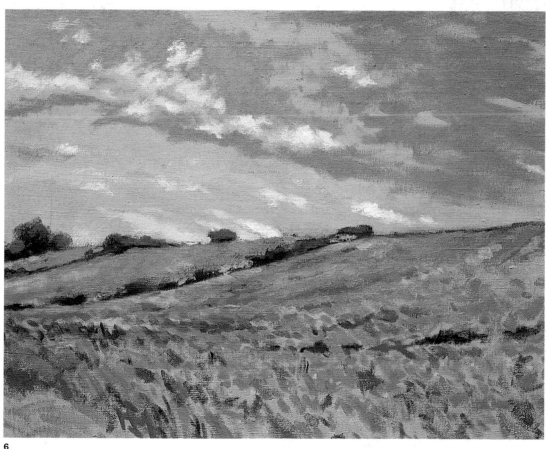

6

2.1 LANDSCAPE

Poppies on a mound using the methods of Monet

MATERIALS

Canvas
A standard stretched canvas of acrylic-primed linen was re-primed a pale grey to make it more like a canvas that Monet might have used. Size 14" x 10" (35.5 cm x 25.5 cm).

Paint
Artists' quality oil colours.

Cadmium Light Red
Cadmium Yellow
Cerulean Blue
Cobalt Blue
Flake White
Red Lake (Deep)
Viridian

Brushes
Long flat bristle brushes in sizes 2 and 6.

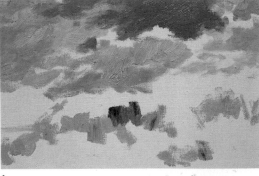

1

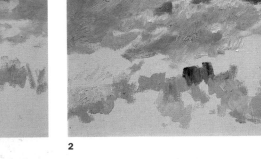

2

3

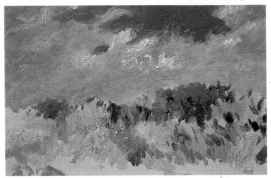

4

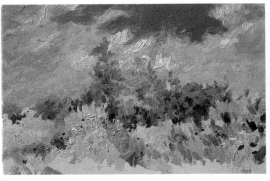

5

FIRST SESSION

1–4 The sky was worked on first using straight tints of Cobalt Blue and White – these were close enough to its real values. Tints of Cerulean Blue and a pale tint of Red Lake (Deep) were then added – not because such tints actually existed, but because values present in the sky vaguely suggested them. Monet translated the colour tendencies that could be observed into more definite colours that could be painted. White was added last in heavy textured strokes.

The greens and other foreground colours were spread around in patches to begin with, to get a vague sense of the scenery as a whole. Monet's approach to colour was not to question anything he saw and here some of the bushes have had orange added to them because, even though they were definitely green, in the strong sunlight there was a hint of orange.

5 Towards the end of this painting session, the hedge on the right was scratched in to represent twigs and branches. This was a habit of Monet's. In this case you can see that it has resulted in a more realistic impression, but this was not always his obvious intention. I subsequently reworked this effect in the second session when the paint was starting to dry.

A loaded brush

The quality of the paint contributed to the finished effect. It was thick and clinging, taking hold at the merest touch of the brush, but was fluid enough to be workable. It was easily pushed around using bristle brushes without the help of turpentine or medium, but was not easily disturbed when painted into or on to while still wet. Variable thicknesses of paint naturally result across the canvas when paint of this quality is loaded upon previously placed touches. The texture and direction of the brushmarks also become an integral part of the work. The handling of the sky in this painting shows this clearly (above).

Note the heavily loaded brush (above, right). You must apply the paint generously in order to get this kind of performance. Working in warm weather, as I did here, assists with the manipulation of paint. Monet's paint must have had a very similar consistency and would have been applied in much the same way.

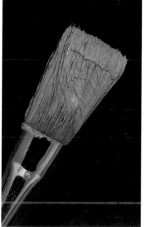

SECOND SESSION

The second session of painting took place two days later at the same time of day and in identical weather conditions. Monet always used Flake White to reduce his colours to tints. It was also employed here. By this time the paint was nearly dry and so I was able to enrich the surface texture by dragging new colour over rough parts of the original painting that were dry enough to hold their shape.

6 Work on the trees across the middle of the painting was continued and they were completed using short, dabbed-on strokes over the lower part of the sky that was now dry. They were painted with tints of Viridian and White and tints of mixed greens. Deep shadows were added to the branches in what looks like Black, but is in fact a dirty purple of Red Lake (Deep) and Cobalt Blue, further deepened using a little Viridian. Black does occasionally feature on Monet's palette, but he also simulates it like this.

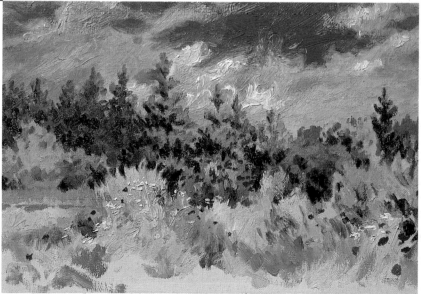

6

Complex colours

Monet used two distinct methods of mixing colour – I used both here. In one, he employed colours in a simple and pure form by applying straightforward tints of a single colour with White, or of clean mixtures of two or three colours with White and touches of pure colour. This produces fresh, bright colouring throughout his painting.

In the other, found in his earlier works, Monet used very complex colour mixtures: a dull green or grey might be composed of five or six pigments – as many as eight have been identified. This is partly explained by working off a palette of bright colours as they have to be 'broken' with each other to get duller values. But also possibly because away from the conveniences of the studio the palette soon gets dirty and one practical way of continuing is to mix new colours on top of and into the ones already on the palette.

The technique is to choose an existing mixture that already tends towards the colour you want to make, or that contains one of its principal ingredients. You can never get back to pure, clean values this way, but you can carry on painting under difficult circumstances.

Here a bluish green tint for the trees, for example, was mixed from a blue left over from the sky. Later the residue of that green was converted into a dull olive green by adding yellow and a little Red Lake. That, in turn, was made into an ochreish tint by adding more yellow, white, red and blue. You can see this progressive mixing happening on the palette (above, right).

7 As painting continued the foreground colour values were enhanced. For example, the road and post on the left were painted in pale blue to represent a less pure blue-grey. A slight exaggeration of your literal observations of colour will give similar results. Concentrate on the bright component of what you see – in this case I emphasized the blue and not the grey.

8 Finally, the painting was retouched in the studio. Monet denied doing this, but there is evidence to the contrary. Here, the two stages of painting had to be united by some further work and the play of red and green in the foreground needed adding to. Enriching the greens was the only way to make the poppies look as red as they really appeared to be.

Doing as Monet did, I signed my painting with the last colour used *(below)* which in this case was red since I had added some extra poppies. The finished painting only took about four hours to paint, but several days elapsed between its beginning and end.

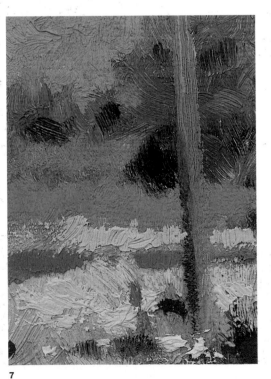

7

8

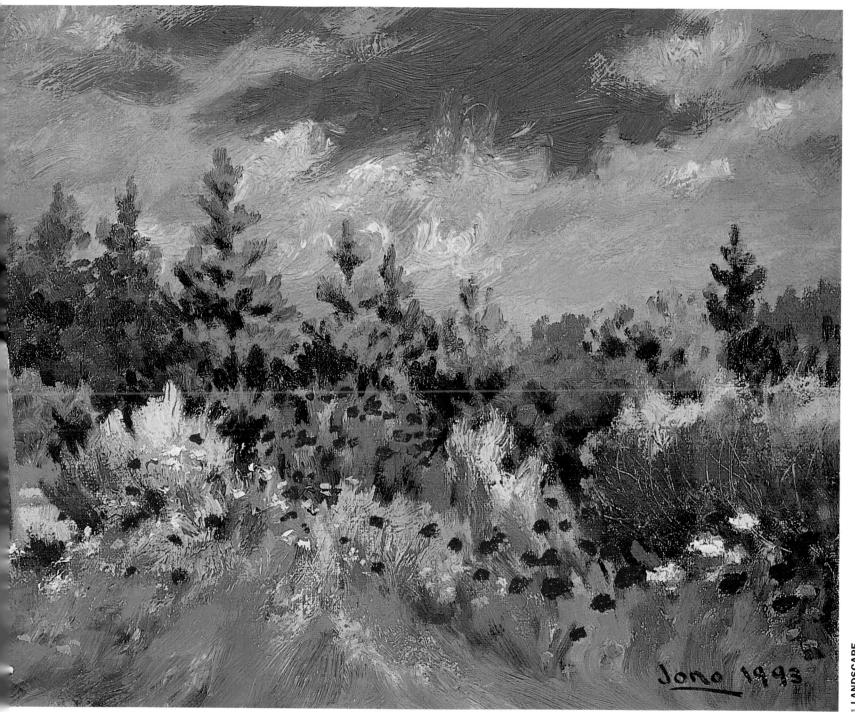

Jono 1993

The rowan tree using the methods of Pissarro

MATERIALS

Canvas
A standard cotton canvas with a white acrylic priming. Size 18" x 14" (45.7 cm x 35.6 cm).

Paint
Artists' quality oil colours at tube consistency.

Cadmium Light Red
Cadmium Yellow
Cobalt Blue
Flake White
Hansa Yellow Pale
Phthalocyanine Green
Viridian

I painted during several sessions at irregular intervals over an extended period. My use of this palette was inconsistent as I did not lay out all of the colours at the same time, but in relation to Pissarro's methods what is important is that the palette depends solely on a selection of high-key colours and White. These were used mostly to produce muted values within a restricted tonal range.

Brushes
Size 2 long flat bristle brushes.

1

2

3

FIRST SESSION

This rowan tree attracted me, as it would have Pissarro, because of the fabulous combination of red and green that it presented. Taking a white canvas, which Pissarro preferred, I began painting following his advice to Louis Le Bail. This meant ignoring all aspects of drawing, avoiding specific outline and detail, concentrating instead on the essential shapes within the impression which would develop from my observations of colour and tone as masses – as occupied spaces – and not as simple, enclosed areas of definite colour.

1 I followed Pissarro's method of painting everything at once using small brushstrokes, noting down colours and tones across the whole image and letting the work develop from there. I covered the canvas with well-spaced brushstrokes in about five different tints. It could easily have been meaningless, but in fact it was an accurate scan of the whole subject, analysing essential and common colour values. I quickly identified the presence of different types of green and grey, mixed approximate representations of them and then placed small brushstrokes of these values where I could see them.

2 I continued to look for variations of colour, placing more small strokes across the whole canvas into the gaps between the existing ones, so that gradually a sense of the landscape would

develop. You can probably see the tree and the ground beneath it taking shape already. If you carry on in this way, the image becomes more and more representative until eventually you have a recognizable impression. Monet sometimes used this method. It is a good basis from which you can continue to work. Compare this, for example, with the early stages of my painting *The mouth of the River Otter* (p. 84).

3 This rather crude image was reached at the end of one brief session on site. It is not a particularly good example of what your painting should look like, but it does contain a lot of essential information, which meant that I could continue without going back to the scene again. Fortunately, this was a very simple subject, but with a more complicated one you might have

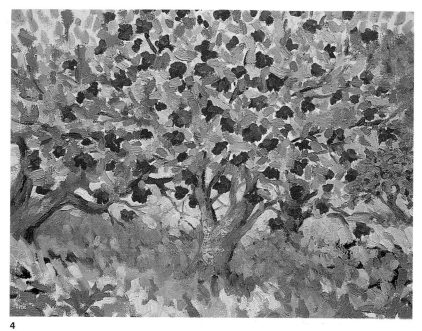

4

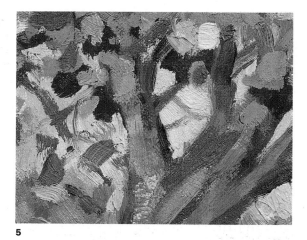

5

6

to complete two or three sessions on site before you have gathered enough information to carry on in the studio.

Some of Pissarro's paintings have very complex structures that suggest a long period of working and reworking, probably too long to have been done directly from nature, although it will have been the starting-point, as the effects being shown would not have lasted as long as it took to paint them layer upon layer.

STUDIO SESSIONS

4 If you can continue painting on location, do; but, if not, finish the painting in a studio as I have done here. This method lets you carry on by filling in the remaining gaps using the existing colours and tones as reference points.

You can also continue by overpainting the original values to make adjustments towards more pleasing harmonies and to correct any deficiencies of shape or definition that become apparent. The trick is not to paint anything out completely at one go, but to move progressively with layer upon layer of small, well-spaced

brushstrokes and then you can constantly relate the new additions to the existing work. This is also a way of breaking down the image into evermore complex colour relationships, which is what happens in the remaining stages.

The first studio session took place only a few days after the on-site session when the memory of it was still fresh, but the remainder was done much later, at irregular intervals spread across almost a year. At each stage new paint was added to previous work that was dry in carefully considered attempts to reach the finished work.

5 Little by little a thick, highly textured paint surface has developed. There are few clearly defined contours, but where there are, around

the trunks and lower branches, I have, like Pissarro, reworked the colours alongside them without painting them out. This produces indented contours where adjacent areas have been built up without touching. For example, the little branches in the main fork of the rowan tree were put in at the first session and were not touched again, but the bright areas behind them have been repainted several times so they are much thicker.

6 Across the whole canvas there are different thicknesses of paint where areas have been worked on as many times as necessary in pursuit of a satisfactory result. The foliage of the tree, for example, is formed by layer upon layer of small strokes.

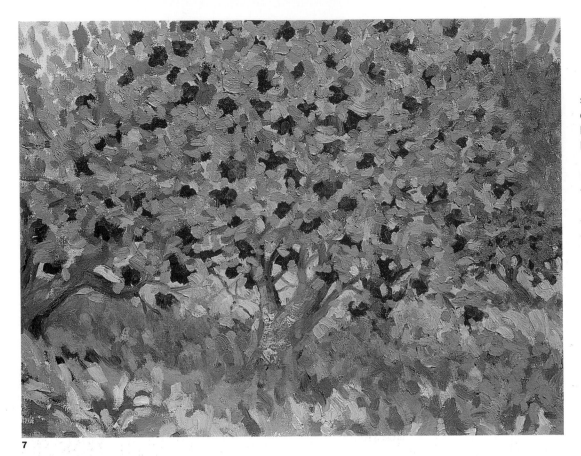

7

FINAL SESSION

7 Completing the painting mostly involved adjustments of colour. The small brushstrokes are suggestive of grass and leaves, but their real importance is that they keep the impression vague, while developing a united, overall surface quality and allow for a multitude of colours to be used.

You may notice that in some places, as in several of Pissarro's works, my brushstrokes are directional and suggestive of the object or space depicted. The colouring follows the principles of *peinture claire* – always popular with Pissarro – and is confined to a narrow tonal range of comparatively pale tints. Almost all of the colours in this painting have White mixed into them. If you examine the work's surface in detail, you will find some surprising colours – tints of blue, orange and vivid green – but the small divisions of colour and the many broken tones give a sense of muted harmony.

Pissarro was sometimes criticized for his muddy colouring, a feature that easily results from the complex intermixing of high-key colours. I also suspect that it is a consequence of the frequent use of a bright red in place of the more typical Red Lake and the use of a slightly orange yellow in preference to a lemon yellow. Here I have broken some of the mixed greens with Cadmium Light Red – because it is an opaque yellowish red it produces dull values especially where Cadmium Yellow has also been used. Furthermore, some of the greens contain traces of the entire palette and approach a non-descript khaki or putty colour.

Towards the end I restated a few of the branches that had been painted out and altered the central trunk, both to improve the painting and to make it coincide with my recollections of the scene – not of its detail, but of the sensation of being there. I particularly remembered the tree seeming to lean away from me.

Although it relates to an original encounter with nature, this painting was ultimately a studio work aimed at the creation of a satisfactory image without resorting to imaginary invention. The vagueness of its definition befits the vaguely remembered impression that it represents. Some of you will find this convenient technique, which Pissarro tended to use late in his career, useful for paintings begun on sketching trips or on holiday where it may be impractical to revisit the site and develop, or complete, the work on location. It is, incidentally, quite hard work patiently developing the qualities of a painting like this in the studio over a long period of time. Hence, perhaps, Pissarro's alleged remark that some of his paintings were like the work of a Benedictine monk.

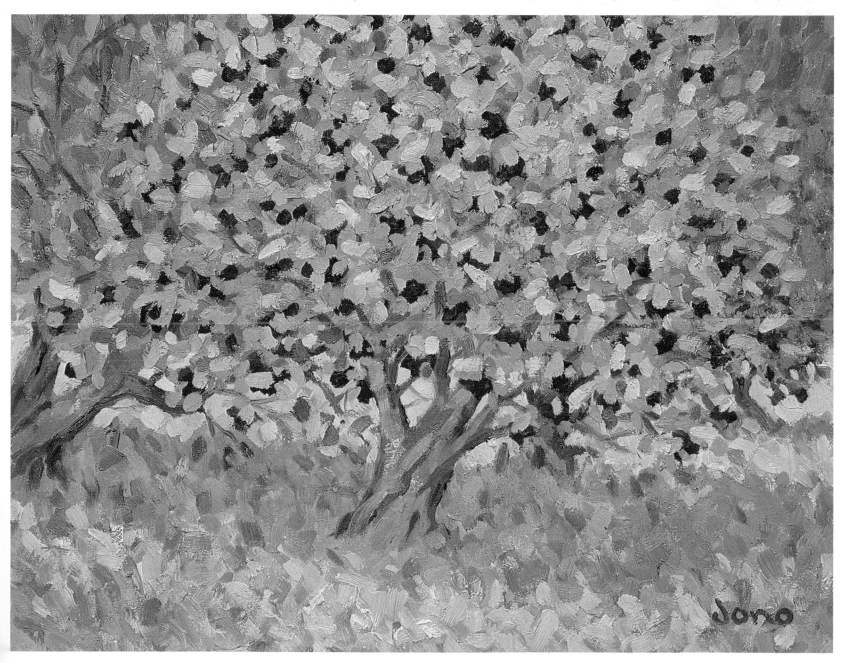

2

2.1 LANDSCAPE

Trees on a ridge using the methods of Renoir

MATERIALS

Canvas
A standard white acrylic-primed cotton canvas that has been re-primed a pinkish beige. A similar ground colour occurs beneath some of Renoir's works but would not be an essential choice. I chose this colour because it was already prepared. Size 14" x 18" (35.5 cm x 45.7 cm).

Paint
Artists' quality oil colours.

Cobalt Blue
Flake White
Hansa Yellow Pale
Manganese Violet
Phthalocyanine Green
Viridian
Yellow Ochre

At the second painting session Cadmium Light Red was added to the palette. A medium of linseed oil and turpentine was used.

Brushes
Two size 4 and two size 2 round bristle brushes – the smaller size 2 brushes were used almost exclusively during the latter part of the first painting session and for all the painting that followed.

1

2

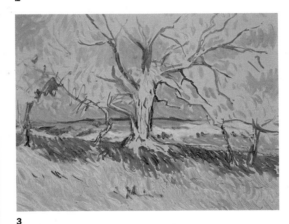

3

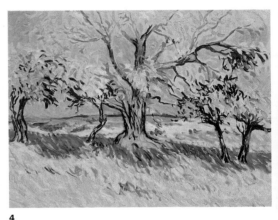

4

FIRST SESSION

1–4 I started with a rapid brush drawing using Manganese Violet diluted to a wash state with painting medium. This was just meant to record the position and essential shapes of the key features.

I immediately followed with colour, defining the subject more clearly as I painted. The pale blue of the sky was put on from the tip of a brush using brief, springy touches – a regular flick of the wrist sets the length of each stroke and gives it a slight curve. By placing them close together with overlapping edges an area is soon covered uniformly without making it look flat. Individual strokes or small groups of them have been used to represent gaps through the leaves of the trees,

so even before they were painted in the sense of the foliage started to emerge.

Next I painted with green, rapidly putting down the first tone across the foreground with parallel curving strokes. I went over the painting again and again filling in the gaps using a different mixed green each time, making the colouring look varied and developing a sense of light and shade.

Pure Cobalt Blue was worked into the wet colours of the background to suggest distance and detail. It was also applied in flickering strokes to the foliage to begin showing areas of leaf in shadow and individual leaves silhouetted against the bright sky.

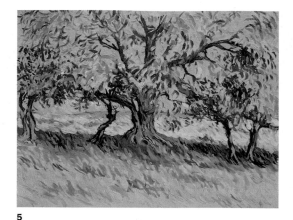

5

6

SECOND SESSION

At the second session, the conditions were not exactly the same, but were similar enough to allow work to continue. This time I studied the colours of the subject more carefully and may perhaps have lost some of the freshness and simplicity that resulted from the first session.

5 The hills in the background were repainted to make them lighter and less distinct which increased the separation between them and the foreground. This was done with sloping parallel strokes curved by a flick of the wrist as before. In places the original painting still shows, adding to the variety of colour and tone. The new colours are not so widely separated in tonal value and all contain a substantial proportion of White.

6 The painting continued with a steady build up of small brushstrokes placed according to instinct and observation. In the foliage of the trees in particular a criss-crossing rhythm of strokes was developed as a response to the detail of the subject – the individual brushstrokes in varying shades of green represent the leaves and the physical depth of the space occupied by them.

The shape and direction of the strokes suggests the movement of the leaves in a breeze. If you follow the directions of the brushstrokes you will see that their curvature is predominantly to the left on the left-hand side and towards the right on the right-hand side of the canvas – my brushstrokes are actually feeling out the shape of the tree.

7 Cadmium Light Red was added to the palette to depict the berries on the bush to the left. During the second session of painting, these were particularly obvious as fleeting patches of sunlight caught and emphasized the striking red/green combination in the colouring.

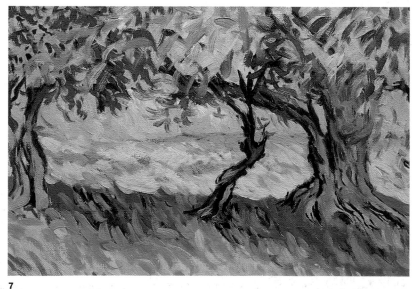

7

Mixing colours

The palette (below) used during the first session shows straightforward colour mixing. On the right a first tint of Cobalt Blue and White has been reduced a second time with more White to make it paler for the sky. The first darker tint was misjudged and was not used at all, but you can keep such a mixture to reduce again or use as a beginning for something else. The patch of strong blue to the side of the dipper is pure Cobalt Blue with medium.

On the left the Manganese Violet has been diluted with medium and prepared as a faint tint with White. This gave a pinkish purple

duller greens a little Yellow Ochre was also added. Some of these variations have been mixed on top of and into each other, altering the value by changing the proportions of the ingredients.

The painting medium was composed of linseed oil and turpentine. For consistency, a single mixture was used at each session that was intended to be around three to four parts turpentine to one part of oil. It is, however, very difficult to dilute accurately on site. The colours of the finished paintings were flatter-looking and less saturated in appearance than I anticipated. A final

that was used on the background hills.

Having two greens on the palette – Viridian and Phthalocyanine Green – allows for a greater range of mixed greens, although the two here are fairly close in value. Both were used in straight tints with White and in mixtures with the Hansa Yellow Pale. For

varnish would recover the richness of the surface.

In pursuing Renoir's methods the key is to ensure that the paint remains fluid for a reasonable length of time. This dictates the quality of the brushmark and the soft irregular blending that occurs where one stroke touches upon another.

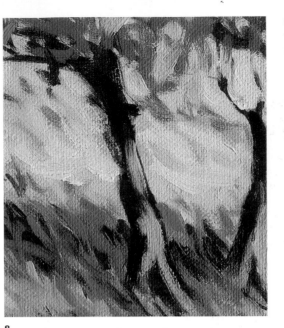

8

8 There was also a suggestion of the same interactive colouring (red/green) beneath the trees where the grass was thin and the reddish earth showed through. I deliberately exaggerated this in my pursuit of high-key colouring.

FINAL SESSION

The previous work was now dry although this is not too significant when working according to Renoir's methods. Since the paint is made fluid with medium, the stroke is not significantly obstructed by the dryness of the lower layer. Also, in the partial covering of new paint, there is still a tendency for some brushmarks to overlap, giving a continuity of the sensation and appearance of wet-into-wet painting.

In the detail *(above, right)* you can see the layered structure. Some of the brushmarks clearly sit upon others that are dry, while some have mingled with adjacent and underlying strokes that were still wet. Note the continuing presence of uncovered areas of beige ground.

9 Finally, I deliberately applied the colours typically found in Renoir's work. He had no illusions about the practicalities of Impressionism and would do as he pleased if it meant finishing a painting successfully. More Cobalt Blue was added to shade the leaves; a pale lemon yellow was introduced for an extreme highlight – dashed across the trees in well-spaced strokes to show how individual leaves caught the sunlight as they swayed to and fro. I chose these colours to enhance the impression, but they were not truthfully part of what I could see.

You must learn to recognize the point at which you have exhausted your subject. Later on in the studio I added a few strokes in pure Viridian to break up the featureless foreground and could easily have done more *(far below)*. Renoir would have added a figure or would have reworked the colour of the grass to harmonize it with the trees. How far you depart from your original impression of nature in search of a pleasing picture is, of course, up to you.

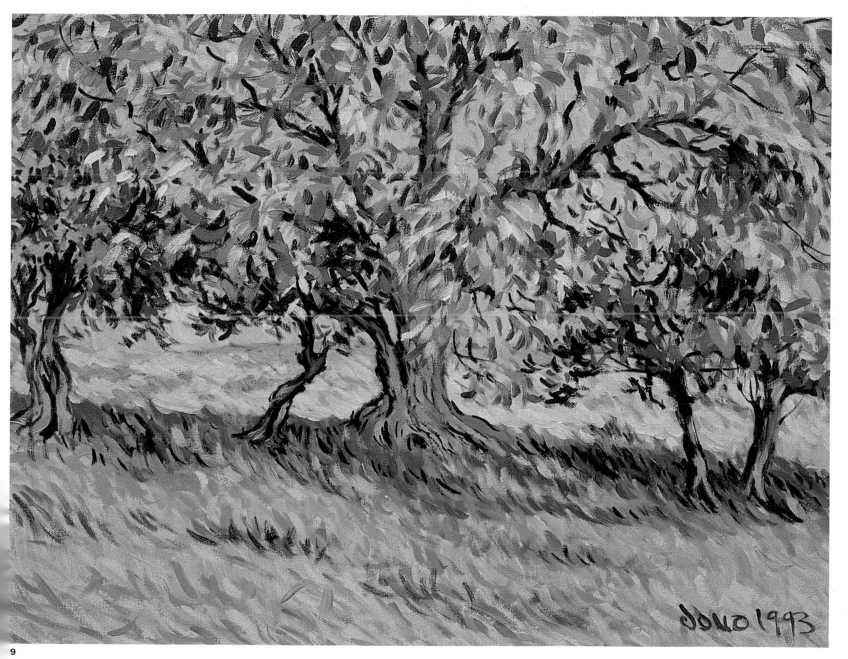

9

2.1 LANDSCAPE

Snow at Drakeholes using the methods of Sisley

MATERIALS

Support
A standard canvas board. The white universal acrylic ground was re-primed a pale pinkish brown with dilute acrylic paint. Size 12" x 10" (31 cm x 25.5 cm).

Paint
Artists' acrylic colours.

Cadmium Yellow (Medium)
Cerulean Blue
Cobalt Blue
Phthalocyanine Green
Red Lake (Rose)
Titanium White

I used acrylics because in cold weather they dry slowly and behave more like oil colours; they are less substantial than oils and have a fluidity in use that I imagine must resemble the usual consistency of Sisley's paint.

Brushes
Size 2 long flat synthetic hair brushes were used exclusively. These were appropriate for the size of the painting and the type of paint.

1

2

1 In order to show how I think Sisley painted, I have taken a subject at which he excelled, a snow scene, and have painted it at a single session as he would have done.

My painting was begun early in the morning, when the sun was still low in the sky, so its colouring represents the quality of light that existed then. Like Sisley, I paid particular attention to the sky, completing it at an early stage, and using rapidly placed, gently sloping brushstrokes.

I also aimed for the immediate crystallization of a simplified and essential image by covering as much of the painting's surface as possible with the first colours used. Pale tints of Cobalt and Cerulean Blue could be used to represent the sky, the snow-covered land and the white-rendered farmhouse, and were an obvious choice to open with.

A pale tint, thinned with water, was first used across the sky and for a rough brush drawing in order to determine the position of the principal elements. You can still see how the farmhouse and the tree on the right were drawn in this way. Having outlined the farmhouse I roughly blocked it in at this stage. The thinned-down tint of blue in fact produced a soft grey under the influence of the pinkish brown ground, both on the farm and in the sky.

The same tints were then dragged across the painting more boldly, blocking in areas to build

a basic image of the scene from the ground colour. In doing this, I instinctively introduced broad, distinct foreground strokes. You find this in some of Sisley's paintings and I am inclined to think it is a natural consequence of working at speed. This was also the beginning of a varied surface, which Sisley also favoured.

2 The painting of the sky was completed within perhaps 10 or 15 minutes by the addition of a warm cream, a peach pink and a pale violet. The violet was also applied to represent a shadow tone in the snow. These colours were based on actual observations of the colour casts and tendencies within the subject at the time, translated of course into the much purer tones of the palette. Incidentally, thinly covered or untouched patches of ground are very active in the depiction of this sky as they often are in Sisley's works.

You may realize that the quality of light that is represented here determines the entire mood of this impression. It has already been fixed at this early stage, and certainly by the time the hedging and distant woodlands were painted in soon afterwards, the impression of the moment was firmly achieved.

From then on, the rest of the painting involved the completion of detail and so it did not matter that as the sun rose in the sky the appearance of everything changed.

3 The distant woodland was conveyed by a flatly painted blue-grey tone 'feathered' along its top edge to give an indistinct junction with the sky. Into this, patches of a clean, strong tint of Cerulean Blue of a similar tonal value were added. Deep tints of purple and blue were used for the hedge beneath its covering of snow and a muted green was then added to show where the snow was beginning to melt under the trees.

Such colours are easily kept clean when using acrylics as previous mixtures dry quickly on the palette, but brushes have to be continually rinsed out to prevent hardening.

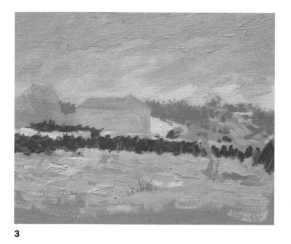

3

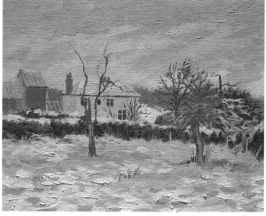

4

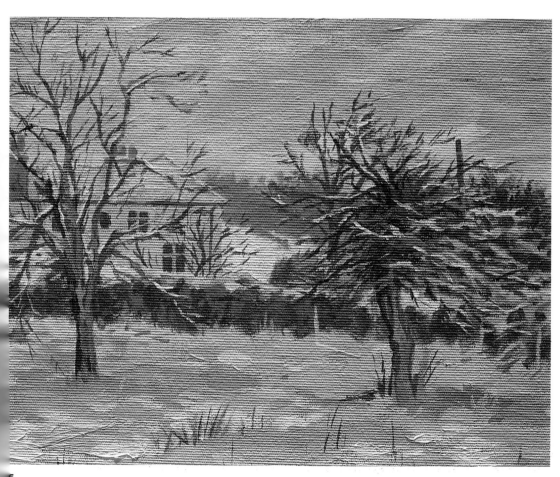

5

4 From now on you can see detail being added. The detail in Sisley's paintings is very sketchily done and, in comparison, my impression is overworked. This is largely because acrylic dries so quickly and is so difficult to retouch; wet-into-wet brushwork is impossible in the later stages of an acrylic painting, even when it is being rapidly done as here. There is also a tendency to be more careful and exact than necessary when using acrylics for fear of losing what has already been achieved.

5 I added finishing detail, working from the back forwards through the planes of the work, completing the buildings first, then adding the trees. You may notice that I have painted the foreground snow thickly and roughly in keeping with Sisley's thoughts on the variation of surface quality as a means of representation. I have also tried to depict the apple tree on the right using wavy strokes similar to those sometimes used by Sisley, but because I had chosen acrylic paint my handling was not as loose as it could have been with oils. A size 2 long flat was used on its edge or corner for the detail of this painting.

Colour mixing

A skilful, but simple and straightforward use of colour mixtures is typical of Sisley. I have tried to follow his example by using only sensible combinations of two or three colours with White. Almost the entire range of values depends on varying the relative amounts of the original component colours, not on adding new ones. For example, I have used the blues and White for pale blues and have added Red Lake for violet-greys. Increasing the amount of Red Lake has produced darker purple-grey; increasing the amount of blue, deeper shades of blue-grey. Yellow, Red Lake and White in varying proportions produced a warm cream and a peach pink for the sky, and an orange for the brickwork of the buildings.

Occasionally I did break a mixture to obtain a more neutral colour, adding yellow or green to sully a grey for example, but I avoided over-complex mixtures. You might like to compare this example with the account of Monet's colour mixing in Poppies on a mound *(p. 60) where a similar colour selection forms the basis of the palette.*

Every colour used in this painting contains White in order to achieve the soft, subtle values typical of Sisley's snow scenes and the restricted range of tone that conveys the atmospheric impression. The palette after finishing the painting (right) shows that I have deliberately worked from just a few simple, clean mixtures.

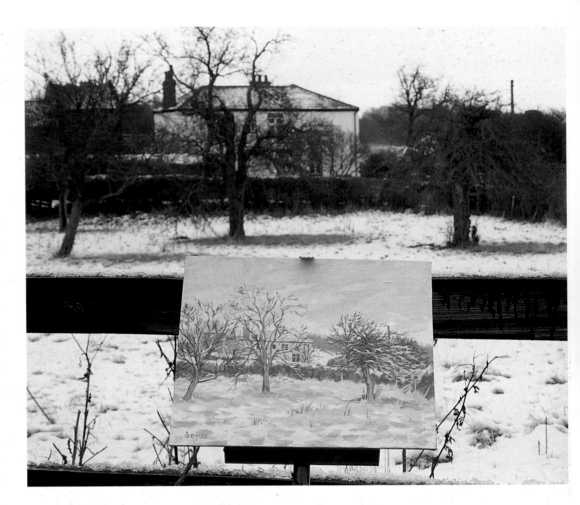

THE FINISHED PAINTING

The finished painting represents the scene as it appeared by early morning light. This photograph *(above)* was taken later in the day from the same vantage point. By then some of the snow had melted and the light had changed, but you can still see that my painting is a fairly faithful representation of the scene. Note how the impression has been simplified, but how closely it depends on reality. Again I cannot overstress the importance of painting on location.

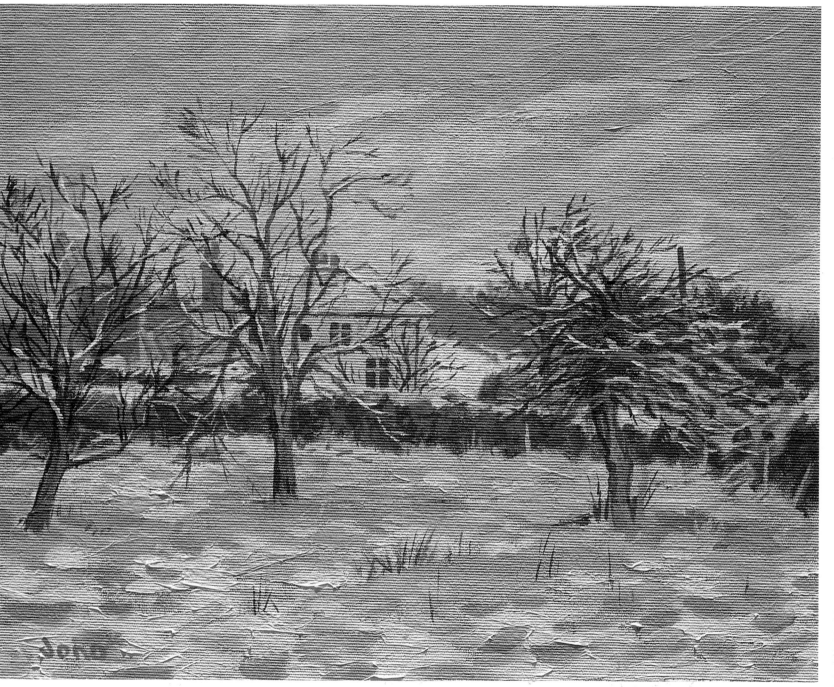

2.2 WATER SCENES

Boats on the River Exe at Lympstone using the methods of Renoir

MATERIALS

Canvas
A standard acrylic-primed cotton canvas with a white ground, re-primed a warm cream. This colour suited the bright sunlit scene and could easily have been chosen by Renoir. Size 16" x 20" (40.6 cm x 50.8 cm).

Paint
Artists' quality oil colours.

Cadmium Red Light
Cadmium Yellow
Flake White
French Ultramarine
Ivory Black
Viridian

A medium of two parts of turpentine to one part of linseed stand oil made the paint richer and more fluid. A premixed painting medium eliminates some of the inconsistency arising from using separate dippers. Stand oil is non-yellowing and elastic and introduces a richness of effect typical of Renoir's works. He probably experimented with a variety of oil painting mediums and you may wish to do the same.

Brushes
Size 4 round bristle brushes; one long flat bristle brush; one size 2 round bristle brush.

FIRST SESSION

I have tried to follow Renoir's example in this painting by concentrating on the sensation of the moment – on what was happening around me – and have made this the basis of my impression.

1 The painting began in the mid-afternoon on a sunny day at a place where the River Exe is tidal. The tide was flowing out, hence the alignment of the moored boats and the evenly rippled surface of the fast-moving water. The activity at the yachting school on the far side of the estuary also attracted my attention and my impression of the time and place was formed from experiencing these movements around me.

Obviously, it would be almost impossible for this exact combination of circumstances to recur – the time of the tide, the weather conditions and the positions of the boats provide too many variable factors. In such a situation you must, therefore, capture as complete an impression of your subject as possible at the first session, which I did by doing a rapid brush drawing covering the whole canvas. This was done entirely in French Ultramarine diluted to a glaze with medium – a rich transparent film of colour. This only took a few minutes.

If you look at the brush drawing, you will see that it contains everything that is in the finished painting – from that point on it was simply a matter of filling in the drawing with colours.

2 The original sketch was quickly taken a step further with more brush drawing in black, green and olive green (again diluted to a transparent state with medium). I used the same brush and the imperfect colours that resulted were freely dashed and scrubbed into place. I concentrated on the boats' reflections and on the light thrown up by the rippling water on to the hull of the black boat in the foreground.

Changing to a clean brush, I then mixed an opaque tint of blue using French Ultramarine and Flake White. As I applied it to different parts of the painting, I varied the amount of White or blue, adding more of one or the other

1

2

as the work developed, to obtain three or four different tones. Painting medium was mixed into these tones with the brush on the palette to give a free flowing, but rather sticky consistency. Everywhere I used rapid, curled brushstrokes, either made with a downward swing or a sideways flick from the wrist. This immediately conveys the idea of movement.

3 Still following Renoir's example, I chose bright and lively colours, suggestive of a sunny summer's day. This meant the deliberate use of pure colours, simple bright mixtures and straightforward tints with White. My colours were only loosely based on reference to the subject.

3

4

The water was painted over again with sideways strokes of pure French Ultramarine to show the dark wave patterns on the surface of the water. Areas of shimmering highlights were rapidly established with short dashes of pure White and, as a vague acknowledgment of the fact that the water was really a grey-green in places, a tint of Viridian and White was peppered around among the strokes of blue. All this was done with shallow cup-shaped marks, achieved with a sideways flick of the brush. Because wet paint was being put into wet paint, there was a slight mingling of the colours which meant that the brushstrokes had a feathery quality. There are also many minor variations of tone where the wet colours intermix as they are drawn through

each other. Already, as you can see, these applications of paint suggest the agitated surface of water.

4 Fresh brief strokes confidently placed at a single touch should be your aim. A great deal can be said with very little effort if you get this right. I noticed that among the yachts in the distance those with red colouring stood out – for instance, one with a red stripe on its sail and one with a red sail. I applied this observation when colouring the two yachts that I had sketched into place on the right, putting them in with a few well-judged strokes using red to focus attention towards that part of the painting and to suggest movement in the distance. This worked well, so I did not want to disturb the effect when I later came to paint in the backdrop of land – you should always avoid altering anything that works.

5 Renoir's use of colour is difficult to explain in terms of strict observation – he has favourite combinations – and while you must refer to your subjects to paint like him, you also have

to be prepared to deviate from the reality of what you see, not necessarily by ignoring it totally, but by deliberately interpreting it in an extreme way.

The rowing boats were an old-fashioned type made of richly varnished wood with a warm mellow brown colouring. I interpreted this as orange, which involved some considerable exaggeration, but that, I feel certain, was how Renoir would have painted them. Orange and blue is a particularly interactive colour combination – they are recognized in colour theory as being complementary and Renoir frequently used them. I applied an orange mixed from Cadmium Red and Yellow and, because of the surrounding blue, achieved a rich brilliance that is highly suggestive of the strong summer sunshine.

Incidentally, I reduced the number of boats that were really present – there is no point in attempting anything too complicated and impressions are simplifications of what they represent. While doing this you can also improve the image. I left out the boats that did not appeal to me visually.

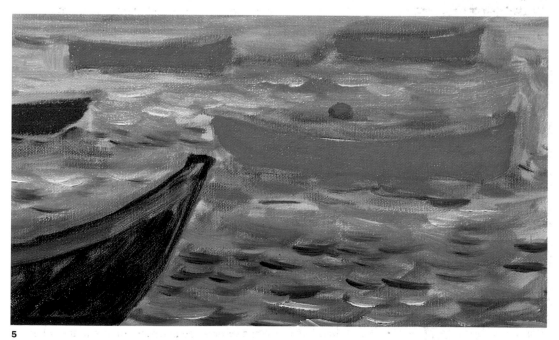

5

6

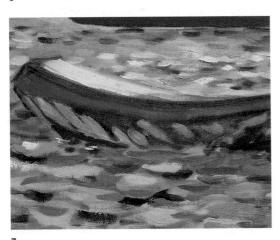

7

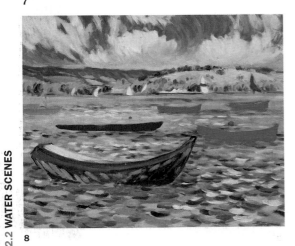

8

SECOND SESSION

6 At the second session of painting the scene was very different, but the black boat was still present and the weather conditions were similar. So I was able to paint in the land on the opposite side of the estuary with fluid paint rich in medium and set down with flickering strokes from the tip of a size 4 round bristle brush. I used the combination of blue and orange again on the far left to depict a ridge of distant hills and what was probably a ripening field running down from the ridge.

A dull green of Cadmium Yellow, Viridian and White formed the basis of the border of trees, but it has been painted into with pure Viridian and blue and the fields on the right are rendered in straight tints of Cadmium Yellow and White and of Viridian and White. Many of these colours are pure and simple and could easily have been inspired by observations of the Old Masters rather than of nature – this is a common characteristic of Renoir's colouring. Some repainting of the sky took place at this time in order to join the land and sky successfully. The use of wet semi-liquid colours into, against and around each other and of swift light brushstrokes brings about the soft-fused quality of colouring that you see here. Renoir may have used more medium than I have, as his effects are more feathery and fluid.

7 I worked on the reflections and water surface around the black boat again. The light reflected up on to the underside of the hull was represented with pale blue paint, thinly applied from a lightly loaded brush. Strokes of Ultramarine, pale green and Black and a few touches of White were then added across the olive green paint in front of the boat to show the reflection of the boat on the surface of the water.

8 At the end of the second session I had painted most of the impression, but some polishing of the image still remained to be done.

FINAL SESSION

By this time the scene had changed significantly so it was lucky that only minor details had to be referred on – thus showing how important it is to capture the essential impression at the very outset!

9 Now I painted with pure Black and White – Renoir was never afraid of Black. I mixed it with painting medium to make it glossy and intense. It has been applied as a glaze over parts of the black boat's hull and to the reflection on the water to make it more distinct. The water-line of the black catamaran was also emphasized

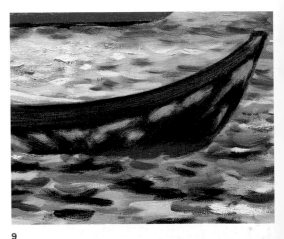

9

10

in Black, the bottom of the hull was, in fact, black, but I would have chosen Black for it anyway. Black and red work well together and you will notice that the black and red theme is played off in different relative proportions by both the catamaran and the black boat.

10 To show the water being broken by the boat's hull, some blobs of white paint mixed to a sticky rich consistency with stand oil medium were casually placed at the junction of the water and the boat's hull with movements of the brush that did not quite touch the canvas. The idea is to touch the canvas with the paint, but not the brush so that some of it is dragged randomly from it.

11

11–12 The previous work was now dry because of the warm weather, so I was able to add to the highlights on the water with dragged-over scumbles of cream paint. The canvas grain and textured brushmarks picked this up from a sticky, lightly loaded brush dragged gently across them to leave tiny speckles of cream across the blue and white paint. Cream is a variety of pale yellow, so it interacts visually with blue and enlivens the separation between blue and white when near them. Renoir used cream to imply the shimmering sparkle of light reflected from moving water. I also added some cream paint to the sky, mostly to areas where the cream ground still showed as a component part of the colouring. Being a little yellower, this additional tint of cream enlivened the sky.

13 I added the catamaran's mast and rudder with White and used four vague strokes of it to suggest the rigging. Such fine details can only ever be suggested in Impressionist paintings and you may prefer to ignore them as they may be difficult to depict and may not be an integral part of the image. Masts were also added to the pale green boats on the left and some minor repainting was then done around these to thin them down – sometimes it is easier to correct an error by partially painting it out.

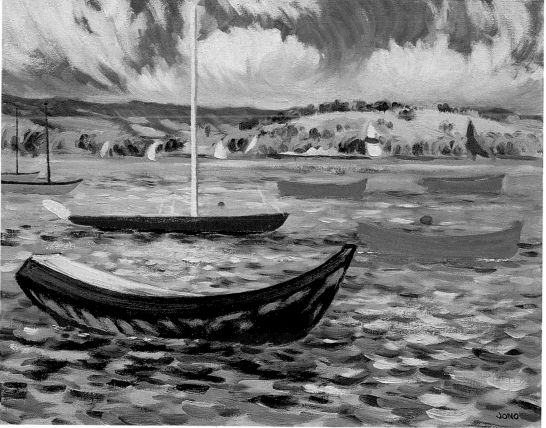
13

12

A view from Lympstone Harbour using the methods of Monet

MATERIALS

Canvas
A standard cotton canvas with a white acrylic priming, re-primed beige. Size 14" x 18" (35.5 cm x 45.7 cm).

Paint
Artists' quality oil colours.

Cadmium Red Light
Cadmium Yellow
Cobalt Blue
Flake White
Red Lake (Deep)
Viridian

Some turpentine was used in a dipper to help the paint flow during the early stages when the canvas was dry, but to a strictly limited extent.

Brushes
Sizes 6 and 2 long flat bristle brushes.

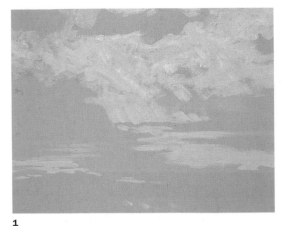

1

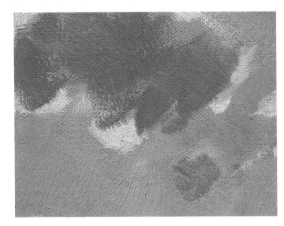

FIRST SESSION

Finding suitable places to paint is part of the art of Impressionism. It is often useful to scout around an area first for a suitable subject. This painting, *Boats on the River Exe at Lympstone* (p. 76) and *Rowing boats* (p. 88) were all done within the same small area.

I was attracted to this image because of the sky. As I started to paint, there were two features that reminded me of paintings by Monet – the trail of clouds passing in front of the sun and the bright, hazy sky itself, particularly towards the horizon. These gave me the opportunity to use some further methods characteristic of the artist.

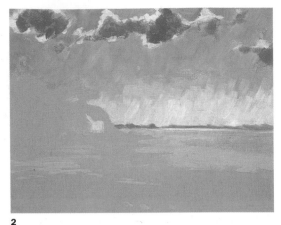

2

1 You have to act quickly to capture the impression of a fleeting moment. Here, I was able to fix the image of the sky rapidly by working against the colour-tinted ground. At this stage I depicted the cloud shapes and the land mass by taking a pale tint of blue around their silhouettes to 'reserve' – leave open – spaces for them. The same tint was used for the open sky and the water beneath it that reflected its colour.

2 To help me work rapidly, the brush – a size 6 long flat – was initially dipped in turpentine to make the colour flow freely. I placed a second layer across the sky almost immediately using the same tint of Cobalt Blue and White, but this time without the aid of turpentine. The colour was applied more strongly with long, almost vertical, brushstrokes sloping a little to the right and slightly curved because of the swing of my arm. A very pale cream made of Cadmium Yellow and White was then placed with a clean brush on the lower part of the sky in the same way and was used to edge around the clouds to show them illuminated by the sun from behind.

Next, the underside of the cloud formation was crudely filled in with a tint of purple, composed of Cobalt Blue, Flake White and a little Red Lake, so that patches of the beige ground colour were left showing *(above, left)*. By this time, the original clouds had gone, but other similar clouds had followed on, so I was able to observe their colours and apply them to the shapes that I

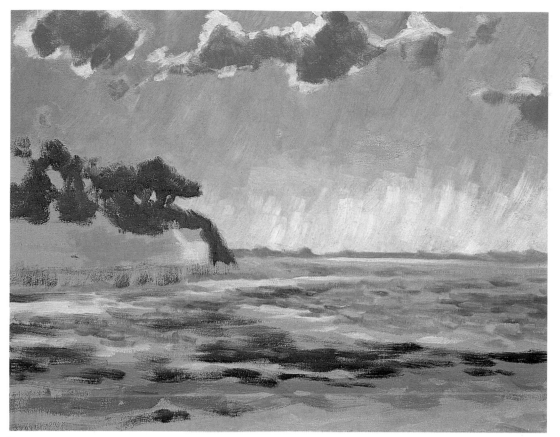

3

The repetitive long brushstroke that I have used scored into the paint, giving streaky variations of colour within it. This is particularly evident where cream paint has been used at the base of the sky (below). Here, the square-ended strokes of the long flat brush are very clearly seen. Especially in his late work, Monet used an overlay of slightly intermingled strokes like this achieved by working into the edge of a wet layer with single touches of another colour – that are placed and not reworked – to create the sense of a hazy atmosphere. It is an idea that can be developed in layers as the paint dries. Monet used it that way almost as the sole basis of some of his paintings, but here that did not seem necessary.

The ground colour in this work also contributes to the vagueness of the atmospheric effects by showing through.

had already recorded. Bringing together separate observations like this is a good way of dealing with aspects of your subject that are constantly changing in detail.

3 It is difficult to determine whether the colour choices that are made are always the result of observation alone, or whether they are sometimes also guided by the knowledge of what will be successful. You have to make immediate decisions with the colours available to you when applying Impressionist techniques, which means that experience is bound to play a part.

I could see here that the clouds were not pure white or grey and my translation of the values observed into cream and purple was genuinely suggested by the colour values present. However, this was not the case in my use of cream at the base of the sky – I could not identify this colour precisely and did not want to spend too much time trying to work out what it was. The colour of this part of the sky was close to white and it contributed to the sense of a sky filled with warm sunlight, so I chose cream because I had it on the palette and knew that it would work. Incidentally, if you ignore the fact that they are in tint form, the colours present in the sky are yellow, blue and purple – colours that, according to colour theory, complement each other well. As you are just trying to create an impression, you need not be too exact – simply respond instinctively to what you can see and make use of your experience.

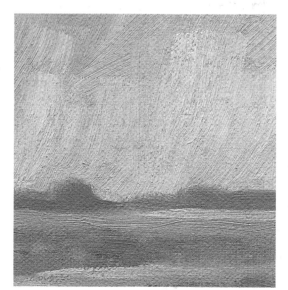

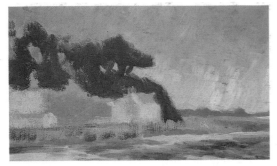

First session

Second session

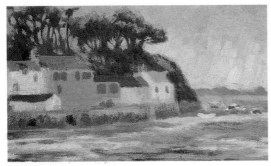

First session

Second session

4

SECOND SESSION

4 The second painting session took place at the same time of day in similar weather conditions, but as often happens the scene was not exactly the same. Apart from a little retouching in blue to clarify the outcrop of trees on the headland, the sky was left alone as it had now changed significantly in appearance. I devoted this session almost entirely to a closer observation of the headland and the spread of water across the mudflats in the foreground.

I kept to the same palette, developing variations of green from Viridian and Flake White made darker with Cobalt Blue, brighter with Cadmium Yellow and duller with Red Lake. Simplified colour and detail were added to the headland and the wet mudflats were developed with a further covering of horizontal strokes, this time shorter and more definite, using mostly pale blue and cream, but also some greens. You can see how the painting was added to by looking at the illustrations *(left)* that compare details from the first and second sessions.

A natural marker

If you look at this detail (below) of the very tip of the headland, you will notice that the rowing boat and rocks are brightly highlighted with thick cream paint. During much of the painting session this area was in full sun, while the rest of the headland was submerged in its own shadow. As the sun moved round, the first white house on the headland began to look as bright as this little area of beach and I was able to use this as a natural marker that told me when to stop painting. Try to take note of some strongly lit feature when you are painting and observe how it relates to its surroundings. Changes in those relationships then give you warning of an overall alteration in the conditions that you were working under.

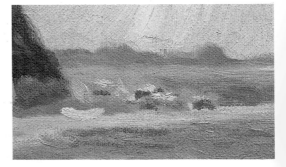

FINAL SESSION

In this session the painting was completed *(below, left)* by adding a little more detail to the headland and by putting in some of the boats and birds that were an essential part of the scene. I used brief, but carefully judged strokes from size 2 long flat bristle brushes.

The two swans *(below, right)* consist of a few strokes of White laid with the flat of the brush for the bodies, but with its edge for the necks and tails. The underside of the swan on the left was shaded by a smear of pale purple into the wet White and strokes of deep purple off the edge of the brush produced the firm shadow beneath the birds. The position of the shadows directly below the swans and the dark boat *(above, right)* shows the time of day, as does the boat's strong

contrast with the surrounding colours which reveals the intensity of light. Note also that the emphasis continues to be on the use of colour, even where a dark shape is represented. The flash of red underneath the boat and the deep blue of the hull are the results of careful observation. The sense of strong shadow is achieved by setting these against a dark purple made from Cobalt Blue and Red Lake.

I did not include all the boats, but selected the most striking examples, such as the red catamaran and the dark blue boat on the right. As the background paint was dry they were placed on top of it. The addition of finishing detail on top of a broadly painted scene is a satisfactory way of combining outdoor work with studio finishing.

Looking into the sun

This painting was done across the middle of the day. The view is towards the sun, but with the sun out of the picture above and to the left of the headland. Subtle contrasts existed between the qualities of light across the scene, but overall it was bright. It also appeared somewhat hazy because I was working more or less into the sun.

It is, in fact, much easier to work with the sun behind you or to the side when painting out of doors. Monet would have chosen to work towards the sun quite often because of the interesting colours and effects that occur and because the strong light

tends to reduce the image to an indistinct impression anyway.

You have to look towards the sun with half-closed eyes, but you must protect your eyes and should never look directly at the sun. Have your canvas positioned to the side so that the sun also catches it – it should not be in its own shadow or yours otherwise you will make errors of judgment due to the pronounced difference between the way that the canvas and the scene are lit. A slight tilt away from the sun may, however, be necessary in order to reduce glare from the wet paint or the ground. This painting was on a tinted ground so this was less of a problem.

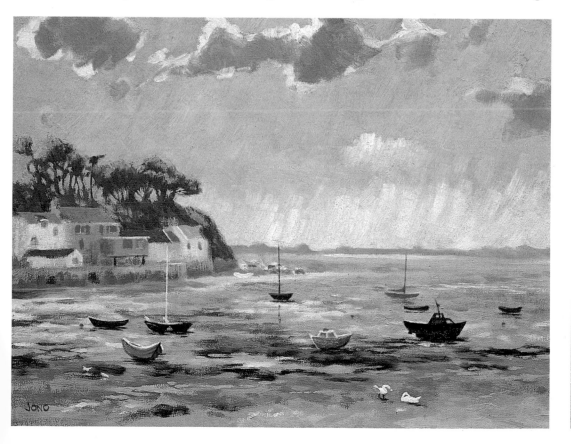

2.2 WATER SCENES

The mouth of the River Otter using the methods of Monet

MATERIALS

Canvas
A standard oil-primed linen canvas with a white ground that was in fact a creamy off-white as oil grounds usually are. Size 12" x 10" (30.5 cm x 25.5 cm).

Paint
Artists' quality oil colours.

Cadmium Yellow
Cobalt Blue
Flake White
Hansa Yellow Pale
Red Lake (Deep)
Viridian

The colours were taken straight from the tube and used without a medium.

Brushes
Predominantly size 2 long flat bristle brushes, but also sizes 4 and 6. I used these brushes because of the small size of the canvas. Monet would probably have attempted this scene on a much larger canvas. A painting knife was also employed.

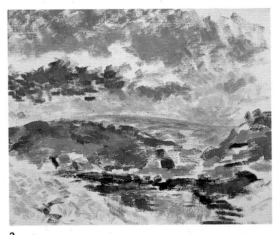

1

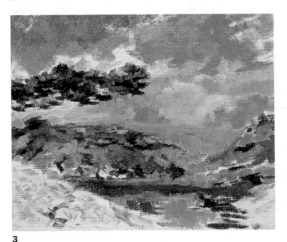

2

3

FIRST SESSION

Monet often worked at the extremes of the day – unusual colour values occur at these times and are easily observed. All you have to do is simplify and exaggerate the colour effects that you see. The secret of this method is the knowledge that such effects are likely to occur. I painted this impression, featuring a row of pine trees, in the evening with the sun going down.

I arrived on the scene at about 6.30 pm, set up my easel and waited. This painting was done in summer when strong, mellow sunlight is to be expected in the evening and stable repetitive weather conditions can be anticipated. Extraordinary lighting effects can occur at any time of year, but they are more predictable and therefore easier to paint during the summer months.

1–3 I started to paint once I became aware of unusual colours – a cloud took on a definite yellow value and the rocks began to look very orange. It is important to work quickly at the beginning, so I rapidly covered the canvas with spaced-out dashes of colour, applying each value separately in a series of sweeps across the canvas. Wherever there was a blue, I put brushstrokes of blue; wherever there was orange, I placed orange; and so on with greens, purple, yellow and dark red. In the space of a few minutes this process was repeated several times, filling the gaps between the previous brushstrokes at each subsequent pass across the canvas. You should not be preoccupied with the subject at times like this – you must concentrate on the colour and, as you can see from the sequence of illustrations, the broad impression of the subject takes care of itself.

For the trees short strokes of different colours were laid alongside each other and began to overlap. I used Red Lake (Deep) and blue for shadow – they enriched the green, imitating the effect of the light on the trees. The purple shadow behind them lasted for only half an hour and then I had to stop painting.

SECOND SESSION

The second session took place the following evening at almost the same time. You have to set up, wait and hope that the effects repeat themselves. If they do not, you must not paint – in this instance fortunately they did, but not at exactly the same time.

From my work of the previous day I knew what to expect and because I already had a basic impression laid out I was able to concentrate on the details of the colour. The sky was now different, but I could tell from it that the first representation was both incomplete and too crude so I had to rework it.

4 The whole of the second session was a process of refining the original impression. As the colour effects emerge again, you should consider their colour value, tone, shape and the variations within them more carefully. This time I depicted the purple shadow more accurately, mixing its tint from Cobalt Blue, Red Lake and Flake White – creating its shape with sideways strokes from the edge of the brush.

The orange rocks were developed, the unpainted parts of them filled in with variations of orange, pale orange and yellowish green. I started indicating the rock crevices, but by now the half-hour period was drawing to a close and the effects were beginning to change so I had to stop painting.

You will notice that during the second session I made a concentrated effort on particular parts while the rest stayed as originally sketched. During the two subsequent sessions very little of the work completed during this session was changed.

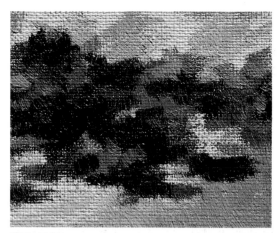

First session

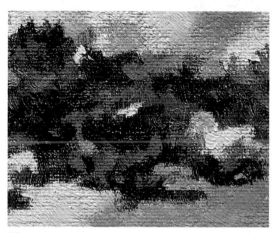

5 Second session

5 I also went over the trees and the area of grass beneath them using mixed greens of slightly different tones and rather more pronounced colour values. I used small spaced-out brushstrokes that visually fragmented the existing colouring without painting it out entirely. You can see how they have been refined in this way by comparing the details of the trees from the first and second sessions. Their profiles were also made more complex during the repainting of the sky by taking small strokes of the sky colours over the edges of the original painting.

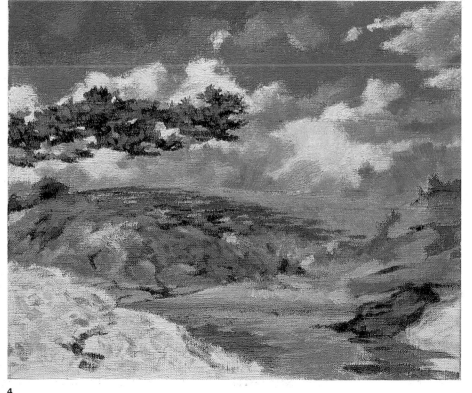

4

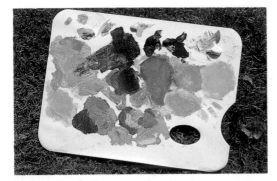

Developing the sense of colour

To ensure the vitality and richness of the colouring, a fresh palette of clean colours should be laid for each session and the brushes thoroughly cleaned before being used again.

The first palette (above) carries the greater number of colour mixtures which have then been broken down further. The green, for example, has been developed towards lighter and darker values with additions of other colours.

The second palette (above, right) is from the third session. There are fewer colour mixtures partly because of the concentration on smaller areas of painting, but also because a definite colour scheme is developing. As this happens, stop looking too precisely at the detail of the colouring. Impressionist landscape painting is a process of simplification including a reduction of the image to the essence of its colouring. Here it was an arrangement of orange, green, purple, yellow and blue, and once this was established the rest of the painting could be completed in terms of those colours.

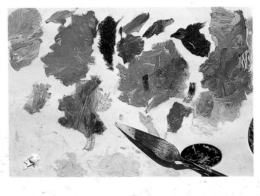

6

THIRD SESSION

6–7 The third session was almost exclusively devoted to the tree trunks. The line of pines was a landmark feature that had to be recorded with some accuracy to be a true impression of the scene. There were two problems – firstly, how to simplify a distinctive group of trees in order to paint them easily. My solution was to concentrate on two or three with outstanding shapes and represent the rest as a mass of irregular vertical lines. The second problem was how to show depth within the line of trees.

It can be hard to analyse a subject when working directly from nature and in this case, the variations of colour and tone resulting from light penetrating unequally through the trees and on to their trunks were far more subtle than I eventually depicted them. I resolved the situation by painting parts of the trunks dark purple or blue and used a paler tint of purple for the areas where the light fell strongest. A slightly lighter tint of a dirty green was also added to the trees that were meant to be the front row. This was an

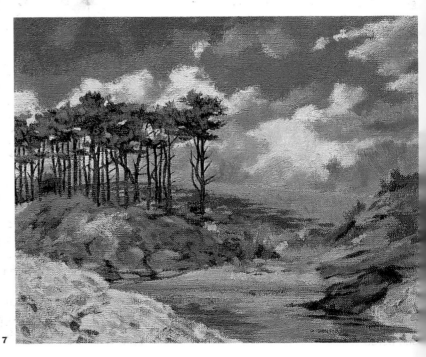

7

extreme simplification of the colour-tinted greys, greens and browns that were actually there. It sometimes helps to half close your eyes so that you only see an impression and are not confused by all the detail and colouring that you might otherwise observe. A little more work was done on the rocks, but most of the half-hour was spent painting the trees.

FINAL SESSION

The conditions reproduced themselves wonderfully for the final session of painting. In fact, the colour effects were more emphatic than they had been in the previous sessions. By now there were only two things left to do – the banks of pebbles on either side of the river and the river itself.

The pebbles were put in with generous dabs of colour, strict observation told me that they were mostly blue-grey, but obviously there were all sorts of colour variations present. I represented them here using very pale tints of the main colours already used – purple, orange, yellow, blue and green. This contributed towards the colour harmony of the whole painting. If you look just above the pebbles on the left, you will notice some bold strokes of orange which were needed to unite the background and foreground. It is often necessary to do something like this at the final stage because Impressionist paintings are worked on spontaneously, without careful drawing as a starting-point. You might have to retouch in the studio, but here I was able to complete the painting entirely on site.

Finishing the river was incredibly difficult – depicting moving water is always hard. This particular stretch is where the River Otter meets the sea and during the half-hour sessions that I painted in, the rising and falling tide caused constant changes to the reflections, so it was very difficult to arrange my colours in a suitable pattern. In this final session, I repainted parts of the river several times, but decided that it could not be illustrated faithfully so I settled for the horizontally brushed colours that you see here.

I should mention that since I used Flake White, just as Monet would have done, parts of the painting had dried before I finished. As a result, some later touches of colour have a different quality – they lie over another colour and allow it to show through. Monet makes good use of this effect in some of his paintings and at times it has the appearance of a deliberate method as in my *Waterlilies* (p. 92).

My final touches were made to the water at the right of the centre of the painting with a painting knife *(right)*. Monet only rarely used a palette or painting knife, mostly in some of his early Impressionist works. I used one here, not to apply paint, but to spread and remove a section of painting that did not quite work.

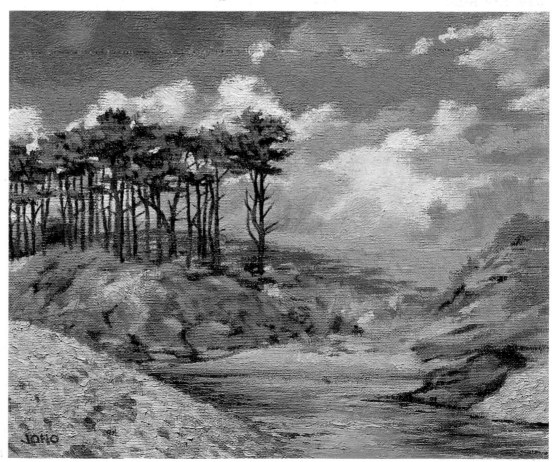

2.2 WATER SCENES

Rowing boats using the methods of Monet

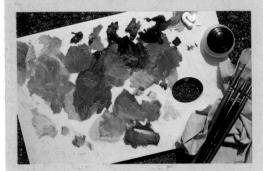

MATERIALS

Canvas
A high quality oil-primed linen canvas with a white ground that typically appeared a creamy off-white. Size 14" x 10" (35.5 cm x 25.4 cm).

Paint
Artists' quality oil colours.

Cerulean Blue
Cobalt Blue
Flake White
Ivory Black
Red Lake (Rose)
Yellow Ochre

Turpentine was used to thin some Cobalt Blue for the initial brush drawing.

Brushes
Two size 6 long flat bristle brushes; one size 4 short bristle brush; one size 2 long flat bristle brush.

FIRST SESSION

1 An eyewitness account claims that Monet began with a drawing in charcoal before painting, but I have found no technical evidence in support of this. Nevertheless, I began with a drawing here, since the definite shape of the two rowing boats had to be shown accurately in order to provide a convincing representation of them. In addition, one of the boats was moving about on the water and its position had to be fixed in the image so it could be painted. My natural inclination was to begin with a free-hand brush drawing, using Cobalt Blue thinned with turpentine to the strength of a wash. Subsequently, I had to redraw the nearest boat to correct its scale and shape. You will make errors all the time when working directly and spontaneously from nature. Fortunately, alterations to an initial wash drawing are easily obliterated by later painting. The Impressionists sometimes began this way and you will find it a practical means of starting a difficult subject.

2 With the brush drawing in place, I went on to apply colour. On a hot day turpentine evaporates quickly, so thin paint – especially a fast dryer like Cobalt Blue – soon becomes tacky and is not easily disturbed once it has been applied.

Moving water is always difficult to paint. You must choose one aspect of it at a time and identify carefully what you can see. Looking at the sky and the immediate surroundings of the water can confirm your interpretation of the water's colours as they are broken up reflections of the surrounding scene. Movement is the greatest problem – the best thing to do is to fix on a particular ripple and follow it with your eyes so that you have at least a few seconds to decide on its shape and colour. It is a matter of asking simple questions – what shape is this and what colour is this – and above all of simplifying what you see.

The water was put down very quickly. It is important to get the shape of the ripples correct. Sometimes they are like elongated 'S'-shaped squiggles drawn out horizontally, which can be achieved by drawing an 'S' shape with the hand as the arm moves sideways. Sometimes they are like horizontal lines of vaguely diamond-shaped dots which are either joined or broken. For these smaller ripple effects, you should make a short diagonal stroke with a flick from a square-ended brush.

The colours used for the water were an amplification of what was actually seen. The pale and mid-tone blue are tints of Cobalt Blue and White. The grey-green and olive green used beneath the black boat are mixtures of Black, Yellow Ochre and White, with pure Black and Cobalt Blue brushed into them for added emphasis. The pale yellow spots showing reflected sunlight are in tints of Yellow Ochre and White and are thickly applied from the size 4 short flat bristle brush – placing them from a heavily loaded brush prevents unwanted mixing

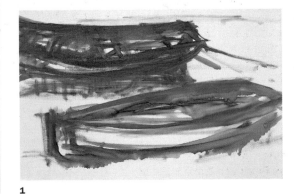

1

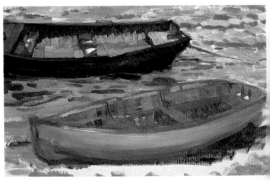

2

into the adjacent and underlying tints of blue. You can see in the detail *(right)* how crudely and openly the dashes and spots of colour are applied. The blue on the stern of the boat and the rope coming from it are untouched remnants of the original Cobalt Blue brush drawing.

3 The black boat has been painted in a way that is characteristic of Monet. I have used dirty greys, dominated by Ivory Black, but also containing various additions of Cobalt Blue, Yellow Ochre, Red Lake and a little White. The rim of the boat has been highlighted in grey; the shape of its hull and some of its planking have been very simply accented in Black. This was done into the wet grey-black paint, using sweeping strokes from the edge of a long flat brush to provoke soft and irregular effects. For the tiny highlights along the front edge of the boat a tint of grey paler than desired has been brushed into the existing dirty grey, giving the tone actually required, but leaving a streak of the lighter value near the beginning of the stroke. That now serves as a bright spot to the highlight and has been encouraged deliberately.

To complete the black boat, the seats were painted in with two strokes of White, each done from a well-loaded brush and brushed only once to minimalize the lifting of adjacent colours. If you look closely, you can see that the White is not, in fact, taken up to the surrounding colours, the gap between them being filled by the original Cobalt Blue drawing. The way that this boat has been painted summarizes how you must always try to paint when applying Impressionist methods – be bold; be confident; make definite strokes that you have thought about in advance; and do not touch them again unless you absolutely have to!

The lighting conditions changed before the boat in the foreground could be completed. To reach this stage of its painting I used Cobalt and Cerulean Blue, with White for the outside of the hull and various mixtures of Yellow Ochre, Red Lake, Cobalt Blue, Ivory Black and White for the wood-coloured interior.

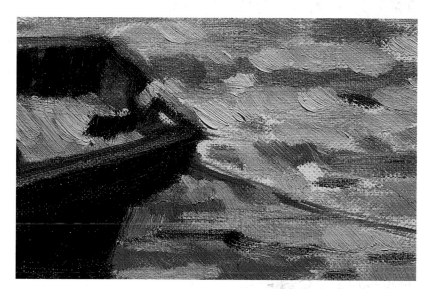

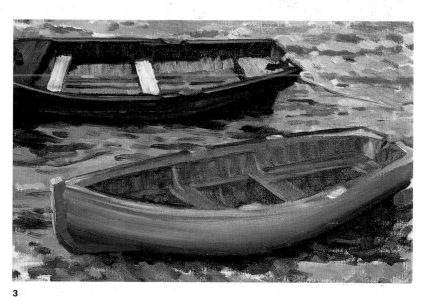

3

SECOND SESSION

The second session of painting took place two days later when the canvas was almost dry. The upper part of the painting was satisfactory, as you can see, so it did not seem worth risking the freshness and directness that had been achieved by attempting to improve upon it. I confined myself to painting out an accidental smudging of the colours at the top left along the edge of the black boat, which had distorted its appearance *(left)*. I also added a few dashes of White on the right, after looking at the water more carefully, to give sparkle to the reflections on the surface. The white highlights just above the black boat, incidentally, are untouched areas of ground exposed between the brushstrokes in blue.

It can be difficult not to want to change your work when you revisit the scene to complete your painting, as Monet did, but if you have painted well, leave what you have done alone. There will be enough problems to overcome without making new ones. Here the boat had changed position and I had to reason out the connection between what I could see now and what I might have seen previously. Even when using Impressionist methods you sometimes have to apply painterly logic, just as you do in the studio.

As you can see *(right)* I left the interior of the boat more or less untouched, though the hull was repainted in dirty blue-greys to improve on the straight tints of blue that had been used before. I concentrated on painting the top edge of the boat, adding a strong White highlight in thick paint all around the edge. This was achieved by short heavy strokes across the width of the edge, laid next to each other, which produced a thick deposit of paint. Getting this crucial highlight perfectly placed proved difficult and as I was not really benefitting from being on site, I gave up after several attempts and perfected it in the studio afterwards.

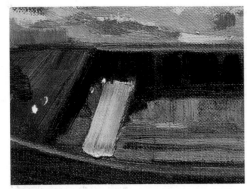

First session

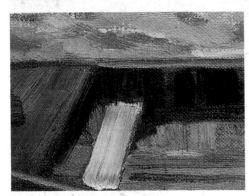

Second session

First session

Second session

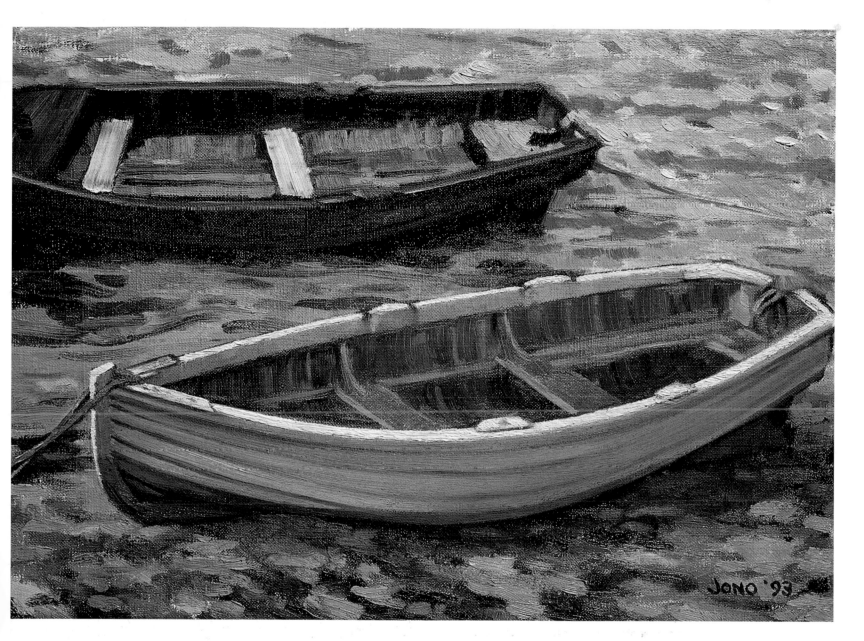

The wet mud beneath this boat at the bottom of the painting looked very different at the second session, so I had to complete the painting (above) using guesswork and reference to other similar parts of the surrounding scenery and to the colours and brushstrokes that I had used at the first session.

There will always be such difficulties when applying Monet's method of revisiting the scene; nature and circumstance seldom repeat themselves exactly. But you will gain from being there, as your immediate personal response to the subject is the essence of the impression.

2.2 WATER SCENES

Waterlilies using the methods of Monet

MATERIALS

Canvas

A standard linen canvas with a white acrylic ground. Monet's late *Waterlily* paintings seem to be on white grounds, although it is possible that some of them may be on very pale grey primings. The elongated landscape format was suggested by Monet's use of panoramic canvases for this theme; he worked to a huge scale, but today's artist will want a more convenient format. Size 20" x 14" (51 cm x 36 cm).

Paint

Artists' quality oil colours, worked from a limited palette.

Cadmium Yellow
Cobalt Blue
Flake White
Red Lake (Deep)
Viridian

Turpentine was used to thin the paint at the very beginning, but with that exception it was used throughout without dilution at its natural tube consistency.

Brushes

Long flat bristle brushes in sizes 10, 6 and 4. The choice relates to the scale of the painting. Photographs of Monet at work on late *Waterlily* canvases show him using brushes that must have been at least size 12 and were probably significantly larger.

92

1

2

3

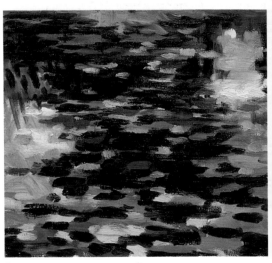

4

FIRST SESSION

1 Monet seems to have started his large *Waterlily* canvases with a scrawling, more or less abstract, laying-in of colours that represented in the most simplified way the masses of colour before him and, as indicated by the frenzied brushwork, the movement and flickering quality of the colours on the water's surface. I began in the same way, spreading out almost instinctively scribbles of pure Cobalt Blue, Red Lake and

Viridian thinned with turpentine to the consistency of a wash. Thus a fully loaded brush could paint at length without drying out and the colours glowed luminously over the white ground.

2 From this starting-point, I immediately progressed to using some mixed colours, adding a tint of pale blue, a greenish yellow and some purple and purplish black made by working the

Cobalt Blue, Red Lake and Viridian together. As yet the painting made very little sense, but it began to take shape quite quickly afterwards. Over the top of the first scrawl of colours, I started to lay broad strokes of more carefully judged values. They began to fill the gaps and united the different areas of colour into a continuous image of the lily pond's surface.

3 I used different strokes at the top and bottom of the canvas: at the top, the strokes are made vertically; in the lower part they are broad and horizontal. A look at the pond explains why. At the other side reflections of trees stretch downwards in a mirror image that seems to go into the water; they are best represented by downward strokes. Close to, you are more aware of the water's surface, reflections of the sky and the colours and shapes of the waterlilies themselves floating over the pond. All of these are more easily represented by horizontal patches of colour because they are experienced across the width of your field of view.

4 So far all of this took a matter of minutes. The next stage was to go over it all again – this time with broad strokes from heavily loaded brushes, applying the colours more exactly as they were seen. I am referring here, of course, to the translation of observed colours into paintable colour effects, applying Monet's principle of 'what colour do I see, then that is what I paint'. Some of the waterlily leaves were beginning to turn yellow, so they were painted as pale yellow streaks. Cobalt Blue, Red Lake and Viridian were also used pure in heavy, horizontal strokes to represent the deepest areas of shadow. In this last covering of the canvas at the first session, the paint was put on thickly, so that it would stick to the wet paint beneath it. Almost all the canvas was covered over again, even where the colour was not changed and as a result the textural quality of the surface had begun to emerge.

I had to stop painting, not only because the sun had moved round, causing the image to alter, but also because the build up of paint made it difficult to apply more.

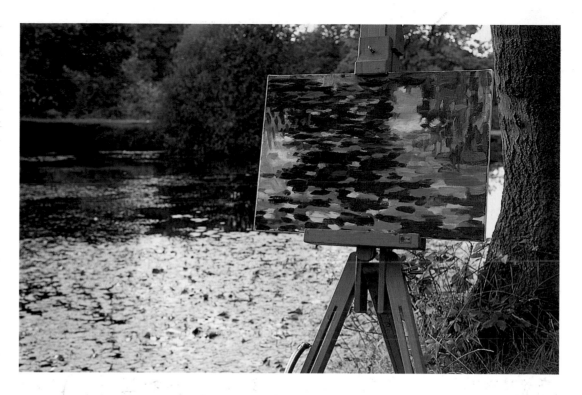

Painting from nature

You can see the painting at the end of its first session by the lily pond from which it was painted (above). I cannot stress how important it is to work directly from nature when following the Impressionists' ideas and in particular when applying Monet's methods. Despite the discrepancies between a photograph and actual observation, and despite the fact that this picture was taken when the painting session had finished and the conditions had changed, you should be able to see that the colours on the canvas are not random patches of totally imaginary colour and that the seemingly haphazard brushstrokes actually represent factual elements of the scene.

The vertical strokes at the top right corner of the canvas are the downward reflections of the bush seen here at the other side of the pond to the left of the canvas. The pattern of horizontal strokes rising from the bottom of the canvas, diagonally across its centre towards the top left, is the curved sweep of waterlily leaves seen extending across the pond from where the easel is situated. The dark area on the edge of these leaves on the left appears in the painting as a concentration of pure colour strokes to the left of its centre. The few more or less vertical strokes that appear on the left are the reflections of some reeds on the far left just out of the picture.

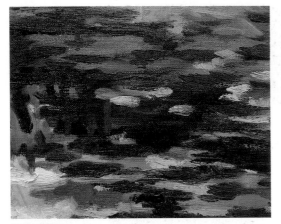

First session

5 Second session

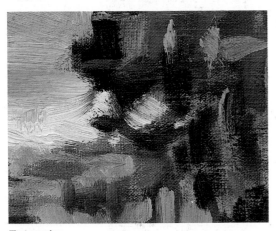

First session

6 Second session

First session

7 Second session

SECOND SESSION

The second session took place a week later, under more or less similar conditions at the same time of day. The canvas was almost completely dry and there was little risk of the fresh paint disturbing the paint already there.

I painted using the same palette of colours – starting with a clean palette, fresh paint and clean brushes – going through the same motions of observing the scene, then placing the colours and brushstrokes as these observations dictated. In the second session I used small brushstrokes, subtle variations of colour and, in many places, a change of direction of brushstroke compared with that in the previous layer. Because the lower layer is heavily textured, new brushmarks are broken up as they are dragged across the rough surface. This allows both layers' colours to be seen and to interact visually, adding greatly to the overall harmony.

Comparing the illustrations of these details from the first session (left column) with the same areas after the second session (right column), you can see how the colours are broken up with smaller strokes put over the original large ones. This breaking up of the image also emphasizes the idea of indistinct reflections on water dancing before your eyes.

5 Some new horizontal strokes have been put in to represent the lily leaves in the middle distance as they appeared at the second session, using an orange and pinky orange colour made from mixing Cadmium Yellow, Red Lake and White.

6 Short vertical strokes of pale blue, green and yellow have also been used to break up areas that represent the reflections of trees on the other side of the pond.

7 In the foreground, greens and yellows were added to confirm the shapes of the waterlily leaves, but mostly these were suggested by using patches of blue, which 'cut out' the leaf shapes from the existing layer by painting the areas of water between them reflecting the sky.

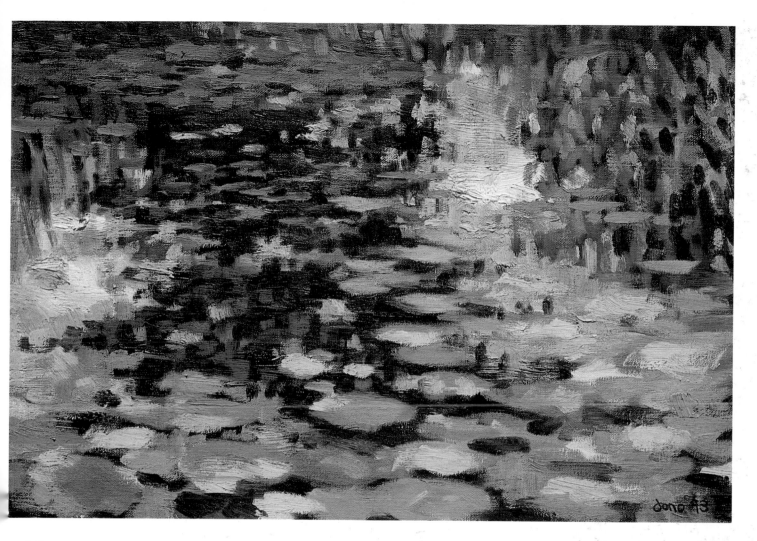

THE FINISHED WORK

The second session had to finish because the lighting conditions changed and I later decided that the painting was complete, but Monet's technique allows for reworkings to suit the taste of the individual artist. In his early paintings of the waterlily pond and the Japanese bridge, Monet seems to use two basic layers put together in much the same way as I have described. His later *Waterlily* paintings were worked on for many years and could not possibly have been done directly from nature. They might

have started like this, with repetitive reworking in his studio, exploiting the possibilities of dragging new wet layers over contrasting dry ones, thus adding ever-increasing subtlety to the effects. You can see in the detail *(right)* how working layer upon layer over dry paint begins to introduce colour effects that could not be painted directly. Thus you, too, can rework a painting like this many times over in search of a more essential and abstract version of the impression.

2.2 WATER SCENES

2.3 STILL LIFE

Still life with a basket of apples using the methods of Cézanne

MATERIALS

Canvas
A standard stretched canvas of acrylic-primed linen, re-primed a yellowish cream with acrylic paint. Size approx. 10" x 12" (25.5 cm x 30.5 cm).

Paint
Artists' acrylic colours from a limited palette.

Cadmium Yellow (Deep)
Cobalt Blue
French Ultramarine
Phthalocyanine Green
Red Lake (Rose)
Titanium White

The palette could easily have included Black and a yellow earth – Yellow Ochre or Raw Sienna – and maybe another green. If my still life had contained a white cloth and some pears, for example, these additional colours might have been needed.

Brushes
Synthetic-haired size 2 long flats were used exclusively to apply colour and a synthetic-haired size 3 round delivered the brush drawing. Synthetic hair brushes suited the acrylic paint. In oil, I would have chosen bristle flats and a soft-haired round.

1

2

It is quite easy to explain what Cézanne did in simple practical terms, but the reasoning behind his work is more complicated. I have discussed this in my *Still life with plaster cast* (p. 100). Cézanne was not a true Impressionist, although he still referred to nature, as he looked beyond the impression of his senses towards an intellectual analysis of his subject. You can attempt the same, or you can just apply his methods and enjoy the results.

1 My first action was to re-prime the canvas, using an imitation Naples Yellow with Titanium White for a cream ground. I put down a strong enough tint of the warm cream to emphasize its yellowness. Cézanne had a definite preference for cream grounds – a colour that interacts favourably with blue which he used extensively, considering it to be the colour of atmosphere. Cream is a reduced form of yellow and yellow and blue are complementary colours.

2 I assembled a still-life subject typical of Cézanne: a basket of apples, a cloth to drape as a background, a small round plate and a few other less important objects to fill the pictorial space. Then I set them up as Cézanne might have done.

Firstly, I packed the basket with newspaper so the apples seemed to fill it, rising up in an attractive mound to give an image of fruitfulness. The basket was then placed on the cloth with the plate and some loose apples. This was set up lower than my canvas so that I would look down on it while painting. If you paint standing at the easel, put the arrangement at waist height, if you are sitting, put it on the floor.

The basket and the plate were propped up from the back with a piece of wood and a matchbox – Cézanne is said to have used coins. By adding to or taking from piles of coins you can try out alternative heights and make subtle adjustments. These props are hidden from view as you paint and are used to exaggerate and emphasize the elliptical shapes that occur where round or rounded forms are seen at an angle.

For example, in my painting, because of the extra tilt, the rim of the basket, the edge of its base and the arch formed by its handle all become more generous curves; there is a greater sense of the volume of the basket; and the plate is more rounded – you may see this more clearly in the finished piece. If you compare these shapes to the rounded forms of the bottle and candle holders in the background that are treated in normal perspective, you may appreciate the effect that this manipulation of the angle of view has had on the feeling of solidity and the sense of presence conveyed by the principal objects.

3 I started with a drawing from a size 3 round in dilute French Ultramarine. Freely and simply sketching the composition in outline did not take long so I went straight on to apply the colours. The drawing should identify the essential shapes within the subject at the outset, then adding the colour becomes a structured, although not exact, filling in of the spaces determined by the blue outlines.

You should aim to make the drawing flow easily, but touches of hesitation and uncertainty are desirable – do not look for exactness. Repeat parts of the drawing if you have to on top of the previous attempts and add richer strokes to accent the shapes as I have done so that you have a clear description of them within the drawing. This is what Cézanne did.

4 The subject must now be assessed in terms of colour and tone and, even more importantly, of surface shape. Each small area on the surface of each object has to be treated as a separate building block or jigsaw piece – as a distinct part of the whole – with its own approximate shape and size and a relative position and direction. To paint like Cézanne you must identify the surface planes and then simply colour them in.

You can see how I have started doing this: firstly, I chose, or mixed, a colour to represent a particular value that I could see. Then I looked for places where that colour and tone existed and asked myself what shape they were and whether they tilted towards me or away from me and by how much. The answer is always approximate so you have to paint an area of colour of about the right size and shape which you fill in with even parallel strokes from a flat brush. These should touch at the edges or overlap by a small amount.

The slope of the strokes is used crudely to represent the direction or relative angle of the plane and by changing direction from one small area to another the idea of a surface that is not flat is shown. This mannerism has been called Cézanne's 'constructivist' stroke *(below, right)*.

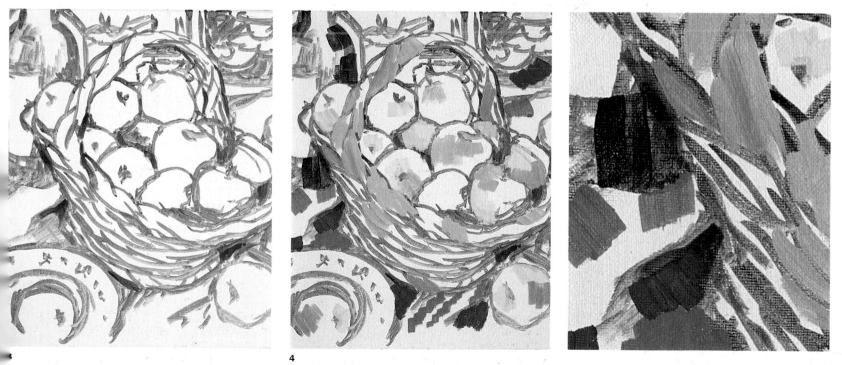

4

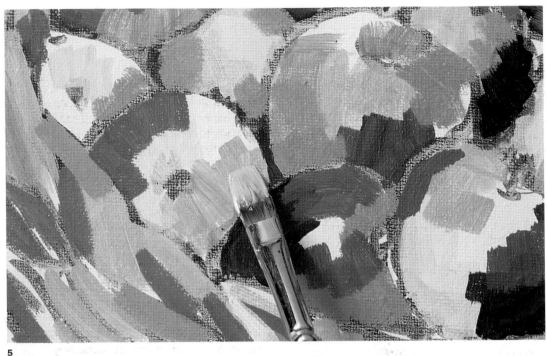

5 The rest of the painting continued in the same way. On the apples the patches of colour were smaller, the brushstrokes shorter and the variations of value and direction were carefully studied in order to express their roundness. I used the Red Lake transparently on the apples as Cézanne would have done. This means that you can often see the brush drawing through it as you can with one of the apples at the front of the basket.

6–7 The basket itself was painted mostly with single strokes representative of its weave that departed a little from the dominant stroke pattern: there are some gently curving strokes and some long ones here. This method still involves the intense study of nature, even though the pattern-like arrangements of brushstrokes may seemingly provide a simple formula for painting. As Cézanne put it: 'One has to look hard at one's model and feel it very accurately; and then express oneself distinctively and forcefully.'

As my painting began to take shape I went back over it several times looking for ever-smaller divisions of each surface to represent with different colours and tones – more time is spent studying the subject than painting. Pure White highlights were put in last of all.

Using modern acrylic paints has advantages because you can work wet on to dry very quickly and are not hampered by the wetness of the previous colour, but a hint of hard-edged sharpness, that you do not get with oil, enters the image. Since the brush shape and method of delivery – always a deliberate even stroke from the flat of the brush – allow limited accuracy, these successive representations of spacial planes tend to overlap so you eventually get a roughness and irregularity in the way they are joined together. This is pleasing and you should encourage it. It brings a softness to the finished work that the method otherwise lacks. Some of the final highlights were dragged on instead of being placed as firm strokes for this reason.

5

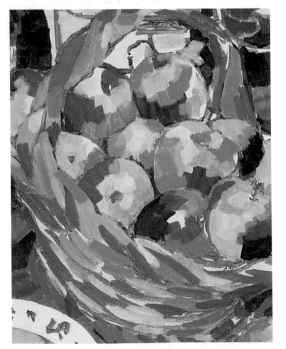

6

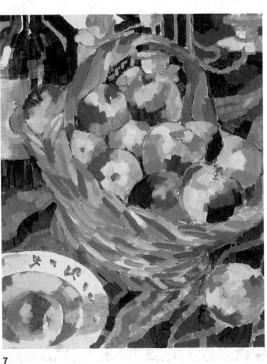

7

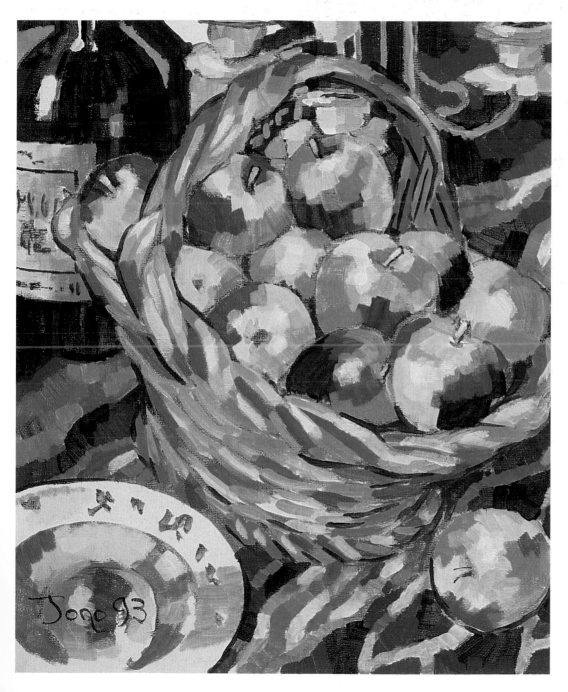

FINAL SESSION

Another cumulative effect of adding colour is the breaking up and suppression of the blue outline drawing that is being painted into. It is never intentionally painted out, but it is partially obliterated in many places as the colour is added in broad strokes. This softens the image, but means that definition is lost. As my painting reached completion, therefore, I restated parts of the drawing to accent the forms, again using French Ultramarine from the round brush just as Cézanne would have done. Without this accenting all the attention to shape and form can still produce an image that is surprisingly flat.

You may also notice that in my finished painting, parts of it are less finished than others: the foreground apples, especially the one on the left, for example. The plate it is on is barely painted either and is largely the cream ground of the canvas. You will find features like this in many of Cézanne's works.

Still life with plaster cast using the methods of Cézanne

MATERIALS

Support
Acrylic-primed sketching paper intended for use with acrylic paint, but also suitable for oil, re-primed cream with acrylic colours.
Size approx. 16" x 20" (40.6 cm x 50.8 cm).

Paint
Artists' quality oil colours.

Cadmium Yellow
Cobalt Blue
Flake White
French Ultramarine
Red Lake (Rose)
Viridian

Linseed oil and turpentine were used to thin the paint on the palette.

Brushes
Sizes 6 and 2 long flat bristle brushes were used to apply colour and a size 4 round in synthetic hair – in place of the sable brush that Cézanne might have drawn outlines with.

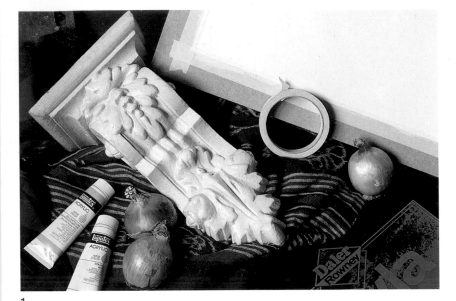

1

1 This painting is based on one of Cézanne's that shows a plaster cast of Cupid. For his, Cézanne used oil sketching paper prepared with a cream ground, but I chose an acrylic sketching paper instead because it could be altered easily and quickly. I taped the sketching paper to a board to prevent buckling and then brushed two thin coats of cream-coloured acrylic paint over it.

Next, I assembled similar subject matter – a piece of 19th-century decorative plaster, some onions and various objects from the studio, such as a canvas and an old drawing board for the background and a few other pieces including a small low table. Cézanne's still lifes invariably contain a set of solid objects, some of which will approximate to simple three-dimensional geometric shapes. Cézanne once said: 'Treat nature by the cylinder, the sphere, the cone, everything in proper perspective so that each side of an object or a plane is directed towards a central point.' It helps if you choose still-life objects whose shapes can be simplified easily – Cézanne's own still lifes are a good example to follow.

He seems to have been fascinated by shapes, spaces, solidity of forms and the ambiguity of what we see when relying on sight as the sole means of interpretation. He painted his personal view of reality, of nature, as it exists in three dimensions. In doing so, Cézanne also expressed, or perhaps simply recorded, the relationship between the artist, a human observer, and the still life – a collection of static inanimate objects that surround human existence.

Cézanne's method was to arrange the still life carefully beforehand, introducing contrasts and contradictions into the image. As he painted he examined the objects, not as a whole, or even as specific items, but simply as a series of spacial relationships between himself and points on their surfaces. I suppose he was trying to paint the impression of solidity by means of perceived measurements – he explained: 'I mean to say that in an orange, an apple, a bowl, a head, there is a culminating point; and this point is always – in spite of the tremendous effect of the light and shade and colourful sensations – the closest to our eye; the edges of the objects recede to a centre on our horizon.' Cézanne drew attention to the relationship between the artist and the subject by choosing to work from a position that exaggerated the effect of his own movements.

2

Two initial steps are essential in re-creating Cézanne's methods: firstly, you must select and arrange objects as he might have done – I will explain what I did in my account of the finished painting – and secondly, you must position yourself to paint in the same way. Cézanne put himself so close to his still-life subjects that he saw them in an unconventional way. Whether he did this intentionally or because of difficulties with his sight is a question that need not concern us, but it is an interesting point to consider.

This close, you may misjudge size, as well as shape – I unintentionally drew the plaster cast taller than it really was. Cézanne's position was probably similar to mine relative to his subject and easel as he also enlarged the cupid that he painted.

In order to repeat what I think Cézanne did, I put the plaster cast upright on the small table and set up my easel immediately next to it, so I stood looking down at it from about 2 ft (61 cm) away. The board with my paper on was upright on the easel right in front of me. My view of both was restricted.

2–3 I started as Cézanne did with a pencil drawing placed on to the cream ground. Then, when I was ready to paint, I repeated the drawing in Ultramarine oil colour thinned to a fluid consistency over the pencil lines. My outline drawing made sense, but already contained distortions because it was made up of separate

observations of its parts, each relating to my changing viewpoint and not to each other.

At this stage you must not stand back and look at either your subject or your drawing. The idea is not to see the objects as a whole, but to examine and then record them piece by piece. Your sense of perspective will keep shifting, since you have to alter your angle of view constantly in order to look at the objects properly – try to become aware of this and exaggerate the effects as you draw. My proof that Cézanne was doing the same is in a letter to his son: 'Here, on the river bank, motifs abound, the same subject seen from a different angle offers a subject of study of the most vital interest, and so varied I believe I could keep myself busy for months on end without changing my position, simply leaning now a little to the right, now a little to the left.'

3

4

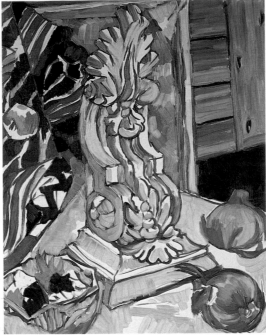

5

4 With the blue drawing still wet, I began to apply colours in groups of parallel strokes, representing by their direction, area and combined shape a single surface plane in each case – where the planes were curved my brushstrokes curved also, tracing out the shapes as if they were being touched. The colours were not applied in any particular order, but I did concentrate my initial efforts at the centre of the painting and worked outwards as the subject took shape. Cézanne seems to have done this occasionally.

The plaster cast was first worked on with tints of blue, green and yellow which all picked up blue from the drawing, giving the blue tints a streaky appearance and making the green into a grey-green and the yellow rather like Yellow Ochre. The warm cream you see here used on the onions is the same value that appears on the plaster cast, although it looks like Yellow Ochre or olive green because it has picked up the blue.

5 The same range of colours was also used on the table cloth, the bowl and the canvas propped up at the back. Pure Red Lake was placed in a few instances. Tints of purple were developed from Red Lake, Ultramarine and White, while values of yellow and orange were used on the onions, drawing board, canvas frame, chair edge and apple. Where these have become tainted by the blue drawing, values like Yellow Ochre and olive green have again resulted.

The details *(right and above, right)* show how the brushstrokes map out the surface planes of the objects and how the colours become tainted with blue as the still wet brush drawing is picked up. Notice also how the cream ground is being used – parts of it are yet to be painted over, but other sections are deliberately left exposed to represent a tonal value on a pale object. The cream ground is still effective in this way in the finished painting. Cézanne often used the same technique in his works.

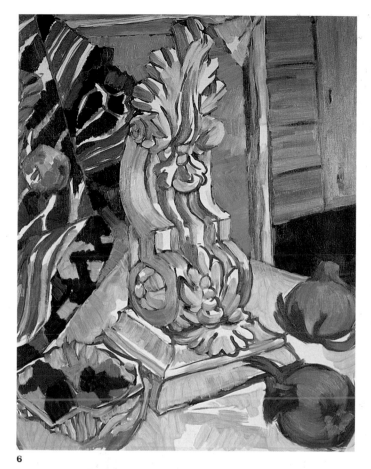

6

of paint; do not worry, therefore, if you have to rework any sections of your paintings when following his methods.

At about the same time I added a pale green tint to the painting, using it to break the monotony of the blues, particularly among the shadow tones on the plaster cast – Cézanne's colour schemes frequently involve relationships between 'cool' and 'warm' colours: grey, green, blue and white set against yellow, orange and red.

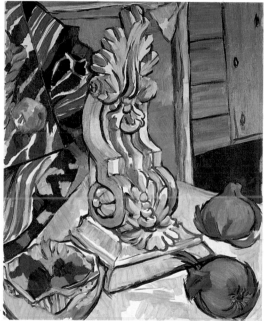

7

6 Cézanne painted slowly by all accounts, each brushstroke being carefully contemplated before it was placed. He seems to have had some difficulty identifying and describing the subjects' surfaces, although you should find it relatively easy – once you have understood the concept.

I continued here by adding more colours and strengthening ones I had already applied, always using strokes that described or re-affirmed the shape of the object. I also decided at this stage that I did not like the way I had painted the back of the canvas behind the plaster cast or the strength of colour I had used on the drawing board, so they were reworked with tints of blue. Cézanne did not always achieve what he intended in a single covering

7 By now the blue drawing had been partially painted out in many places and elsewhere its defining power was diminished by the relative strength of the surrounding colours. It was redrawn, again in French Ultramarine, not everywhere, but only where I felt the need to accent and redefine shapes. Cézanne may have lost and redrawn contours several times over in the course of some paintings and you may have to do the same, depending on how easily you arrive at a satisfactory image.

Cézanne's colours

Cézanne was arguably not a good colourist and he seems to have admitted as much when he said: 'With a small temperament one can be very much of a painter, one can do good things without being very much of a harmonist or a colourist. It is sufficient to have a sense of art.' There is, however, another probable reason for the quality of his colour. Faithfully following Cézanne's technique here, I worked in oil colour adding extra oil as a medium while I painted. His use of oil makes the paint look thin and fluid, but also rich with a low gloss. The oil keeps the paint wet so brushstrokes mingle where they touch, or overlap; his colours are frequently tainted with one another, or with blue from the drawing as a result; and there is often an underlying tone that seems to suppress the colouring. Cézanne's works may have yellowed and darkened because of over-generous additions of oil.

During painting, I added oil and turpentine to my colours from a double dipper, putting my brush into the linseed oil and then into the turpentine (right). I was deliberately casual and haphazard about it, going by the consistency of the paint, not by exact or consistent measurements. My additions were on average two or three parts of turpentine to one part of oil, but may have reached one to one. The paint was fluid but never runny – this is not good practice, but it provokes the right effects. There is already a slight darkening of the finished painting.

8 Pure White was added almost at the end to highlight the plaster cast, table cloth and canvas turnover, and in places to break the redefined drawing again – you do not want the outlines to be too exact. It was also used to paint in the white stripes on the purple cloth which were represented in shadow with a tint of Cobalt Blue. Finally, I applied green to add the onion shoot and to complete the pattern on the chair.

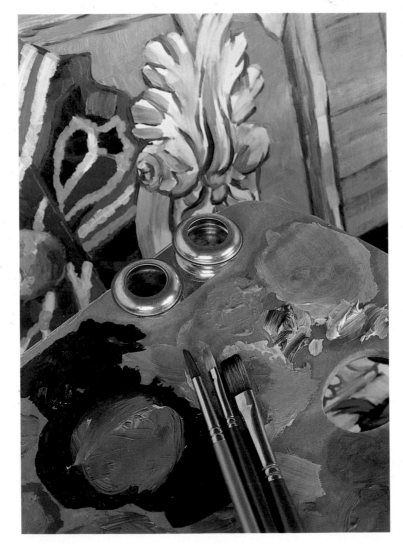

Cézanne's ideas

Now, I must explain this painting in another way as it uses imagery and ideas taken from Cézanne's work that could be considered to be as much a part of his methods as the way he applies paint. Beginning with the onion in the foreground, notice that the base line of the plaster cast crosses the shoot and was reemphasized like this when the contour was redrawn. The shoot was painted green, with the colour taken up to this line, but not across it; it also curves like the base of the cast and does not extend beyond the contours of that part of the base – it is just possible that this is not the shoot of an onion at all, it could be a mark on the plaster cast or even a chip out of it. The spacial relationships and meaning have deliberately had an element of doubt introduced into them.

If you look at the painting as a whole and consider how the subject matter has been chosen and arranged you will see that I sought out contrasting shapes and characteristics among the subject materials as I arranged them: the board, canvas and table top are flat and angular, but the onions are very round and solid-looking. The cloth draped over the chair at the edge of the painting on the left is made up of irregular curves. To contrast with it, I have placed my previous painting *Still life with a basket of apples* (p. 96) on top of it. This depicts the same cloth, but here it appears on a canvas that is itself flat and angular.

Neither these objects nor the chair are shown completely within the painting to make instant recognition of them difficult. To heighten the ambiguity some of the white stripes on the cloth and the canvas are aligned and one of them has been painted, without interruption, from one to the other.

The apple on the canvas is on a painting and is therefore flat, but it looks just as solid as the onions, so its status, too, is ambiguous – it has been placed on a painting within a painting that is concerned with three-dimensional qualities, but is itself flat. The plaster cast is the most

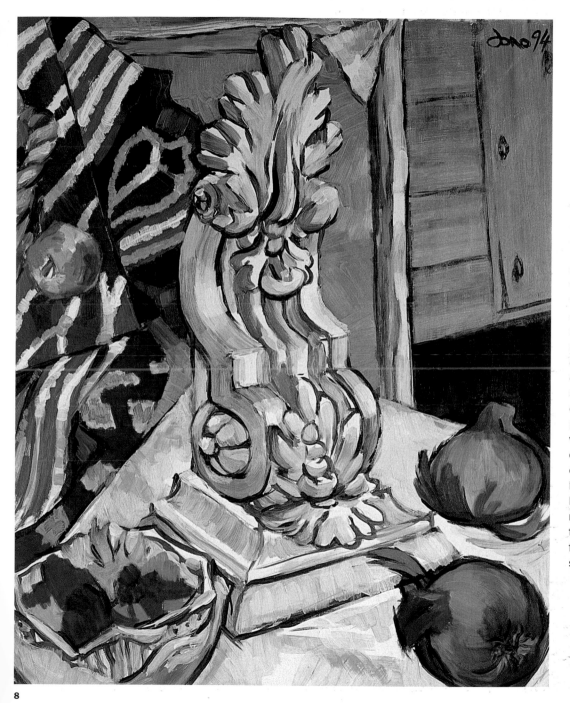

complex of all – it has curves and straight edges, angles and irregular details. It is obviously very solid but is visually full of contradictions, as the rest of the painting points out – the loose edge of canvas behind it and the cloth on the chair to the left signal softness through curves and irregularity, while the drawing board propped up at the back and the table top beneath it imply something hard and unyielding because of their straight contours and definite angles.

The plaster cast is both visually soft and physically hard, as is the decorative bowl next to it, which has a combination of curved and straight contours, sharp angles, blunt forms and both regular and irregular details.

Arguably, when taken to these extremes, Cézanne's methods are about trying to paint the essential substance of things – their fundamental nature as revealed through three-dimensional form – through the structure that underlies the colour and tone of a merely superficial impression. Cézanne seems to confirm this when he says: 'All that we see dissipates, moves on. Nature is always the same, but nothing of her remains, nothing of what appears before us. Our art must provide some fleeting sense of her permanence, with the essence, the appearance of her changeability. It must give us an awareness of her eternal qualities. What lies below her? Nothing, perhaps. Perhaps everything. Everything, do you see? And so I join her roaming hands.' You can deliberately attempt to create such images if you want, but if you follow the basics of Cézanne's methods, some of these things will happen anyway.

Still life with *peonies* using the methods of Manet

MATERIALS

Canvas

A standard stretched cotton canvas with a white acrylic ground, re-primed a very pale cream with acrylic colours. The mix contained much more white than usual, giving a cream that could almost be described as off-white. Size approx. 12" x 16" (30.5 cm x 40.6 cm).

Paint

Artists' quality oil colours.

Cadmium Yellow
Lamp Black
Phthalocyanine Green
Red Lake (Deep)
Red Lake (Rose)
Red Ochre
Titanium White
Viridian

I used two palettes, one exclusively for painting the peonies' heads, on which were put the two Red Lakes – one much darker than the other.

Brushes

Two size 6 long flat bristle brushes and one size 4 and two size 2 round bristle brushes. A long-bladed, flexible, crank-handled palette knife was also used.

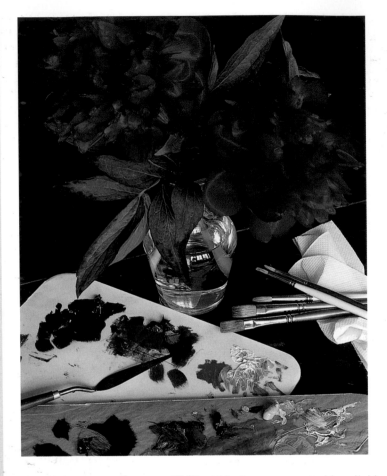

Manet chose peonies as a still-life subject, so I was tempted to do the same when they came into flower. This gave me an opportunity to illustrate Manet's direct technique, including his use of the palette knife.

Manet's method assumes that everything can be painted in a brief and clever way, but painting *alla prima* – at one go – in a single covering of colour is not always the easiest or the best way of painting. Without altering the immediacy of this technique you have to vary it to accommodate your subject and unfortunately the technical choices are limited.

The problem here is the colour of the peonies – they are a dark reddish pink with strong accents of shadow and a few silky highlights. I decided that opaque pink tints would probably not work because they lack the depth of colour and the strength of contrast needed. A pure Red Lake used thinly over a pale ground seemed a better starting-point if they were to be painted *alla prima*.

For that reason, I chose a very light cream canvas. White and off-white primings were used by Manet as well as pale grey. On grey, pure Red Lake would have resulted in a purplish black, whereas on a near-white ground I could paint the divisions of light and shade that Manet typically focused on without adding White to the colour.

1 I started with a rose-coloured Red Lake – a pinkish red quinacridone pigment – brushed out thinly with a size 6 long flat to determine the shapes of the two peony heads. The one

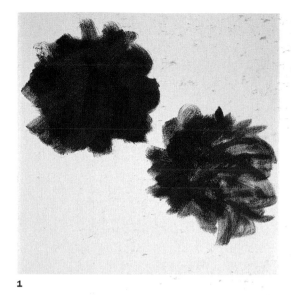

1

on the left was seen full face and so was painted as a coloured silhouette, while the one on the right was seen more at an angle so I instinctively used brushstrokes that imitated the shapes and directions of the petals.

2 The paint was used at tube consistency, but was of a good quality and could be easily manipulated. Even so you can only achieve a certain thinness with a brush – Manet was aware that a palette knife could go further. He perhaps discovered this when scraping off unsuccessful parts of his paintings, although he sometimes also worked paint with a knife in an underlying *ébauche*, suggesting that he was fully aware of its potential. In any event scraping down is part of Manet's technique – he used the exceptionally thin layer of colour left by the knife, smooth and blurred, as a foundation to work into.

Straight after putting the Red Lake on I scraped off all that was removable with the edge of my painting knife. This left the trace of colour that you can see at the centre of the flower, peppered with pale dots. The dots are the raised threads of the canvas, showing the cream ground.

Then I took up the brush again and, without putting any more paint on to it, painted into the film of colour with sweeping strokes that loosely corresponded to the way the petals radiated out from the very centre of the flower. This manipulation of the thin covering of colour gave me the effect you see on the right and the left of the knife mark – streaky brushmarks scoring through almost to the ground, suggestive of the delicate surface texture of the petals.

My use of a pale cream ground gave me an unexpected result at this point. I had chosen it simply because tints are easier than white to work on, especially the stark white of a modern acrylic ground. Spread this thinly over it, the pinkish Red Lake took on a decidedly more reddish hue because of the tiny amount of yellow in the priming visible through it. The real peonies also had a rather indefinite colouring with hints of red among the definite pink, so I was quite pleased to accept these unpremeditated consequences.

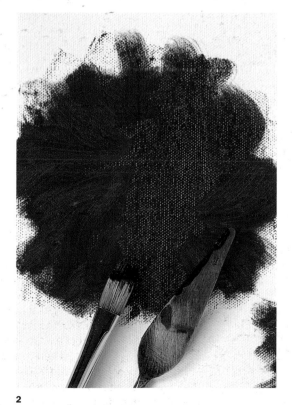

2

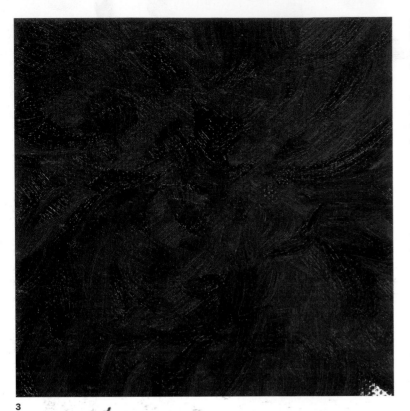

3

paint on the brush and are a streaky blend of the two colours. They were made with twists, sweeps and flicks of the brush, off its corner or edge, or with it half turned towards the flat face.

4 The second peony head was not developed until it was clear that the first one was starting to work. There is always the risk with this method that the choices you make instinctively may not be successful. The second peony head required a less concentrated effort.

5 You may need to add highlights as well as shadow. The peony petals had a glossy finish that picked up the light so that had to be depicted to make them look solid and to capture their appearance adequately. The only way to do this was to put White or pink into the wet Red Lake.

Once a transparent colour becomes opaque it changes totally. I had to think carefully about where to put the highlights and to look constantly at the subject through half-closed eyes, to reduce it to its essentials. Cautiously I applied pure White from a size 2 round, reducing it to pink in places by stroking it through the Red Lake.

3 In some ways Manet's method was traditional – he used strong accents of shadow to define shapes and forms. His still lifes were immediate impressions taken from real-life subjects, but not literal impressions of nature. He worked in a studio setting with classic directional lighting. I painted in a room lit by one window, so the peonies were well lit from one direction. This gave strong shadows among the complex petal arrangements of their heads which I painted next.

My brushstrokes are shown approximately life size. With a clean size 6 long flat I used a darker Red Lake – a deep reddish purple quinacridone violet – to place shadow strokes into the first Red Lake. They suggest different intensities of shadow and reverse out from the lighter Red Lake base the vague shapes of petals. The darkest strokes, like the ones at the centre and to the left of it, are thicker, but even they are graduated by being drawn through the first Red Lake. The paler strokes were placed with little

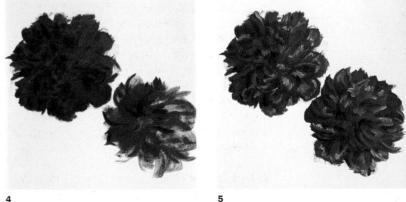

4 5

The portrayal of these peonies could have been more convincing – although less typical of Manet – if I had worked on them further. But, the principle of spontaneous *alla prima* painting is not to go too far. Do not risk losing what you have done already and know when to err on the side of caution.

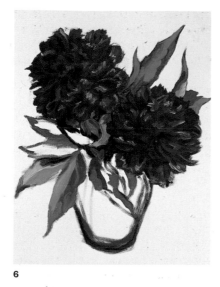

6

The background uses Black and grey with a little Red Ochre and Red Lake worked into the Black at the bottom to give just a hint of the dark wood surface that the vase is standing on. The pale grey reflection at the bottom left implies it is polished and confirms that the surface is there. Without these touches, the vase would appear to float in space.

I was tempted to go back to this painting once it was dry and rework it, but then I would not have been following Manet's methods. The bravado of the painting as it stood was, in fact, more typical of Manet than a cautiously approached finer finish would have been.

6 With pink still on the brush, I drew in the peony leaves and the glass vase and immediately began working on top of this brush drawing with mixed values of green. As you may realize, there was no preliminary drawing for this painting – it was developed as it was painted and only at this stage was the whole composition accounted for. This has resulted, understandably, in a slight imbalance in the finished painting, with the vase a little off centre and too much empty space in the top right of the canvas. This is to be expected when working in Manet's technique as the perfection of the brushwork and its real or apparent spontaneity is the predominant aim. The success of other aspects of the painting is often sacrificed as a result.

7 I did not use Black in the darkest parts of the leaves, but Manet probably would have done. I started initially with tones placed next to tones, as you can see, and completed them with a few slick strokes over the top. The vase was painted in a similar fashion, using shades of grey almost exclusively; these were casually brought together and then worked into with Black and White. Heavy White highlights placed with deft strokes into and over the wet paint completed the effect.

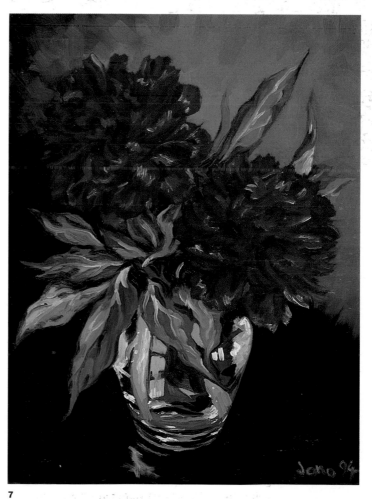

7

2

2.3 STILL LIFE

Still life with carnations in a vase with a ribbon using the methods of Manet

1

MATERIALS

Canvas
A standard cotton canvas with a white acrylic ground primed a pale grey using artists' acrylic colours. Size 16" x 20" (40.6 cm x 50.8 cm).

Paint
Artists' quality oil colours.

Burnt Umber
Cobalt Blue
Lamp Black
Phthalocyanine Green
Raw Umber
Red Lake (Rose)
Titanium White
Yellow Ochre

Black, White and earth colours dominate this selection. A dipper of painting medium was on the palette, but was barely needed.

Brushes
Sizes 2, 4 and 6 long flat bristle brushes. A palette knife was also to hand although it was not actually used. It is a piece of equipment that Manet often employed as I also have in *Still life with peonies* (p. 106).

Manet's most important paintings were planned and practised performances but his still lifes were more genuinely spontaneous. That is why I have chosen a still life to show the most vital part of his method, his use of paint. Manet worked instinctively, but within quite narrow technical boundaries. So it is possible to re-create his technique by doing similar things – painting spontaneously according to the same set of rules.

These appear to be: reach the finished effect by the most direct route possible; rely totally on the suggestive power of the skilful brushstroke; and use the clever manipulation of wet paint at every stage. Finally, if you do not succeed by these means, start again.

Manet's method obviously depended on intuitive and accumulated skill, but you can acquire some of this through experience. His technique was based on simple, direct painting done in a single layer taken gradually across the whole of the canvas, but its appearance is deceptive. Manet's motive for painting this way was to impress his audience with what seems to be a dazzling demonstration of his ability.

1 I chose a vase of pink and white carnations as my subject and started, as I am sure Manet might have done, by making a brief positioning sketch on the pale grey ground with a few sweeping strokes of a Conté crayon. This gives you a rough idea of what to paint where and prevents major compositional errors. You can see how minimal this sketch was by looking at the full view of the canvas shown later on.

2 My painterly instincts suggested that it might work if I started painting with patches of White at the visual centre of the painting – so I took a chance. I chose a pale grey ground – firstly, because it seemed plausible that Manet would have done the same, and secondly, because I could paint the white carnations against it and instantly see them defined which would not have been possible on a white ground.

My initial patches of White paint represented the basic silhouettes of the three carnations at the centre of the arrangement. They formed a group that I could paint to completion together. Studying the real flowers carefully I saw that I must model with subtle shadow. I also observed that reflections within the white petals and perhaps also their translucency produced a slight colour cast to the shadows and towards the centre of each flower a yellowish tint was apparent.

3 My first touches of colour into the wet White paint reflected these observations. A brushstroke made into wet oil paint is softened by the action of the stroke which partially mixes the colour on the brush and the colour on the canvas. The tone of the colour being placed alters too, especially working into White like this. The added tones were mixed as a pale grey, a greenish grey and a brownish cream. Their exact values did not matter, provided they were fairly close to what I wanted, since they would be blended out by being applied into the wet White foundation.

If you half close your eyes the detail is eliminated and you can see a broad summary of the light and shade, and colour. I used this method to decide how to place my strokes. They were put on tentatively at first, but with a confident light touch. You must place the stroke once and leave it – if you attempt to rework it everything could be lost. This does not mean, though, that you cannot put a stroke on top of a stroke. You may notice at the centre of the carnation at the bottom left that some brief strokes of dark grey sit on top of cream ones. These were done sensitively with the merest touches from a brush loaded with grey against the wet surface of the cream. You may need to wipe off and reload the brush between making strokes of this kind because it will pick up some of the lower colour each time.

4 I had to keep working since the carnations were not yet recognizable. Looking at the real flowers suggested how I could imply more detail by adding subtle modulations of shadow and bright White highlights where the edges or folds of some petals caught the light. I tried this first on the carnation at the bottom right. Intermixing the shadow tones I had started with and making them deeper or paler than before gave me the variety I needed and a few carefully judged strokes gave me the effects.

All of this was done with size 2 long flats, but they had to be manipulated – the straight edge or corner of the brush was used sometimes or a movement was made during the stroke that took it, for example, from the corner to the edge and then a little towards the flat of the brush and back again. This is easy when you know how and in theory anyone can learn to handle a brush in such an expert manner.

A clean brush heavily loaded with sticky White paint was used for the White highlighting on the petal edges. Here and there a flick of White was used to suggest the jagged edges of the carnation petals, but mostly the highlights were put down boldly with brief brushstrokes that placed a generous deposit of White on to the wet paint beneath them.

5 Any of the moves I had made so far could have been wrong choices – nothing is certain when using this method. I did not paint the other two carnations in the group to completion until I had finished the first so that I had the experience of painting the first one to guide me. If things had not turned out well I could have scraped off the bottom right-hand flower with my palette knife and started over again, without losing what had already been achieved on the other two. After about 20 minutes or half an hour, this group of carnations was complete and would not be touched again at all.

For you to achieve a similar effect that quickly might be difficult at first, but with practice a spontaneous flow should develop.

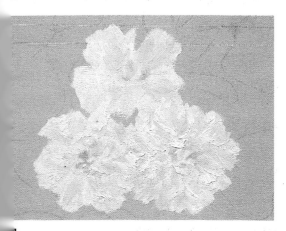

2

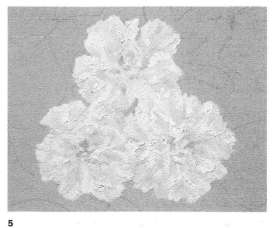

3

4

5

Manet's paint

Only White, Yellow Ochre, Black and Green were on the palette to begin with (below). You can see the consistency of the Titanium White being used – thick, sticky and fluid, making it very easy to manipulate with the brush and rich – likely to dry with rather more gloss than usual. This was a special White that I prepared myself modelled on qualities I had noticed in Manet's paintings. It had a very high pigment to oil ratio and also contained a small amount of stand oil.

Manet could afford good paints and probably used hand ground colours from a specialist colourman – perhaps even made to order. They would have been thick, but fluid, like mine. The consistency of the paint is important when re-creating Manet's methods. He aimed for brilliant direct handling – a showy performance sometimes at the expense of other aspects

of the painting – and you must have paint that responds well if you are going to achieve that.

As a failsafe I also had a dipper of medium – a mix of turpentine and stand oil – to add if needed. You may have to use a rich medium more if your oil colours are less easy to manipulate. Use it sparingly – to increase the paint's fluidity without thinning it appreciably.

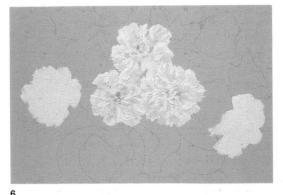

6

7

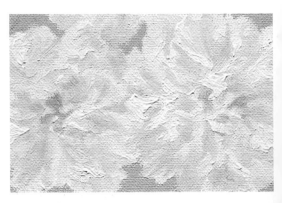

6–7 Confident now that I knew how to paint the white carnations, I used the same method for the two carnations at the sides – I placed patches of White roughly corresponding to the silhouettes of the flowers and then worked on them as before. All the white carnations were now complete, but nothing else had been painted. In the close-ups (below) you can follow the pattern of my brushstrokes clearly to see how they were made – you can study the variations of colour and tone among the shading as well and how the thicker highlights sit on top of the lower wet paint.

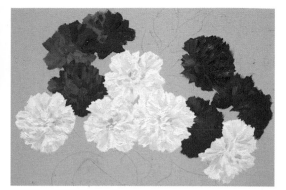

8

8 The pink carnations posed another problem. Looking at them I could only see different tonal values of strong pink which I thought should be represented with tints of Red Lake and White. Instead of placing a flat patch of pink I roughly modelled the flowers with brushstrokes of various values to begin with and then added touches of White and pure Red Lake into these pinks in an attempt to suggest definition and form with highlights and shadow accents.

9 I was far less successful at painting the pink carnations than the white ones. Part of the problem was the presence of white in the pinks I had started with, which prevented me from obtaining a deep enough shadow tone when pure Red Lake was added. I could have started again, putting the shadow accents in first straight on to the ground, and then adding the mid-tones and highlights over them, never letting White into the deepest shadows. Manet might have scraped the pink carnations off with a palette knife and begun again, keeping the white ones, but any remaining trace of pink would still have caused trouble and I decided to accept the pink carnations as they were. Such decisions are arbitrary.

This confirms the point that Manet's methods are too narrow to work perfectly. You simply cannot paint everything to perfection so directly. It would be easy enough to improve the pink carnations by adding overpainting to parts of them when they were dry, but that is not what Manet did. Spontaneous painting was the painting of genius in his eyes and he either did not recognize its deficiencies or accepted its limitations. Indeed, some inconsistency of quality is not unusual in Manet's paintings – the end result being carried by those parts that have turned out really well.

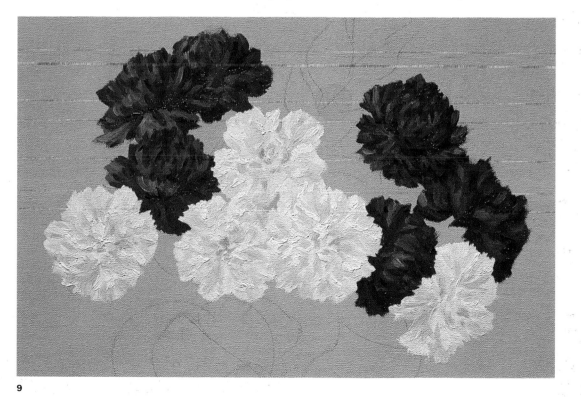

9

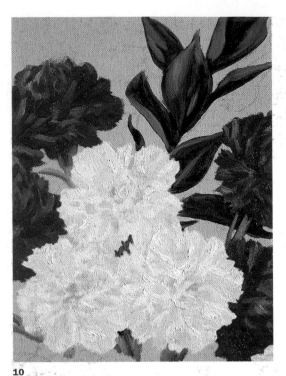

10

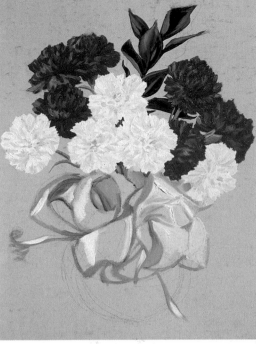

11

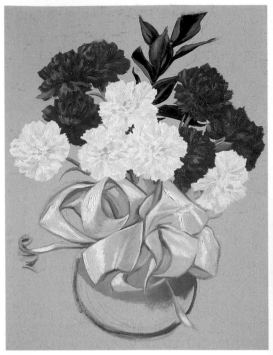

12

10 It seemed best to continue with the painting as it was – I added the spray of dark green leaves next. Manet used Black quite freely and here I have added it to Phthalocyanine Green to get the deep tone with which the leaves were drawn. Tints of green and White and Yellow Ochre have then been brushed into the wet drawing.

11 Initially, the florist's ribbon was worked out of the grey ground, first drawing it with a deep blue-grey and then adding pure White highlights using the pale grey ground for the mid-tones in between. This quickly gave a good impression of the ribbon. It was completed with tints of pale blue and blue-grey placed next to each other and teased together at the edges with the brush. Finally, a few finishing strokes and heavy pure White highlights were added to give the ribbon a silky look.

The finished painting shows the ribbon clearly. It was really an exercise in tonal relationships

with the odd dashing brushstroke completing the effect. The loop on the left shows how important good highlighting is. A streak of White along the top of the ribbon reveals how the edge catches the light, while the zigzag stroke taken downwards through its highlight expresses the silky sheen on its surface.

12 The vase was brush drawn as before and coloured in quickly with tints of pink and blue-grey. Yellow Ochre was used for its gold decoration, placed straight into the wet paint using the corner of a long flat brush to get the narrow stroke. Some of you might be more comfortable switching to a small round bristle brush for a detail such as this. If I had misplaced any of the Yellow Ochre strokes, the wet base colour would have become tainted and I would have had to scrape the vase down and repaint it. Bold White highlights straight into the wet colours beneath them completed the vase by indicating

its highly reflective glaze. This can be seen on the left of the vase in the finished painting.

13 The background started with a mix of Raw Umber and White, which gives a colour-tinted grey. It was taken around the flowers with a size 2 long flat cutting into their edges with small strokes, making them toothed and instantly recognizable as carnations. All the paint was still wet, of course, so every stroke had to be certain and made just once. When you take the edge of one wet colour into another like this, you can push the first one out of the way and there is no intermixing. You may have to wipe off the brush from time to time, but with dark or dull coloured backgrounds you can easily lose picked-up traces of colour by working them in.

14 Pure Burnt Umber finished off the background. It was taken around the patch done in Raw Umber and White and then with

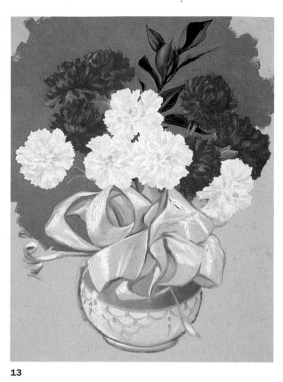

13

the same brush the two background colours were worked together to give a patchy graduated tone. The result is a crude imitation of the sort of background that appears in the Dutch and Spanish paintings that Manet admired and that inspired him to paint.

The last touches were made with the same brush still carrying traces of the lighter part of the background. A few light strokes placed into the wet Burnt Umber imply reflections on a dark polished surface that the flower arrangement appears to be standing on. These reflections are just above the signature, immediately beneath the vase towards the left and directly under the decorative twist of ribbon. As you probably realize, the whole painting is still wet at this stage. As it dries there may be a slight loss of contrast and perhaps a deadening of the colour. These effects are quite likely to be beneficial.

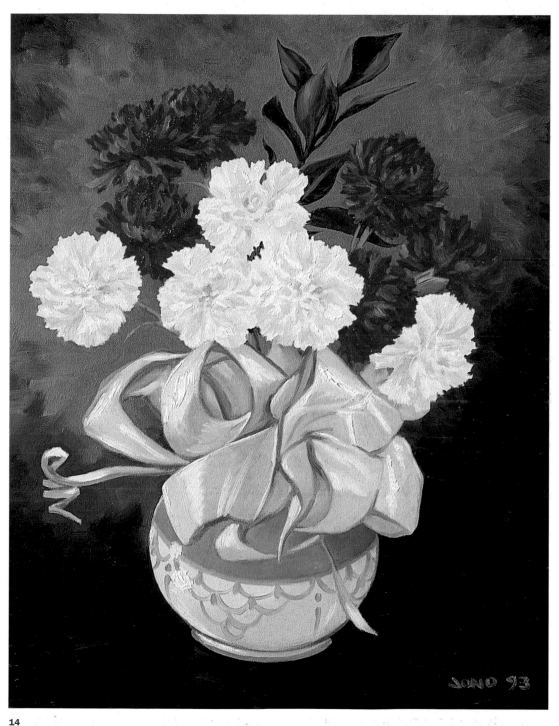

14

2.3 STILL LIFE

Still life with yellow flowers using the methods of Van Gogh

MATERIALS

Canvas
A standard commercially primed canvas, chosen specifically for its coarse grain as some of Van Gogh's paintings are on rough cloth. This one was linen with a white acrylic priming that I re-primed a warm grey. Size 18" x 22" (46 cm x 56 cm).

Paint
Artists' quality oil colours selected for their authenticity in this context.

Chrome Green
Chrome Lemon
Chrome Orange
Chrome Yellow
Flake White
French Ultramarine
Red Lake (Deep)

Brushes
Sizes 2, 4 and 6 rounds and a size 6 long flat in bristle.

1

This painting is obviously based on Van Gogh's *Sunflower* series. I wanted to use the genuine chrome pigments here because that wonderful mellowness of the original paintings is probably due to them. Chrome Yellows have a reputation for becoming duller as they age, suggesting that Van Gogh's paintings were originally brighter, perhaps like mine is now. It should, in theory, acquire a more subtle appearance as it matures.

The thick creamy texture of the chromes straight from their tubes and of good Flake White also contributes to this technique as does the fact that they are all fast, thorough driers in oil. You can do a painting like this with other more modern colours, but it is not quite the same experience or as convenient.

1 This work, like all my demonstrations, was based on research that included the study of original examples. I chose a warm grey priming as Van Gogh appears to have used a dirty grey-brown canvas in one of his paintings. To create something similar I applied a tint of Raw Umber and White acrylic paint thinly and evenly in two coats with a large brush.

Van Gogh probably chose whichever primings were cheap rather than considering their relative technical merits: cream, off-white and white are all in evidence and I am sure that one of his paintings is on a pink ground. He also used raw unprimed cloth, so I cannot say that my choice was typical, but it seems to have worked very well.

2 Sunflowers were out of season when I did my painting, so I used these similar-looking large yellow flowers. You may notice that their arrangement in the vase is exactly what has been depicted, though I made it more compact to fit the canvas.

I started with a light, freely done sketch in charcoal because it made sense to have a rough outline to work to. I can only speculate that Van Gogh might have done the same. It helps you to

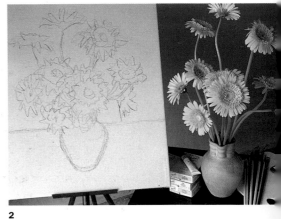

2

work quickly if you start this way and speed was certainly a feature of Van Gogh's technique.

A letter to his brother, Théo, gives some idea of how he might have proceeded – he refers to the *Sunflower* series saying: 'I am working at it every morning from sunrise, for the flowers fade so soon, and the thing is to do the whole at one go.' However, he refers to three canvases being in hand and expresses the hope that a particular one will turn out the best. This suggests they were not actually completed when the letter was written and may not have been done at a single session.

A continuous start-to-finish process of session after session seems more likely in the light of my experience of doing this example. My painting took longer than I expected, but the first stroke was probably still wet when the last stroke was put on. Thick, wet oil colour has to be placed more carefully and therefore more slowly than you might imagine.

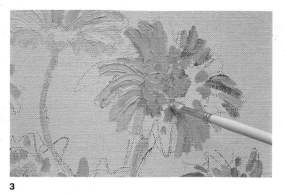

3

4 To begin with you will only be able to get a certain amount of paint on to the canvas, even with a very heavily laden brush. Do not be tempted to use a larger brush, but keep on adding stroke after stroke of the same size.

Put them next to each other at first, gradually filling in the open spaces and then go back, placing new strokes on top of the original ones where you think appropriate. Continue with a heavily loaded brush, adding colour upon colour; and always make the stroke express its subject – for example, a long petal with a long stroke, as before.

3 I started painting at the centre of each flower, putting dabs of yellow and green, in tint, into each other and Red Lake into orange and yellow, depending on the flower type *(above, left)*.

Then I began to paint the petals, working outwards from the middle, with brilliant yellows, placing brushstrokes that physically imitated the radiating petals. Around the centre they are short and slightly curved, but they become long, even strokes for the outer petals. I have made these flowing, not straight like the real petals, in response to the feel of the paint – enjoy using such heavy colour and do what comes naturally.

5–6 You can see here how my painting gradually developed as I worked on all the flowers at once. I was constantly looking for variations of colour within the theme of yellow, but I did not have to separate one tone clearly from another as the scored-through texture of the brushstrokes and their raised edges provided a physical separation. In other words you can place identical values next to each other, relying on the brushmark to identify them as something different. They eventually became like low relief sculptures in paint. For the jug I used shorter, rougher strokes from a dryer brush.

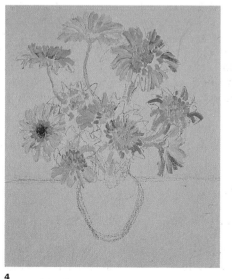

4

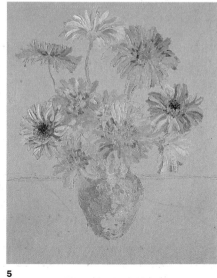

5

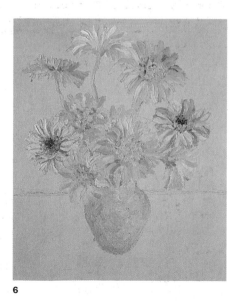

6

A feeling for colour

Van Gogh's passion for colour and his emotional involvement with his paintings are elements of his technique that you must attempt to adopt if you are to paint in his manner. He painted his Sunflower series when he was pleased at the prospect of Gauguin coming to stay and he chose the motif because of a pleasant memory of a sunflower in a restaurant window, so these bright, joyful paintings are an expression of a state of mind that is being projected by the artist. They are not

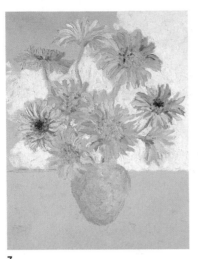
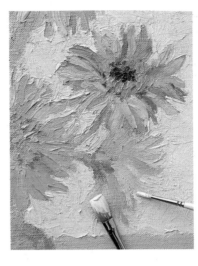
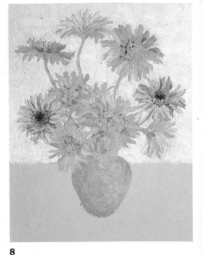

7

8

simply perceived impressions of nature.

The colour, too, expresses his emotional state. In his letters he speaks of 'arbitrary colours' and constantly describes the colours he has used or is going to use in a painting. With reference to the Sunflowers, he wrote: 'Now to get up heat enough to melt that gold, those flower-tones, it isn't any old person who can do it, it needs the force and concentration of a single individual whole and entire.'

Almost all the activity on my palette (above) has concentrated on the use of yellow in an attempt to follow this principle.

7 The background was painted with a pale tint of creamy yellow containing a lot of White as shown in the detail (above, centre). It has subtle modulations of colour – the result of inconsistent mixing and of picking up traces of the flower colours as the background was edged around them. As far as possible this was put on with a long flat bristle brush that covered broadly, but a small round had to be used as well to get around all the intricacies of the flowers.

Some of you may find it easier to put the background in first, taking it up to a coloured outline of the subject before it is painted in, but I do not think Van Gogh would have worked this way – it is too premeditated. In one of his Sunflower paintings an extra flower has been added on top of the background while it was still wet, but this was probably a late addition to balance the composition.

8 What you do often find in the backgrounds of Van Gogh's paintings, and I have repeated it here, is a criss-cross pattern of vertical and horizontal strokes from a fairly large flat brush. This creates a weave-like texture and adds interest to an otherwise plain background, but it also helps to disguise any unevenness in the colouring. This was easiest to do after the colour

was on, working gently over the surface of the heavily painted background with almost no paint on the brush.

9 The flowers were standing on a little wooden table that you can see in the photograph of the palette (left). I translated its grain into the pattern of directional strokes that were added next. These are in a tint of orange and White, plain orange, yellowish green-grey and pure Red Lake.

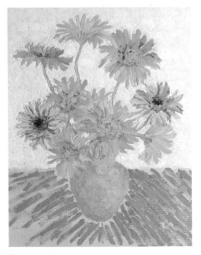

9

10 . The table was completed with a heavy build up of paint adding to the textural effects on the canvas *(below)*. The highlights on the jug are painted in pale blue – a tint of Ultramarine and White. A few touches of pale blue were also added to the flower stems. Van Gogh's *Sunflowers* were, in his own words, to be a 'symphony in yellow and blue', so I felt I had to introduce blue somewhere. Next, I did as Van Gogh sometimes did – I repainted contours, bridging the gap between the subject and background or accenting the painting where definition was lacking.

If you compare the finished painting with the previous stage, you should be able to detect some drawing from the point of a round brush – in orange on the flower heads and Chrome Green and Ultramarine on their stems. Finally, pure Ultramarine was used to draw around the jug; define the stems at its mouth; separate the two planes of the background; and sign the painting. This is typical of Van Gogh, except that I think I have used the wrong blue – Cobalt, Cerulean or a mid-tint of Ultramarine would have been better, as pure Ultramarine looks almost Black.

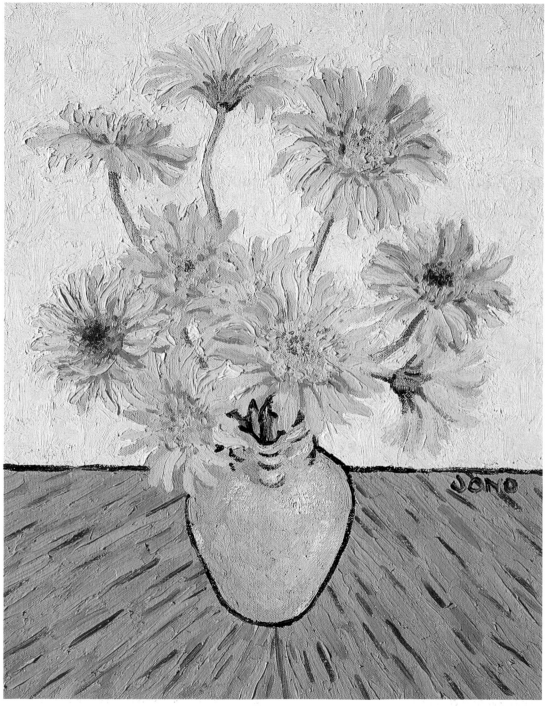

10

2.4 FIGURES

Girl having her hair brushed using the methods of Degas

MATERIALS

Support
Cream-coloured, 140lbs, 300gsm, watercolour paper coated with glue size. Size just under 22" x 19" (approx. 56 cm x 49 cm).

Paint
Artists' quality oil colours thinned with turpentine on a glass palette.

Cobalt Blue
Lamp Black
Red Lake (Deep)
Red Ochre
Titanium White
Viridian
Yellow Ochre

Brushes
Small and modestly sized long flat and round brushes mostly in bristle between sizes 2 and 6, but predominantly size 2.

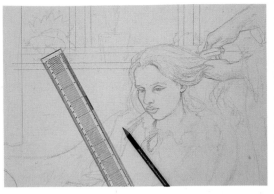

1

2

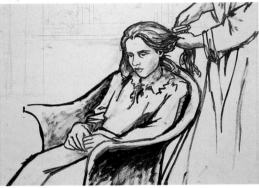

3

Works in Degas's manner must always evolve from drawings. If you are not good at drawing, you might like to consider using reference photographs as a starting-point – Degas, himself, may have done this occasionally – but do try to develop your drawing skills. They are not only fundamental to Degas's methods, but are involved in every technique shown in this book. The idea that drawing and painting are entirely separate activities is nonsense – it is just that sometimes you draw as you paint.

1 Paper should be sized to prevent oil from penetrating its fibres if it is to be painted on with oil colours. This keeps the paint workable, but more importantly prevents the paper from being degraded. The tinted watercolour paper was taped to a board and then coated with glue size – a solution of hide glue in water that is used in the preparation of canvas. You could also use gelatine, which is a purer form of it, traditionally used to size papers. I applied it at the normal strength for canvas, approximately 70gsm to a litre, which roughly equates to one measure of dry glue to fifteen measures of water. On paper you might reduce this to 1:20, but it should not be stronger than 1:15. The size has to dry before you can work over it.

2 I started with a pencil sketch straight on to the sized paper, done from life, that I used to guide the black brush drawing that followed. I also used pencil with a ruler to draw in the dead straight horizontal and vertical lines of the window. Degas probably would have done the same – exact guidelines are sometimes visible in his drawings, although he does not work to them precisely.

3 Degas thinned his oil paint significantly for use on paper, probably with turpentine, so I did the same here. The paint used for the drawing was reduced to a wash-like state, but its blackness was maintained. Because turpentine evaporates quickly the black drawing soon became static, though not actually dry, allowing the colours applied next to be dragged over it in places with a minimum amount of disturbance or discolouration.

4 Next, the effect of light streaming through the window behind the figure was represented by emphasizing the distinctive highlight that

occurred along one edge of the girl's face. Degas sometimes modelled with broad masses of colour, representing strong divisions of light and shade, but he also investigated the subtleties of modelling within areas of shadow. I have made a limited and uncertain attempt at both in this painting – softer highlights were eventually picked out around the eyes where the face is shaded.

5 The painting was continued to completion by adding more colour to the drawing. The girl's hair and the chair she is sitting on were painted in pure Red and pure Yellow Ochre and in tints of those colours with White. The chair was worked wet into wet with some pale strokes put in along the upper edge implying how the light softly highlighted the wicker work. Her clothing is composed of tints of Red Lake with White, divided into three tonal values for modelling form.

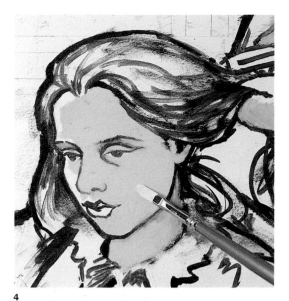

4

Making a monoprint

Degas was constantly trying out ideas in different ways. For instance, he would work over a monoprint in pastel, or perhaps oil. This technique involves making a drawing in dilute oil paint or printing ink on an unused printing plate. A single print can then be taken from it by covering it with paper and passing it through an etching press, although you can also do it with less sophisticated equipment.

When Girl having her hair brushed was dry, I placed the sheet of plate glass that I had used as a palette, now cleaned, over the central part of the image. With bristle brushes I drew over it broadly on the glass, tracing out the image with brown oil paint and a little turpentine, being careful not to spill any of it on to the painting.

The glass was then removed to a flat surface, a piece of paper was placed over it and a linoprinting roller was used to take a print. You can repaint the plate immediately afterwards and take another print which will be slightly different. If necessary, you can retouch the print directly from the brush to improve its quality.

The image is reversed by the process, changing its character (below).

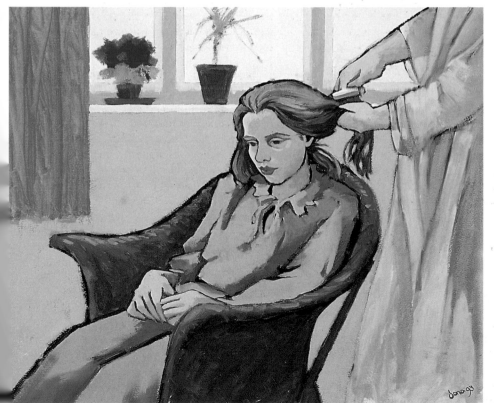

5

2.4 FIGURES

On the beach at Exmouth using the methods of Monet

MATERIALS

Canvas
A standard stretched canvas of linen, thinly primed with a white acrylic ground, re-primed a very pale grey with artists' acrylic colours. Size 12" x 10" (approx. 30.5 cm x 25.3 cm).

Paint
Artists' quality oil colours at tube consistency applied without a medium, although a dipper of turpentine was on the palette and was used once at the very beginning.

Burnt Sienna
Cadmium Light Red
Cadmium Yellow
Cobalt Blue
Flake White
Ivory Black
Yellow Ochre

Note the presence of earth colours and Black on this version of Monet's palette and the absence of Red Lake.

Brushes
One size 2 and one size 4 long flat bristle brush and one size 2 filbert bristle brush. The filbert was not a deliberate choice and was used as if it were a long flat. When sketching out of doors, you have to make use of what you have with you. A long-bladed palette knife was also required.

1

2

This demonstration was inspired by Monet's painting, *The Beach at Trouville* (1870). It records a similar subject being painted in very similar circumstances and probably repeats Monet's actions in a variety of general and specific ways.

1 I had re-primed my canvas before setting off to paint with a very pale grey as that was the colour of the ground in Monet's painting. The subject was my wife and elder daughter sitting beneath a beach umbrella. Seated figures are probably the easiest to paint because they feel relaxed and are unlikely to move very much when being painted.

There is never a definite method for a painting like this, but there is usually a definite time factor. It made sense to me to start with a brush drawing, so I began by roughly sketching in the figures and their surroundings in outline, using Burnt Sienna from a size 2 long flat. I thinned the paint with turpentine to keep the underdrawing thin and lean so it could be painted over without being disturbed. In any event, Burnt Sienna shows its colour best when used thinly and transparently.

I was aiming for the simple sketchy marks that much of the brush drawing is composed of, but it is difficult to gauge how much colour you have on the brush when you are about to make the first stroke, so my opening touches were too heavy.

I instinctively started the brush drawing at my wife's head – the visual focus of the painting. As I began with too much paint on the brush I had to use a palette knife to scrape it down, removing the excess paint to leave a much thinner covering and a softer image.

Where I have scraped with the palette knife the weave of the cloth shows through, peppering the Burnt Sienna with dots of the pale grey ground. I realized that Monet must have done the same in *The Beach at Trouville* because the head of his wife has traces of this effect around the back of it, in her hair, and along the edge of her hat. It seems that Monet began in the same way, started at the same place and made the same mistake, which he corrected as I did.

2 Once I had the brush drawing in place I started to add colour. First I used a straight tint of Yellow Ochre and White to put in the main stretch of sand across the background with rapidly dashed-down horizontal strokes. As the colour on the palette ran out I mixed a little more, although not matching the previous tint exactly. A slight tonal variation therefore occurs among the strokes and can be seen particularly on the right, where you will also notice that large gaps of pale grey ground remain uncovered. Together, in a very a simple way, these aspects combine to suggest the trampled sand around the figures on this popular beach.

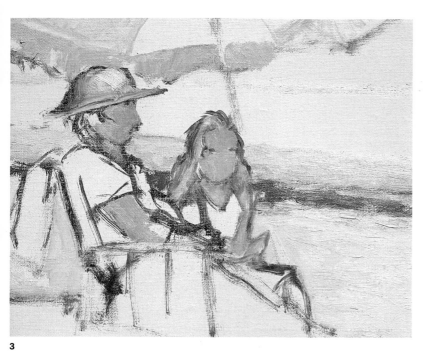

3

Still using a tint of Yellow Ochre, I then painted my wife's straw hat and my daughter's hair, working a little of the Burnt Sienna from the drawing into it to get some variety of colour and tone. The hat is rounded off with a heavy, bold stroke of a very pale tint of Yellow Ochre, crudely mixed immediately before being applied from an extra brush load of White and some of the tint already on the palette. Then I moved on to a slightly grey-pink used for the underside of the beach umbrella. It was not an exact match to the subject, but it seemed appropriate.

3 A line of seaweed ran across the beach in the background and was interpreted using a dull mixed green. Horizontal brushstrokes, dragged dryly over the canvas, to leave yet more patches of grey ground untouched, implied the broken-up and indefinite character of the background.

The horizontal strokes used here, and for the rest of the beach, echo the flat horizontal plane of the beach. To complete it I applied more of the Yellow Ochre tint and the pale grey-pink used on the sun umbrella, showing a variation in its colouring and adding a sandbank that could be seen a little way offshore.

4 A deep earthy flesh tone was then placed on the faces, arms and legs of the figures. They were under a sunshade, so the flesh tones appeared quite dull and dark. Next, I painted a straight tint of blue into the gaps in the background where the sea belonged. Again, the brushwork was horizontal, but some of the strokes flick upwards at their beginning, or end, or both, like wave shapes and a few little streaks of pale grey ground remain uncovered looking like foamy white wave crests.

As with the sand before, the colouring of the sea is, in fact, uneven. Slight variations have been introduced by imperfect mixing, but there are also subtleties of tone and colour due to its differential thickness over the ground. Where the brushstrokes are deeply scored and the paint is thin, the resultant colour is affected more by the pale grey ground showing through than it is where the blue is applied more heavily.

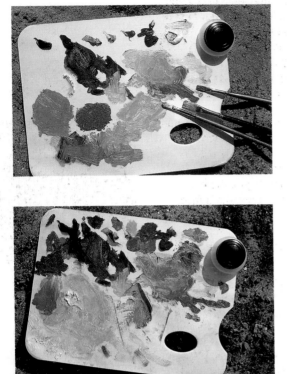

5 The figures were then developed with colour-tinted greys. My wife's bright red jacket, draped over her shoulder, and my daughter's red skirt were painted in next. Note the touches of dark paint immediately beneath the red, showing pockets of shadow where the red jacket does not lie flat, and that the red skirt has a lighter tone worked into it, as if the light is catching it. This is a very strong pink – Cadmium Red with a tiny amount of Flake White.

The painting process tends to slow down when you are this far through a painting because you have to start thinking more about what you are doing. I used some grey for accents of shadow around my daughter's head to define it more clearly and for deeper shadow around my wife's back. Then I started to add a pattern to her blouse with a tint of Burnt Sienna and White. I was still using the ground at this point – working against it as a reference tone, or letting it stand in for a value I had not actually painted.

6 You can only finish off by reference to your subject. I kept looking and painting, adding the yellow chair with its brown stripes and the yellow striped towel hanging down from it. The pale parts of the towel are again the grey ground. The deepest yellows are almost pure Cadmium Yellow, but do contain a small amount of Flake White. A very pale yellow, imperfectly mixed with White to make it sparkle, has been taken in a long streak along the top of the chair arm to show the sunlight catching it. I have also used a little of this yellow to highlight my daughter's hair.

I had to add finishing touches to my wife's hair, as it was still composed of the Burnt Sienna drawing, and the suggestion of features was put into the wet paint of the face with delicate touches of a Burnt Sienna tint. Little strokes of a mid-pink provided both figures with lips. A greenish grey and some pale blue completed my wife's skirt and then the pattern on the sunshade was suggested with flicks of a green-grey from a dry brush and with dots of a dark pink and a pale peachy pink, close to a tint of Yellow Ochre. This was the same colour used to complete my wife's forearm and to complete

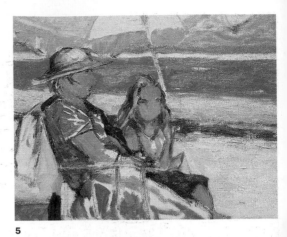

5

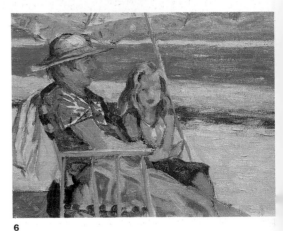

6

my daughter's face, showing how they caught the sunlight that was not blocked by the sunshade.

7 Now I just had to add White. This was done off the edge and corner of a size 2 long flat. Not much was used, but it made an appreciable difference. The fringe around the edge of the beach umbrella was put in with it and I used the direction of the strokes to imply the presence of a light breeze that formed part of my impression of the scene, although by the time I had finished painting the breeze had dropped. Nature changes rapidly in front of you while you paint, even when working across a short period as I did here, so you must make arbitrary decisions about what you include.

The palette

Here is the palette part way through the painting (far above). The Burnt Sienna, second from the left, has been thinned with turpentine, but all the other colours have been used at tube consistency. On the right, underneath the red, blue and White, is the area where the first simple tints of Yellow Ochre and White were mixed. On the far left, directly beneath the Black, the pure blue tint, used for the sea, was mixed. I have started to use more complicated, broken colour values by adding other elements to the clean tints already on the palette. Eventually,

as you can see, I started adding the different mixtures into each other with my, by then, dirty brushes.

To complete the painting, I had to return the palette, as best I could, to something like its original condition. Next you see the palette when the painting was finished (above). I used the palette knife to scrape up all the mixtures that I no longer needed and deposited them in a lump at the centre of the palette. Then I was able to start again with clean tints and could carry on using controlled and intentional mixtures.

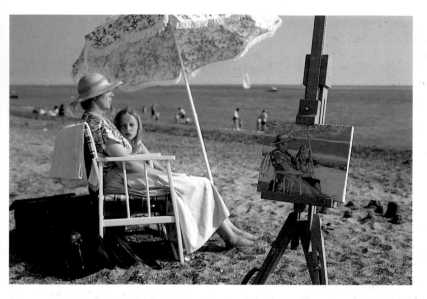

sun had moved round and the sea had covered the sandbank, but it is still easy enough to see how my impression relates to the scene. My wife and daughter's clothes are not exactly the same, but this is not significant. This is a painted impression, not a photograph, and it represents the feeling of a moment in time, not the exact truth of its every detail.

There must have been more of a breeze when Monet painted his impression because very little sand entered my paint. There is a grain just below the largest of the wave crests and, as you can see in the detail (right), there is one embedded in the paint of my wife's face. You may find it useful to study the brushstrokes in the finished work (below) as they show how the wet paint has been manipulated as it has been placed.

White was used on the right-hand edge of the beach umbrella pole to make it look more solid, but the White stops short of the top because it is in the umbrella's shade. A tiny touch has also been placed on the neckline of my daughter's white clothing to show it catching the light and to make it come forward from her neck. Then about a dozen short strokes of White were applied over my wife's blouse to complete its pattern and round out the figure. If you compare this to the previous stage you should be able to see that the shoulder now appears to come further forward than the head, which it did not before.

A lot of pale grey ground is still left exposed in this painting – it represents footprints in the sand, the underside of the umbrella, parts of the towel and both figures' clothing. As such a painting dries, you can expect the colours to soften as the effect of the underlying tint becomes more apparent. Usually this is beneficial and may bring out subtle nuances of colour and light that, at the time of painting, you were hardly aware of putting in. If you have painted well, in tune with your reactions to the subject, these will be a natural part of your impression.

Here is my painting in front of my subject just after it was completed (above). By then the

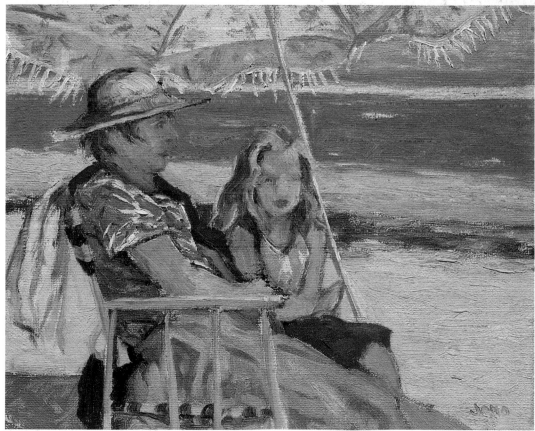

2.4 FIGURES

2.4 FIGURES

After the bath using the methods of Degas

MATERIALS

Support
White, 140lbs, 300gsm, 'not' ('cold-pressed') surfaced watercolour paper. Grey watercolour paper and green pastel paper were also used in the preliminary stages. These or any good quality white, or colour-tinted artists' papers could have been used. Size 11" x 15" (28 cm x 38 cm).

Media
Watercolour pencil and pastel pencil: a dark brown watercolour pencil produced the original drawing and its counterproof. Pastel pencils in tints of pink, yellow and blue were used with white for the figure. Various earth colours were applied as well, including a very attractive rich orange earth. Bright colours and tints appropriate to specific areas of the subject were chosen as required.

Other materials and equipment
Water, a mouth diffuser, a linoprinting roller, a bristle brush and pastel fixative.

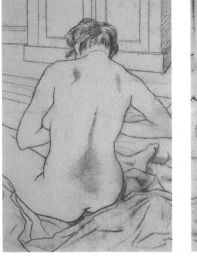

1

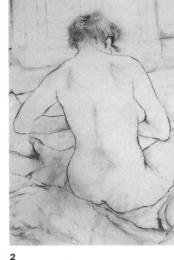

2

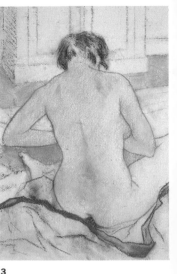

3

1 In this small pastel I have translated some of Degas's original methods for use with modern materials – pastel pencils and watercolour pencils were not available to him. The general concept I followed is very close to Degas's methods with counterproofs of chalk, or charcoal drawings, or monoprints, with ordinary pastel placed over them.

This work started out as a figure drawing, done from life, using a dark brown watercolour pencil on green pastel paper. As you can see, it is a fairly crisp linear drawing – typical of Degas's subject matter, but not his style. He would have produced a softer image.

2 I then tried to take a print of my original drawing (known as taking a counterproof). Degas would have done this with chalk or charcoal drawings. You take a sheet of wet paper and place it on top of the original drawing. Then you press the two together firmly, either by putting them through a printing press as Degas probably did, or by running a linoprinting roller over them as I did. You have to do this on a very firm, flat surface and must press hard. Then you peel off the top sheet and, if all has gone well, you have a reverse image. Much depends on the type of paper you use

and on the strength of the original drawing. You may have to retouch the counterproof afterwards to get the desired effect.

Since watercolour pencil dissolves in water it is quite likely to print off well on to a wet top sheet. It also tends to spread into the water just a little as the print is taken, which may introduce a rather charming softening and shading of the image as it blurs slightly. This vaguely resembles the effect you get from a monoprint done with printing ink or oil colour.

In this case I succeeded in producing two good counterproofs of my original drawing. One on grey paper that is shown here as an example of how the print should appear and one on white paper that was then worked over in pastel pencil. The rest of the illustrations show that piece in progress. If you do not get a perfect counterproof, try reworking it – with watercolour pencil you can do this while the print is still wet, which will result in a soft fuzzy effect from the pencil.

3 The image is reversed by the process of counterproofing, giving it at once a different character. When the counterproof on white paper was dry I taped it to a board and began working over it with a few pastel pencil colours.

Degas sometimes used earth colours and soft pinks for flesh, but he also used colour combinations that were highly inventive and personal. I applied one of my own favourites here, a combination of yellow, pink and blue and began by placing the yellow and pink to represent the lightest parts of the body and the areas of mid tone. This was hatched on roughly and then rubbed into the textured surface of the watercolour paper with my fingers. The effect was not quite what I wanted, so I then sprayed it with water using a mouth diffuser and rubbed the colour in again. This spread the pastel pigment in an appealing way and, when dry, gave me an effect with some of the looseness of watercolour, but with the colour quality of pastel.

4 When the paper was dry I began hatching over the figure using parallel diagonal strokes,

all more or less going from top right to bottom left – a stroke pattern that usually suits a right-handed person. Since my first yellow was a little too strong, I switched to a paler lemon yellow and added the blue for the shadow tone. These were placed according to the divisions of tone across the body and each colour was taken over the one next to it, so that at a short distance they began to look as if they were blending.

Again, I used my fingertips, pressing the colour into the paper's surface to make it stay in place and to soften it a little by taking the exactness away from the pencil marks. Compacting pastel pigment into a textured surface like this gives quite a solid, almost paint-like finish.

I then went over the figure a third time to fine tune the tonal relationships of the colouring. I used the same sequence of colours again and continued to apply them in hatched strokes. In fact, I deliberately emphasized the hatched stroke as a visual feature in the piece as it is sometimes very apparent in Degas's work. When I had adjusted the divisions between yellow, pink and blue as I thought fit, I hatched

over all the flesh colouring with white. With pastel, or pastel pencil, you can use white on top of other colours, or blended into them, to get paler values and also, as I have used it here, to soften the transitions between adjacent colour values and tones. Here this has introduced an opalescent quality to the flesh, particularly in areas of delicate shadow *(above)*.

I had edged around the contours of the figure early on in a pleasant orange-coloured earth and re-stated the figures' outline with this at various stages during the work – as Degas himself might have done. My techniques varied across the rest of the piece according to what was being represented. The pink towel to the figure's left, for example, was first coloured with two separate tonal values of pink, which were then rubbed out with my fingers to give a smooth, blended covering, broadly depicting tonal values that could then be worked over. The strip of carpet in the background was rubbed in with water when the paper was sprayed at the beginning. Next, I began work on the cupboard at the back.

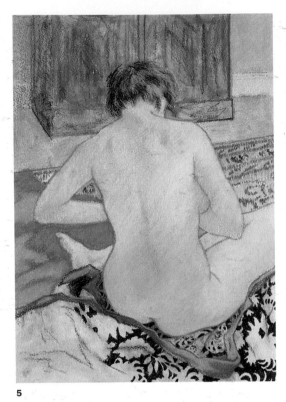

5

6

the cupboard was made of wood. The washed-out quality of this part of the image also helped to establish its relative importance by making it less distinct and therefore identifying it as part of the background. I completed the figure's hair at this stage and began work on the kimono that was draped around her on the floor.

5–6 As I continued working, I carried on varying my methods. This resulted in different visual qualities so I could convey the idea of objects by the way they were represented. Thereby I was also helped to express some of the general concepts within the image in visual terms.

The cupboard in the background was drawn in with some rough streaks and rubbings of colour that grazed the paper's texture, using a deep earthy red and a dark brown. Then I used a wet bristle brush to paint these out over the area occupied by the cupboard. This spread some of the pastel colour into a thin wash, giving an effect almost like watercolour, while some of the pigment deposit stayed more or less in place. The original strokes and scuffs of colour were now made more vague by the action of the brush and by their envelopment in a tint of colour where there had previously been white paper.

The streaked effect that resulted helped to suggest the idea of woodgrain, confirming that

7 The background cupboard was completed using a ruler so that its contours could be restated perfectly straight and the arched panels on each door could be accurately shown. Because I was using pastel pencil it was possible to do this with a precision that would have been difficult with ordinary pastel. As you probably realize, I was redrawing straight lines that had been put in at the very beginning – if you look back at the original drawing, you will note that the perspective of the cupboard, wall, skirting board and carpet edge had all been drawn in neatly with the aid of ruler. I feel that this was in keeping with Degas's methods.

The pink towel was finished with small strokes to convey the idea of a soft, comfortable material. Three tints of a strong pink, representing a light, mid and deep tone of the same colour, were used for this and were then worked over with tiny strokes of white for a still softer-looking effect. The kimono was completed

with colours based on its actual pattern, but these had to be toned down and played around with before the work was finished. The kimono, like the other surrounding and background objects, was meant to complement the figure as an accessory, not to detract from it by being too strongly coloured or finely detailed.

Finishing touches were then added, the most important being the accenting of the figure's outline with some stronger drawing in key places. The outline is less emphatic than it would usually be in a work by Degas, but the emphasis of the figure's shape by this means is still fairly typical of his manner.

Symbolic effects

The ways in which I have handled different parts of this image are significant – they are all expressive of some idea. I have already explained how the towel and the cupboard were handled. Note also how the figure's hair is almost a blur in places which makes it look soft. Since the head is not sharply defined and the shoulders either side of it are clearly stated, it appears to tilt forward from the body.

In fact, despite its firm outline, the whole figure looks soft because of the delicate colouring and because of the way it is lit. The light is obviously coming from the right-hand side and all of the hatching describes its direction, meaning that the figure is quite literally bathed in light. The towel and the crumpled kimono echo the softness of shape and surface found in the figure; the straight lines of the carpet edge, cupboard and skirting board are in complete contrast to these qualities, so, as intended, they tend to emphasize the soft curvature of the figure.

These objects are important compositionally as well – the centre edges of the cupboard doors indicate a vertical axis running straight through the figure and the front edge of the cupboard base intersects this in line with the figure's head. That, in turn, is the uppermost corner of a triangle, formed by the figure's head and elbows, so your eye is drawn to that point. There are also strong diagonals and other shapes within the composition that contribute to the image.

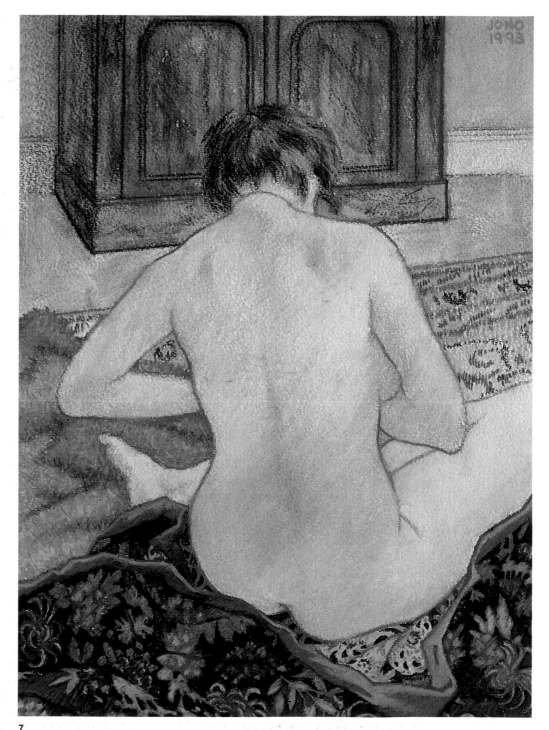

7

Woman drying herself using the methods of Degas

MATERIALS

Support

Coloured pastel paper mounted on acid-free card (Canson Mi-Teintes Artboard). A mid-toned sandy orange tint was chosen – Degas used pastel papers in various colours across a pale to mid-toned range. His large pastels are sometimes composed of several sheets, but here a modern product offered the potential of scale more conveniently. Size 32" x 40" (approx. 81.3 cm x 101.6 cm).

Media

Charcoal and artists' soft pastels – the pastels were taken from a 'Portrait' selection. I chose tints of the following earth colours after a process of trial and error: Raw Sienna, Yellow Ochre and Golden Ochre (a warm yellow-brown), English Red (a rich red-brown) and Burnt Sienna. The colour names and exact values vary from pastel range to pastel range so I will describe them simply as earthy tints from cream through light orange-browns to red-brown. I also used black, grey and white, as well as some strong bright colours in the background.

Other materials

The original drawing was done in black chalk on cream-coloured pastel paper. Fixative was applied with a mouth diffuser as part of the technique.

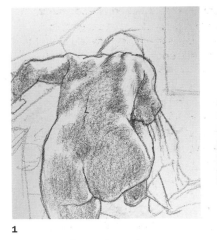

1

2

This demonstration is based on some of the methods that Degas seems to have employed with pastel. His technique was so varied, though, that it would be impossible to show every aspect of his working practices in a single example. For instance, some of his pastels are on top of monoprints while others combine pastel and gouache, but not always on paper, sometimes on canvas. His use of pastel also varied enormously in scale. Paradoxically, as well as constant variety, there is also repetition, not just of imagery but also of facets of technique. The freedom of Degas's drawing and his skilful use of colour are the result of practice and familiarity.

Degas's starting-point was always a drawing, which he would work from using his imagination and experience. He may also have progressed according to whim – introducing alternative techniques to see what would happen and exploring the potential of each idea before moving on to another one. There is, for example, a piece by Degas in charcoal and pastel on tracing paper. He either chose this unusual support deliberately, or suddenly decided to convert a tracing into a finished work. It may even have been a way of recovering the image from a work that went wrong.

Degas would probably have developed an image or a method as he went along by making arbitrary decisions at certain points. This allowed him to try out new ideas continually. If you are to do the same, you must be adventurous in your thinking and be willing to experiment with potentially interesting techniques.

1–2 This large pastel started as a life drawing in soft black chalk on cream-tinted pastel paper. It was the only time that I worked from the model. Later I enlarged the drawing freehand on to a large piece of artboard, using charcoal instead of chalk. This allowed me to alter the proportions of the drawing slightly – alternatively, you could scale up accurately from a drawing, or draw directly on to a pastel support, without working from another drawing at all.

My chalk drawing concentrated on the figure and did not have much of a background, so it never occurred to me to add tonal values with charcoal into the background of my larger drawing, but I think Degas might have done this. It probably pays to develop the whole concept in charcoal to begin with. Fixing the charcoal drawing, or rubbing it into the paper with your fingers, so it no longer has a loose surface and can be worked over cleanly with pastel is the next important step. I used my fingers partly to get soft tones and partly to rub in the drawing, but also applied fixative.

3 You should try to have a colour scheme in mind when you start, then you can work out

3

4

which pastels suit it as you go along. Unlike paint, where you can choose a specific palette to mix everything from, with pastels you are reliant on pre-established values and must develop your colouring in their terms.

The colouring of my figure began with a light earthy yellow, an earthy orange-pink and a slightly blue-grey. I placed these with broad, well-separated and roughly parallel strokes which still let me see the charcoal drawing, guiding my choice of which value to place where. From the onset my strokes followed the form of the figure to begin establishing its shape.

The grey was used to create a neutral half-shadow. The other colours represented the first steps in a yet to be completed range of tones that would model the form while providing colour. I soon added more values of yellow and red earths, extending and filling in the gaps of my sequence of tones – basically I was working from yellow to red, while working from light to dark.

4 As you can see, I continued to add colours with parallel strokes, but kept changing their direction. As they criss-crossed over each other they were visually broken down, softening the transitions of tone and mixing the colours without blending them into each other. They are seen as if they are mixed, but, in fact, they remain separate. Note how the strokes continue to describe the surface of the figure as if they are wrapped around it – whatever direction they go in, they trace out the curves of the shapes they would encounter if the figure were real.

When Degas portrayed flesh like this it was described as 'granular' by one contemporary critic. However, it was widely recognized as being more realistic than the idealized representation of the female form with unnaturally smooth pink flesh in the academic painting tradition of the day.

Degas's choice of subject was effectively part of his method. My image has a similar theme to many of his – I have shown the woman, who is drying herself, behaving very naturally and aware of only her own presence. His figures do not usually look out of the picture, but look inwards at what they are doing and are unaware of being viewed. As Degas said: she is like a 'human animal, occupied like a cat cleaning itself with its tongue'. He told George Moore: 'Hitherto, the nude has always been represented in poses that pre-suppose an audience, but these women of mine are honest, simple folk unconcerned by any other interests than those involved in their physical condition. Here is another; she is washing her feet. It is as if you looked through a keyhole.'

Degas created impressions of very ordinary human activities and made art out of their simplicity and truth. He, himself, said: 'Artists are always in such a hurry, yet we can manage very well with what they have overlooked.' To follow his example make your figures self-occupied and show them in activities that are so unremarkable that you would not immediately think of them as subjects – this will, in fact, be your work's strength.

Pasting up pastels

Some of Degas's pastels are larger than a standard sheet of artists' paper. He pasted sheets of the same coloured paper on to stretched canvas, or sometimes on to card. They were usually joined edge to edge, since that is less likely to show beneath pastel. Today you can get very large sheets of paper, or paper-covered board, that make large-scale pastels easier, but Degas's original method still has attractions – these sheets (below) are being pasted on to canvas.

In his works a large central panel is often added to, implying that Degas was extending or

altering a drawing to arrive at the final composition. You may wish to try this by cutting out the best part of a drawing and adding new pieces to it to change its shape, getting the image just as you want it. If you do this, I suggest sizing raw canvas first and mounting the paper with arrowroot starch paste, or using a conservation-quality paper adhesive.

5–6 As you can see, I worked on the whole of the figure at once and might easily have worked on the background, too, if the same colours had been involved, but I had decided to apply a strongly coloured background. This is a device that Degas occasionally used. I began to block it in, mostly with a deep yellow-orange and orange and red.

7–9 I experimented as I worked, as Degas would have done. Some colour was put on from the end of a pastel stick, resulting in definite strokes; some was rubbed on using a short length of pastel on its side which gave a broad dusty deposit of colour that I then rubbed into the paper with my fingertips. Rubbing with a circular motion spreads pastel dust evenly. These are alternatives that you can use for different effects, but they can be combined with each other as well.

10 Next, I used my hand like a comb, spreading my fingers and dragging their tips through the colours, as Degas possibly did. It seemed right

and suited the large scale of this pastel. You can rough up the quality of an image this way, making it slightly less exact and improving the colour harmony by spreading colours from one area to another as your fingers pick them up. If you compare the full view of the background before and after completion, particularly above and to the left of the figure, you should be able to see how doing this can benefit a work.

11 Degas's colouring can either be subtle and subdued, or extremely bold. Here the deep blue towel sets off the reds and oranges that dominate the colour scheme. It is shaded with pure black as is the red towel next to it. The contour of the figure was also re-emphasized with black pastel at this stage and the flesh was re-touched with a darker red earth than I had previously used to balance the tones across the image as a whole. The white towel is scribbled on with white, grey and one of the flesh tones – a brownish cream – and also has some of the underlying tint of the paper showing through.

7

8

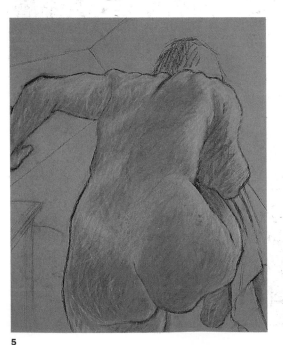

5

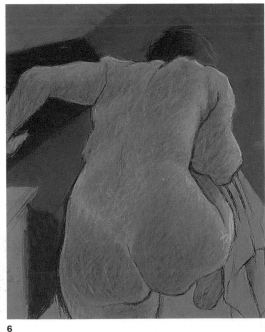

6

9

10

12 Degas experimented with fixatives that were quite crude and likely to saturate and darken the pastel. This can still happen if you apply modern fixatives heavily, but the effect is not necessarily undesirable.

I fixed this pastel after completion, using a mouth diffuser to blow liquid fixative over it in three applications. The last two illustrations both show the finished pastel, but in the final one it has been fixed, which has darkened it and also made the underlying charcoal drawing, with its masses of tone, more apparent. The figure and the space around it are more united and the sense of light and shade – of light entering the window and enveloping the figure – is greatly improved as a result.

Degas liked a squarish format – and my pastel would have been more like one of his if it had been trimmed. If you are going to adjust the composition of your work, it is best to do so at the beginning, before much pastel is applied, but there are no definite rules.

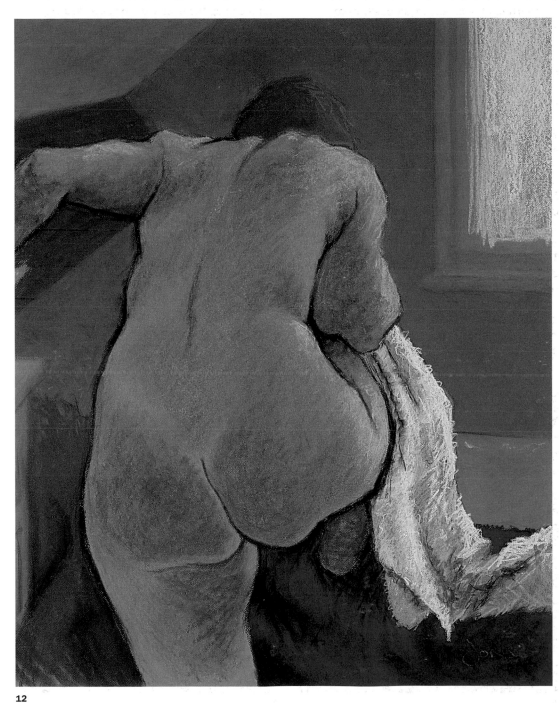

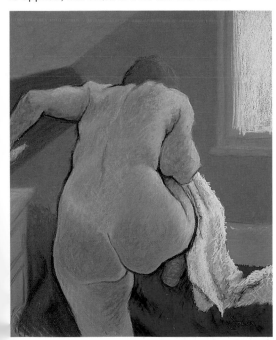

11

12

2.4 FIGURES

The conversation using the methods of Renoir

MATERIALS

Canvas
A standard stretched cotton canvas with a white acrylic ground. Size 18" x 14" (45.8 cm x 35.6 cm).

Paint
Artists' acrylic colours.

Cadmium Lemon
Cadmium Light Red
Cadmium Orange
Cadmium Yellow
Cerulean Blue
Cobalt Blue
Golden Ochre
Mars Black
Phthalocyanine Green
'Phthalo' Turquoise
Red Lake (Rose)
Titanium White

The number of colours is due to the palette changing from painting session to painting session. Renoir, of course, would not have used acrylic paints.

Brushes
Sizes 4 and 2 round synthetic hair brushes and sizes 2 and 1 round bristle brushes. Most of the painting was done with the synthetic hair brushes, but bristle was introduced towards the end to get softer effects.

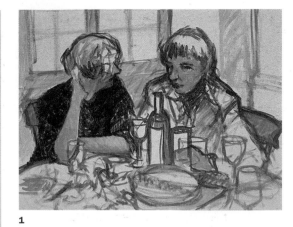

1

Renoir's figure groups are of two kinds, either they are small, intimate groups sketchily painted, often giving the impression of having been done hastily, or they are large, complicated arrangements of figures, painted to a careful finish that must have been done over a period of time. My work combines elements of both – it begins in a sketchy manner, but develops into something more considered.

Renoir sometimes used a sketch as a model for a larger painting that was probably worked out in detail as it progressed. Later in life, he turned to drawing as a starting-point, making preliminary studies and then constructing the final image in the studio. This painting of mine could have been treated as a preliminary sketch, which is, in fact, what I intended until part way through. Deciding on how to develop a work as it is being painted is typical of the relaxed approach to painting that Impressionism requires.

Renoir always depicted an informal moment, usually when people were at leisure, so I have taken the theme of a conversation after a meal. Renoir explained to Ambroise Vollard how his friends posed for his figure group paintings. This allowed him to re-create the original subject with their help, painting from it in a series of sessions.

I followed his example and started my painting with two friends as models, choosing their conversation as my specific subject. Painting people that you know puts both you and your models at ease – the poses are more natural and your painting is likely to be more relaxed. They had adopted their positions of their own accord and, apart from a request that they remain reasonably still and move closer together, I did not interfere, or attempt to set up the image. The more natural the poses, the truer your impression.

1 I started with a brush-drawn sketch using dilute Red Lake, a colour that I judged would easily disappear into the subject's colouring as more paint was placed over it. Washes of Golden Ochre (a slightly deeper and more transparent version of Yellow Ochre), 'Phthalo' Turquoise (a manufactured blend of Phthalocyanine Green and Phthalocyanine Blue) and Red were applied to the brush drawing as soon as it was in place. Then I started to mix flesh tints and apply them to the faces and arms. As with any subject, the idea was to capture the essential impression as soon as possible.

As I was sketching, I had concentrated on the idea of a confidential conversation and emphasized the subjects' inward leaning forms with their heads together, tilted towards each other. I was particularly pleased with the head of the figure on the left *(above)* to begin with, but unfortunately was not able to maintain the quality of the original sketch into the finished painting. Eventually I had to work on it from memory, using my imagination to fill in missing details. Judging by a few of the

figures in Renoir's paintings, he may also have had this problem, which emphasizes the importance of working from nature whenever possible.

The rest of the subject was sketched in faithfully, but briefly, to convey the impression of the place and the moment. In particular, of course, the objects on the table set the scene – a meal had been eaten, wine had been consumed and the mood was relaxed. Flickering, light brushstrokes in a thin wash of Red Lake were used to represent the wine bottle, glasses and other items on the table – these strokes established how the objects would eventually be painted in a light 'feathery' manner. Renoir would have employed similar brushwork. This area of the initial sketch remained quite active in the finished painting (above).

Painting subsequently continued away from the scene without the models. It is neither practical nor necessary to re-create the scene for every touch of paint that goes on the canvas. You must learn to work from memory and painterly experience some of the time – the more you paint, the easier that becomes.

2–3 The second session took place soon after the initial sketch had been done while the scene was still fresh in my mind. The background was taken a stage further. All the colour was applied with flicked, hatched strokes – running diagonally downwards from

the right to the left – so that the brushmarks tapered at their ends. The painting process at this stage amounted to little more than colouring in over areas of the sketch using small strokes. Slight variations of colour were naturally introduced by inexact remixing of tints so flat areas of colour were avoided.

Working on figures without them to refer to is not ideal, but occasionally it cannot be avoided. In the original sketch some sense of the light and shade was recorded in the initial washes of Red Lake, which gave me some idea of how to continue painting without the presence of models. At this stage I also began to depart from a faithful representation of the subject in order to introduce passages of painting based on features that typically occur in Renoir's work.

The hair of the figure on the left, for example, contains some pure Red Lake and some Cobalt Blue, while the hair of the figure on the right contains some pure Cadmium Red. I did this in one case simply because one of the colours happened to be on the brush and in the other just as an instinctive response. The unexpected use of colour in an arbitrary, but effective, way is quite common in Renoir's painting. Pure blue used as a shadow is also typical of him, so that is how the Cobalt Blue operates here. Putting red in the other figure's hair does not really make sense at all, except that it passes for a highlight and echoes the strong red colouring of the figure on the left. Renoir was interested in the idea of reflected colours – the colour of one object appearing on the surface of another one close by. This is a rather distorted extension of the idea.

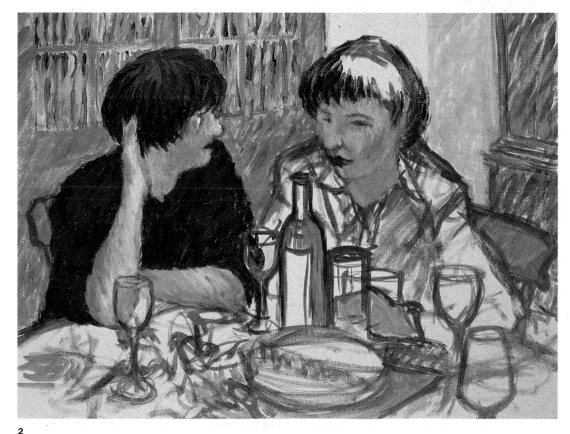

2

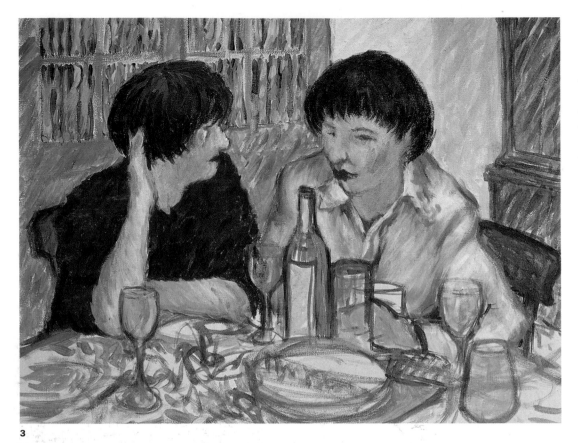

3

strong Red Lake and a firm touch of it at the bottom imply a remnant of wine reflecting its colour around the glass. This is not studied from nature, but is just one of Renoir's mannerisms that I have repeated.

The other glasses and items on the table were worked on in the same loose style. The model, who had originally posed for the figure on the right, was now able to repose, although not in the original setting, but in surroundings that offered broadly similar lighting conditions. In the previous stage the background around this figure was completed by applying tints of pale blue and cream over the foundation colours of the walls and touches of Ochre and a mixed orange over the long-case clock on the right. This allowed the contours of the figure to be more accurately expressed as the background was taken over the

The representation of the right-hand figure's blouse was a deliberate imitation of Renoir. The white clothing in his figure pieces is often painted in a particular way, using feathery strokes of blue and pink to shade the White and glancing touches of stronger blue to provide definition. Here, the original Red Lake drawing provides the pink. It remains visible because it has been gone over very lightly in places. The intermediate values are very pale blues, thinly applied, while the stronger hints of shadow and the accents that briefly confirm the shape are worked with pure blue using casual touches into the still-wet White and pale blue paint. Pure White was used for the highlights.

The blouse was painted very quickly, so the wet-in-wet touches could be made before the acrylic paint dried. In oils there is more working time and the minor improvements I

made later could also have been worked wet into wet. Cerulean Blue was added to the Cobalt Blue already on the palette to do this. Using two different blues to tint the White created a more interesting and luminous effect.

4 A light, springy touch is needed to achieve the quality of brushmark seen on the blouse *(opposite, left)*. You must dab and flick the paint into place, never keeping your brush still or letting it rest on the canvas. I used this approach based on light brushwork and delicate colours for other aspects. For instance, if you compare the glass by the figure's arm on the lower right as it was previously with the enlarged detail of the same glass at this point *(right)* you can see that it has been created with flickering strokes of blue and White that only partially obscure the Red Lake drawing. The scribble of

edge of the rough painting that preceded it. Renoir does not often use definite contours – the outline of the figure on the right in my painting is still quite carelessly defined. Light, flickering brushstrokes are again the key.

A few finishing touches were now added to the white blouse. Some extra flicks of White and blue were used to suggest lace on the collar and cuffs and a curved stroke of blue was added to emphasize the figure's breast beneath the blouse – the women depicted by Renoir are always voluptuous.

The hair was repainted with ochre, a mixed brown, black and a tint of green with some White dragged into it. Highlights in brown hair do sometimes appear to have a greenish tint, but here the colour has also been chosen to set off the flecks of bright red that were already in the hair and that were repeated more emphatically at this stage. Playing with colour is an essential part of Renoir's method. In this painting note also the use of pale lemon to highlight the figure's hands behind the glass – I simply felt like using it, although it could be interpreted as reflecting the colour of the coffee cup behind it.

There is a more intentional placement of a reflected colour on the glass on the left of the wine bottle between the two figures. A firm stroke and some scrawling strokes of the same green used for the bottle were placed to show the colour of the bottle being reflected in the glass. A streak of green also appears on the left-hand side of the tall glass to the right of the bottle, where the bottle and glass are close together. The bottle itself was substantially repainted with this same tint of green, touched around with blue and White to make it appear to be more like glass, but some of the Red Lake drawing still shows through on the bottle neck. This can be seen on this page in the full view of the canvas and in the detail showing the blouse. These effects were not painted from life, but were based on my observations of how Renoir had handled similar details in his paintings.

Perfecting the figure's face presented a problem – the figures were not meant to be portraits, but it is difficult to paint from life and not seek some sort of likeness. What particularly mattered here, though, was the expression and a considerable amount of painting and repainting was required to achieve this. The face, as seen here, is still not complete.

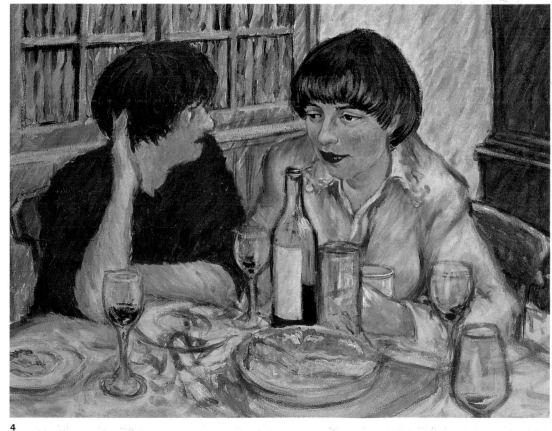

4

5 The figure on the left had not been taken much further than the original sketch, but now had to be worked on in order to finish the painting. The model was unavailable, so it was completed without her and, as you can see, this figure is far less effective than the one on the right. The

already eccentric colouring of the hair was taken further, adding more blue, bright red and green. Both figures' faces are painted in quite delicate tints, mixed from Red Lake and White, highlighted with almost pure White and shaded with a soft tint of bluish purple. Renoir often gave the women in his paintings very delicate and pale rose pink complexions like this. The bright red lips also seemed appropriate for a painting in the manner of Renoir.

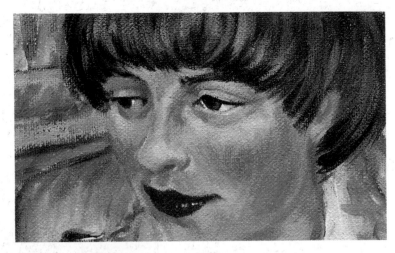

The face of the figure on the right was softened using small bristle brushes instead of the finely pointed synthetic hair ones that had been used previously. Some very thin, translucent tints were applied with them, through which some of the previous painting continued to show. The pure White highlights on the lips make them look moist and the White highlights in the eyes contribute to the expression. The enlarged detail *(left)* shows the finished quality of the face and also the effectiveness of the two White highlights at the very top of the bottle.

The table was finally completed using mannerisms borrowed from Renoir and pure invention. The spoon shown in the enlarged detail *(left)* was painted from life using a real spoon in the studio – but it was also painted as Renoir might have painted it. Note the lack of precise definition and the flicked-on White highlights with the touches of blue and grey that make it look like shiny metal. There is also a little red stroked into one of the highlights showing the red jacket of the nearby figure reflected in the spoon.

The touch of bright red at the centre of the Red Lake that represents wine in the glass could be interpreted as a reflection from the red figure, but in fact I imitated a Renoir painting where he used a brighter red to show a concentration of light being focused in the wine by the stem of a glass.

The party streamers are the result of a lapse of memory. If you look back to the opening sketch you will see some scrawls of Red Lake towards the front of the table which might originally have been a bouquet or some kind of table decoration, but by the time I came to finish the painting I had completely forgotten what it was.

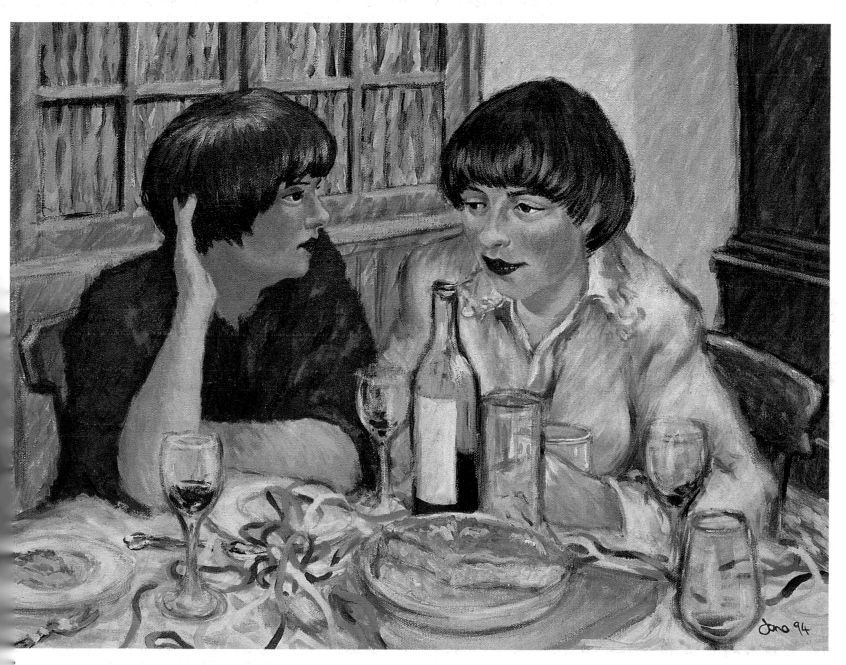

2.5 PORTRAITS

Portrait of Kevin using the methods of Van Gogh

MATERIALS

Canvas
A standard stretched cotton canvas with a white acrylic ground. Size 16" x 20" (40.6 cm x 50.8 cm).

Paint
Artists' acrylic colours.

Cadmium Light Red
Cadmium Orange
Cadmium Yellow Light
Cadmium Yellow Medium
Cerulean Blue
Citrus Green
Cobalt Blue
Dioxazine Purple
Phthalocyanine Green
Red Lake (Rose)
Titanium White

Van Gogh used oil colour, so some of the robustness of his style is lost in the translation of his methods to acrylics. The surface texture obtained from, and the tactile qualities experienced while painting with, heavy oil colour are sacrificed, but other aspects of his technique are well suited to acrylic paint.

Brushes
Sizes 4 and 2 round bristle brushes exclusively, except for the initial drawing done with a small, fine brush.

I decided to paint Kevin in the style of Van Gogh because his beard and beret reminded me of Van Gogh's *The Postman Roulin* (1888). My method is taken from several sources, but is substantially based on my observations of his *Self-Portrait with Bandaged Ear* (1889), which appears to be on a medium grain, off-white canvas that was probably white when new.

Van Gogh once wrote to his brother, Théo: 'When you next send money I shall buy some good marten (sable) brushes, which are the real drawing brushes, as I have discovered, for drawing a hand or a profile in colour.' This confirms that Van Gogh used fine brushes for drawing. In *Self-Portrait with Bandaged Ear* dark blue was used for some outline drawing done straight on to the canvas from a small, fine brush with fluid, dilute paint. It is evident in the Japanese print that Van Gogh has included in his painting and there are traces of similar drawing elsewhere, so this is probably how Van Gogh started – with an outline drawing in thin paint.

In the rest of his self-portrait dry-looking, heavy-textured paint has been applied in strokes of about an inch to an inch and a half in length – probably made by a round bristle brush, perhaps a size 4. This size of brush was used exclusively except for the black fur on his cap which is off a smaller brush, probably a size 2 round bristle. I have used similar brushes, following his example.

The face colouring on Van Gogh's *Self-Portrait with Bandaged Ear* is amazing – it includes a light yellow-green, an orange tint, a purple-grey and an earthy orange that could be an orange tint broken with green. All these are set against each other in adjacent and sometimes overlapping patches of brushstrokes. The direction of these strokes is expressive of the shape of the face. The eyes, including the whites of the eyes, are painted green with the eyelid drawn around in red. Elsewhere on the face there are touches of leaf green and crimson.

The effect of these extraordinary colours is, in fact, extremely rational and they do actually make sense as a portrayal of a face. This was the example that inspired me to paint Kevin's face as I did. The reasoning behind such use of

1

colour is explained by Van Gogh – in 1885 he wrote in a letter: 'May I not boldly take it to mean that a painter does better to start from the colour on his palette than from the colours in nature? I mean, when one wants to paint, for instance, a head, and sharply observes the reality one has before one, then one may think: that head is a harmony of red-brown, violet, yellow, all of them broken – I will put a violet and a yellow and a red-brown on my palette and these will break each other.'

Van Gogh believed that you should study your subject to obtain the sense of nature's colouring and to understand its relationships, but then paint in terms of the striking colours on your palette. This means making use of their inherent beauty to describe nature's colours, which are actually beyond your ability to paint. 'I retain from nature a certain sequence and a certain correctness in placing the tones, I study nature so as not to do foolish things, to remain reasonable – however, I don't mind so much whether my colour corresponds exactly so long as it looks beautiful on my canvas, as beautiful as it looks in nature.'

In order to reflect nature you must create the same sort of relationships between your chosen colours as exist between the real colours of your

subject. A little further on in the letter Van Gogh clarifies his point still further: 'A man's head or a woman's head, well contemplated and at leisure, is divinely beautiful, isn't it? Well, that general harmony of tones in nature, one loses it by painfully exact imitation, one keeps it by re-creating in an equivalent colour range, that may be not exactly or far from exactly like the model. ... Always and intelligently make use of the beautiful tones which the colours form of their own accord, when one breaks them on the palette, I repeat – to start from one's palette, from one's knowledge of colour harmony is quite different from following nature mechanically and obsequiously.'

Whereas Monet simply identified the true colours of nature and then painted them quite literally, albeit within the terms of his palette, Van Gogh said that you should identify the true colours of nature, but then attempt to represent them with equally impressive colours from the palette that are perhaps not literally true. He continued in the letter: 'Here is another example: suppose I have to paint an autumn landscape, trees with yellow leaves. All right – when I conceive it as a symphony in yellow, what does it matter whether the fundamental colour of yellow is the same as that of the leaves or not? It matters very little. ... Much, everything, depends on my perception of the infinite variety of tones of one and the same family.'

1 I began with an outline drawing in Cadmium Light Red, using the acrylic paint substantially thinned with water and a small, fine-pointed synthetic-haired brush – more suitable for acrylic paint than sable – to draw with. I had lightly sketched this outline in pencil previously, so my drawing in paint sat on top of it. This explains why it is so tidy and precise.

2–4 When painting a portrait in the manner of Van Gogh, you must look at your subject and translate the colours that you see to make them more vivid than they really are. They should relate to your observations in some way, but may be very liberal interpretations of reality that let you

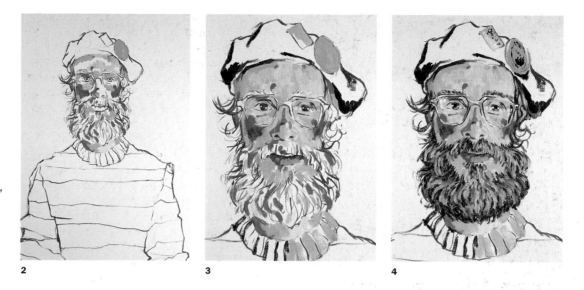

2 3 4

make use of the beautiful colours at your disposal. I looked at my subject's head and considered the flesh tones to be varieties of orange and pink, but this is a very simplified description of what I actually saw. You should look for a sense of colour, a hint of colour, perhaps an undertone, that suggests the idea of something bright that you have on the palette. A rich flesh tone with a hint of brown, for example, can be conceived of as an orange and is then painted as a value of orange rather than as a carefully matched colour.

I started painting Kevin's face with tints of Cadmium Orange and White and Cadmium Light Red and White. I also used a Cadmium Yellow in alternative versions of these tints and put some of it pure into the hair and beard. Evenly delivered, side-by-side strokes were used to create patches of colour, corresponding approximately to areas of colour that I could perceive. As each area of colour was noted and represented, the gaps in the painting filled up and the face took shape.

The tonal relationships are more important than the precise colours. The pale pink, creamy orange, deep orange and deep pink tints simply represent light tones, mid tones and dark tones of flesh values in their proper places. The other

eccentricities of my colouring are no more than reactions to genuine observations – the spots of pure Cadmium Orange on the forehead are a simplified representation of some freckles, placed spontaneously. The vivid pink on the nose, a tint of Red Lake, shows how it had caught the sun; pale blue and green serve as areas of neutral shadow and reflections produced by Kevin's glasses. The green around the eyes is a far-fetched interpretation of fact. I painted the cap badge with it and as it was on the brush it was used for a neutral value that was difficult to determine. I knew that as a green it would interact favourably with the surrounding colours based on red and orange.

The eyes were painted with purple and a blue green tint to prove how arbitrary you can be, but also in the knowledge that these colours would work well together. The beard was painted with yellow, orange, Red Lake, pale blue, dark green and the same blue-green tint that was used for the eyes. Some traces of the Cadmium Red drawing also survived. Several of the colours were used quite pure, for example, the Cadmium Orange, Phthalocyanine Green and Red Lake. The essential relationships between these colours and, most importantly of all, their tones are correct, but they are not literal observations.

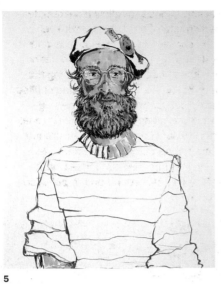
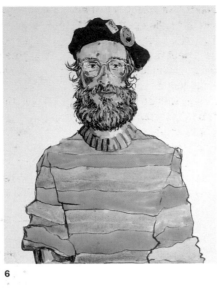
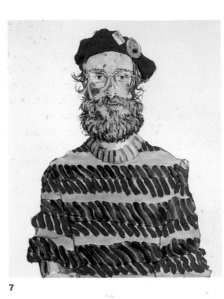

5

6

7

5–8 The head was painted to completion at a single sitting. Try to do this if you can, but you must allow breaks for yourself and your sitter. The rest of the painting was finished from brief written notes with a scribbled diagram that explained the colouring of the clothing, while the background was shamefully borrowed from Van Gogh.

Since the colours you are going to be using are not closely matched to reality, it is possible to work from colour notes – at least for less important aspects of a painting, like the clothing in this case – so long as they are based on real observations. I have no reason to suppose that Van Gogh ever did this, but it is something you might consider if your work done in this manner could not be finished directly from life.

The drawing in Cadmium Red showed me how the bands of colour crossed the jumper. I painted these first with dilute washes of orange, green and blue. In at least one of his paintings Van Gogh has laid continuous washes of colour beneath the heavy strokes – this could be another way of taking colour notes, but on a white ground it also provides a continuity of colour between the heavily applied strokes that follow and prevents the effect being spoiled by tiny patches of white showing through.

In reality this jumper was a subtle harmony of heathery colours, but the colours I painted it in did exist among its threads – I have wildly exaggerated them. First of all I put in diagonal strokes of the same colour as the underlying wash, used pure and at tube consistency. In oil colour these brushstrokes might have created a deliciously rich impasto effect, but artists' acrylics are, in comparison, a feeble medium and their capacity for impasto at a single stroke is strictly limited. Only on the beret and eventually in the background did I succeed in achieving some surface quality in this painting.

Once these diagonal strokes had been placed, I then went back over the jumper filling the gaps in between with the colours my notes instructed – red between blue, green between orange and purple between green. Then, because it did not look particularly like a jumper, I added some short horizontal strokes on top of the diagonal ones suggestive of individual threads (*opposite, above*). These were painted either lighter or darker than the strokes they were on top of. The result was suitably crazy in its colouring, more removed from reality than even Van Gogh would have made it, but nevertheless painted according to his principles.

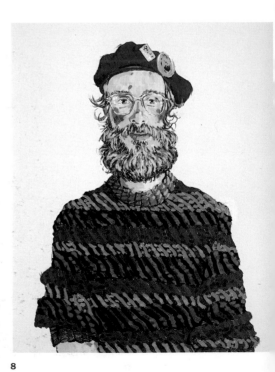

8

9–10 The background to Van Gogh's last self-portrait is composed of swirling patterns with tonal variations that make it look like a plain colour seen through a heat haze. There is a theory that the strong medication he was taking before he shot himself actually made him see like this. It could equally well be the product of his deranged mind, but his explanations of his painting technique are generally quite rational, so this may be no more than an affectation designed to break up flat colouring, like the woven pattern of brushstrokes demonstrated in my *Still life with yellow flowers* (p. 116).

In any event, I chose to follow his example for the background of my painting, with yellow as a striking contrast to the blues, reds and greens of the portrait figure. I began creating the swirls with spaced-out strokes, using tints of Cadmium Yellow and White. Gradually I filled in the spaces between them and joined up the patterns that began to emerge using tonal variations of colour. The wisps of hair around the head are remnants of the Cadmium Red brush drawing that began this portrait and were carefully painted around and in between to preserve them.

9

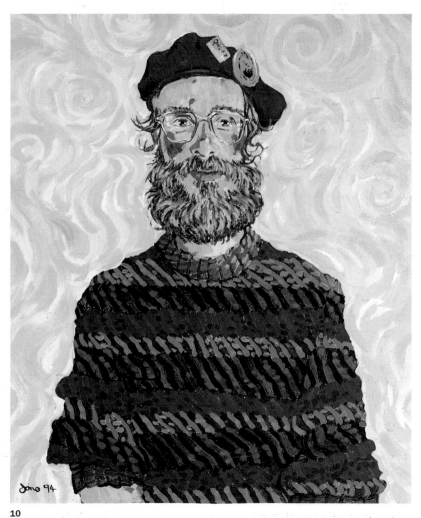

10

2.5 PORTRAITS

Portrait of Angela using the methods of Morisot

MATERIALS

Canvas
A standard stretched canvas of acrylic-primed cotton with a white ground, re-primed a warm cream. Size 16" x 20" (40.6 cm x 50.8 cm).

Paint
Artists' quality oil colours. Separate palettes were used at each sitting based on:

Burnt Sienna
Burnt Umber
Cadmium Light Red
Cadmium Yellow
Cobalt Blue
Hansa Yellow Pale
Ivory Black
Raw Sienna
Red Lake (Rose)
Titanium White
Viridian
Yellow Ochre

A painting medium was kept on the palette for use with these colours, as and when needed, to help them flow. An easy brushstroke is of paramount importance here – sympathetic handling qualities from the paint are vital.

Brushes
The majority of the painting was done with size 2 long flats, but size 6 long flats were also used for the background and costume.

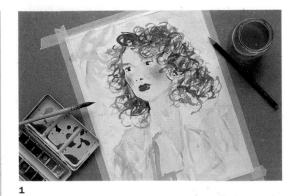

1

Morisot is too often overlooked and the influence of others on her is all too often overstated. She was unquestionably a highly original and individual talent, but her method was very personal and there is little authentic information from which her techniques can be reconstructed. This demonstration is simply my attempt to make sense of the few facts I have.

There are several striking features about Morisot's paintings: one is the fabulously free brushwork, often involving zigzagging strokes; another is the predominance of pale colours in light silvery tones, a mannerism that she must have learnt from Corot. He was indirectly her teacher and became a family friend. Another aspect of Morisot's technique is that the edges of her paintings are frequently unfinished. This is consistent with impetuous brushwork that quite literally runs off the edge of the canvas as it is done. The colour of the ground tends to show because of this and a tint is usually in evidence. Cream seemed an appropriate choice for my painting in her manner.

Finally, there are a number of small watercolour sketches by Morisot that correspond to larger paintings in oil. These may be preliminary studies done on location that enabled her to reconstruct the subjects in the privacy of her garden – her paintings often involve figures and the landscape backgrounds are vague, so this would have been quite practical. However, their exact purpose is unclear. I decided to start this portrait with a watercolour sketch to see if it contributed in any other way to her technique.

FIRST SITTING

1 Morisot's watercolour paintings are even looser than her oil paintings. They consist substantially of single-touch, brush-shaped strokes rather than lengthy manipulative ones meant to spread a watercolour wash. There are relatively few colours laid over previous ones and strips of untouched paper often remain between them. These factors suggest fast work, which would be entirely in keeping with Morisot's mannerisms in other media.

My watercolour study began, as Morisot's usually did, with a light pencil outline, quickly and almost carelessly drawn. I used a traditional wire and quill bound squirrel hair brush – suggested by the marks on her works – and painted by dabbing strokes from it and making loose scribbles from the point. You might find an ordinary size 8 or 10 round watercolour brush equally suitable.

I painted directly from the model and worked as I imagined Morisot would have done, but the result was not a good likeness. This did not surprise me, but I was surprised at how easy it then was to repeat the idea on canvas. When I came to paint the same subject again in a different medium and on a larger scale, I was fairly certain about what to do. So possibly Morisot's real purpose was to familiarize herself with the technicalities of an intended painting before carrying it out.

In this example, it never occurred to me at the time to do so deliberately, but I discovered afterwards that I had used exactly the same range of colours for the lay-in on canvas as I had for the watercolour painting. The time taken struck me as significant too – the watercolour sketch and the preliminary lay-in on canvas only took an hour and a half together. If you compare them you will see that the brushwork and colouring of the watercolour sketch and first stage on canvas are remarkably similar – one is practice for the other.

2 The *ébauche* – the preliminary lay-in using oil colour – was very sketchily done. From the very beginning I deliberately painted with wild and

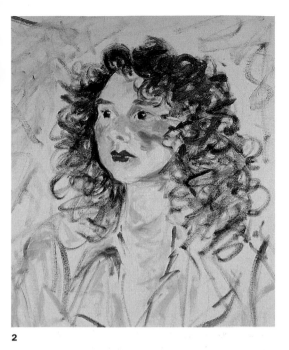

2

because you just have to work instinctively, but I can say that you should not think too much about what you are doing and should just paint. Aim for a result that is really a coloured brush drawing rather than a serious attempt at painting.

If you look closely at what I did, there is very little paint on the canvas, but the coloured ground stands in for it. The forehead, neck and several smaller areas of the face are represented by the virtually untouched cream priming – it also forms a substantial amount of the blouse.

SECOND SITTING

3–6 The face and hair were painted virtually to completion at the next sitting – you can see in this sequence of illustrations how they progressed. I began by going over the face and neck more thoroughly with flesh tones. I observed my subject carefully, of course, but also used the lay-in – the *ébauche* – as a guide. At first the colour was put on loosely with broad strokes and the flesh values were not carefully judged. I particularly misjudged the strong pink across the cheeks, nose and forehead.

Almost immediately I reworked the face, painting into and over this first application of colour with paler pinks, using a light dancing brushstroke. Looking at the paint surface, you might at first take this to be diagonal hatching and in a way it was. I was constantly repeating Morisot's zigzag motion of the brush as I painted, but only touching the canvas with certain parts of the stroke.

Try hatching lines with a pencil on a piece of paper very quickly and you will see what I mean – your hand actually traces a zigzag pattern. I think you have to repeat this action almost continuously when painting like Morisot, but the brush should not be in constant contact with the canvas. This means that the strokes fly about in an apparently random way, although they are, in fact, under quite considerable control. Note the small zigzag stroke by the nose and the dark zigzag strokes through the eyebrows – my hand was constantly tracing out this movement while painting.

Straight tints of Cadmium Light Red with Titanium White were mostly used for the flesh. You need a small amount of Cadmium Light Red and a lot of White for the very pale values seen here. A light grey was used to shade the flesh around the eyes and beneath the chin. This was my way of achieving the silvery toned colouring that I associate with Morisot.

abandoned brushstrokes, using a zigzag stroke wherever I could – starting at the top and zigzagging downwards as I put colour on. As far as possible I worked as I imagined Morisot did – laying on paint without a moment's hesitation. I cannot really tell you what to do

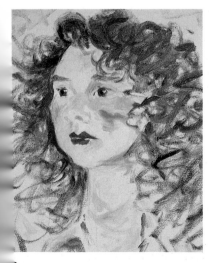

3

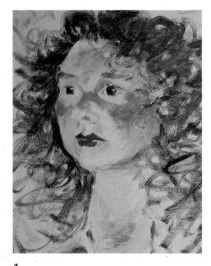

4

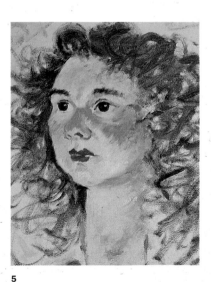

5

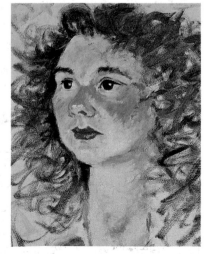

6

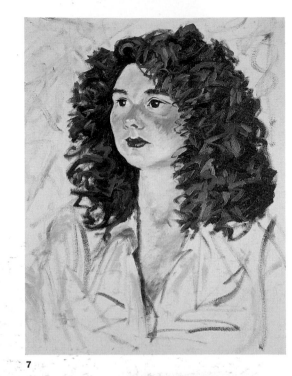

7

– until the space occupied by the hair was filled. Obviously I studied the hair as I painted, but only for a general idea of light and shade. I made no attempt to put each curl in its proper place. Black zigzags were also worked into the wet earth colours to extend the range of tone. The curls overlapping the face and around the outline of the head were studied before being painted and represent a simplified version of reality.

FINAL SITTING

8 The time that elapses between portrait sittings is valuable as it lets you reconsider what you have done. At the final sitting I added a few finishing touches to the face that reworked it in very minor, but important ways. The grey shadow between the nose and the eyes was reduced, for example, and the white of the eye on the right was extended by a very small amount around the left-hand side of the coloured iris. A few softening touches were added to the nose and mouth as well. You have to look at your subject to see if alterations are necessary, but do not overdo the retouching – the painting must retain its fresh, spontaneous feel.

The curls falling forward by the eye on the right-hand side were also put in with some care *(opposite, above)*. These had been noted in the original lay-in, but had been painted out as the face was worked on. You cannot confine fast, free brushwork to preserve minor details – if they get painted out you just have to put them back in. The blouse was painted with a very light tint of lemon containing a great deal of White. Heavy, zigzagged strokes of pure White provided the highlights, while the shadows were put in with a silvery grey and a few wet-in-wet strokes of Burnt Sienna. The blouse was painted very casually, almost carelessly, and a good deal of what you see is still the cream priming *(opposite, below)*.

The background was completed with Viridian and White, chosen for its pale silvery coolness rather than as a means of representing any object, though Morisot sometimes poses figures in front of vaguely indicated plants or bushes. A zigzagging motion and strokes radiating outwards

7 I asked Angela to sit for this portrait because of her hair – you can see how it leant itself to the use of zigzag brushstrokes *(above)*. The original lay-in of the hair was just painted over repeatedly with fluid zigzag strokes of earth colours – pure and intermixed with an occasional touch of White

from the head left the edges of the canvas poorly covered – just like in a Morisot. The background was painted everywhere at once, so that my irregularly mixed tints, encouraged by adding more Viridian, or more White to the brush in between strokes, were spread around. Because the junction between the hair and the background was complicated, the edge of the hair was the last part of this painting to be painted – perhaps I handled it with more care than Morisot would have done, but you must always do what seems right in your own painting.

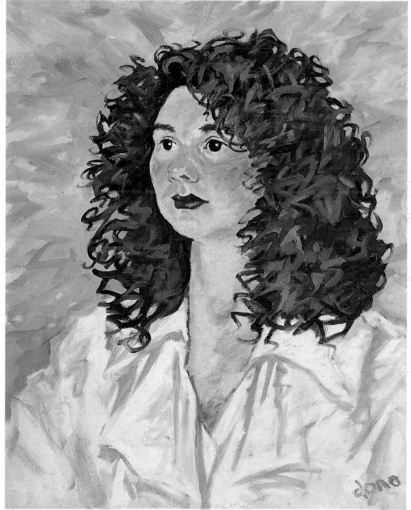

8

2

2.5 PORTRAITS

Portrait of Tricia using the methods of Degas

MATERIALS

Canvas
A cotton canvas with a white acrylic ground. Size 20" x 16" (50.8 cm x 40.6 cm).

Paint
Artists' quality oil colours, using mostly earth colours, Black and White.

Brushes
Size 6 long flats and sizes 2 and 1 rounds in bristle.

Other materials
Red and yellow soft pastels, Indian ink, linseed oil, siccative oil, a piece of rag and a transparent orange oil colour mixed from Red Lake and a Yellow. This was only used for the glazed priming and was separate from the colours painted with. For the original drawing soft black chalk and pastel paper were used and tracing paper was employed during its transfer, but was not strictly necessary.

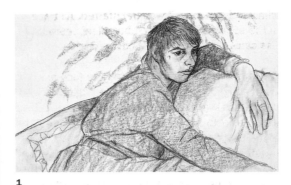

1

2

3

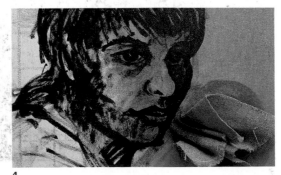

4

1 The technique demonstrated here is based on Degas's actions, though the actual chain of events is of my own making. This portrait began as a drawing done from life in soft black chalk on off-white pastel paper. Degas's practice of working from drawings and not from life apparently also extended to his portraits. As Morisot recounted to her brother: 'Do you know that Monsieur Degas is mad about Yves's face, and that he is doing a sketch of her? He is going to transfer the drawing that he is doing in his sketchbook on to the canvas. A peculiar way of doing a portrait!'

2 This was an experiment and I was more interested in the processes than the result, so I decided to work with just the head from my drawing. There are various ways of transferring a drawing to a canvas, but the one that suited my purpose here was squaring up – a technique that Degas definitely used.

Squaring up particularly suits situations where an alteration in scale is necessary, although that was not the case here, but you will see why I chose this method shortly. When squaring up, the drawing being transferred is covered with a grid of squares and then a similar grid, perhaps larger or smaller, is drawn over the canvas. What appears in each corresponding square is copied from one grid to the other. It is usual to draw the grid directly on to a working drawing, but I did not want to spoil my original drawing and so used a piece of tracing paper marked with a grid in ink held over the drawing with a paper clip to prevent it moving.

3 Georges Jeanniot gave a fascinating account in his memoirs of a visit by Degas to his studio, during which Degas toned a canvas over an Indian ink drawing employing the method I now used. He did not actually transfer the drawing as I have done, but this is an obvious possibility.

Degas took one red and one yellow pastel and squared off the canvas using one colour for the vertical lines and the other for the horizontal ones, so I did the same here. Then I transferred the drawing rather crudely with one of the

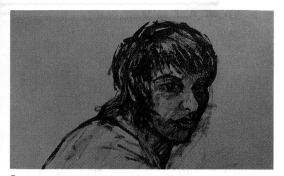

5

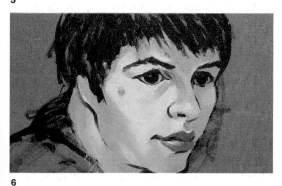

6

with no sign of how it was transferred. All trace of the squaring up in pastel has disappeared. The canvas was then put aside to dry.

6–8 A week or so later I painted the face as Degas might have done, using the original drawing as a reference for light and shade. I was also able to correct some of the deficiencies of the transferred drawing at this stage, again by referring back to the original. As earth colours are more likely to appear in Degas's works than bright colours, I completed the painting with a palette composed chiefly of them. An orange or orange-brown glaze-like tone does appear in several of Degas's works, suggesting he may have adopted a similar procedure at times.

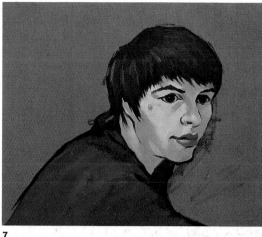

7

pastels, copying it square by square, and with that as a guide, repeated it over the top in bold strokes with Indian ink as Degas advised.

4–5 According to Jeanniot, Degas then asked for some linseed oil, turpentine and siccative – something that accelerates the drying of oil – and mixed these together. He then used them to brush over the canvas, dislodging the pastel as he did so and creating an orange glaze through which the Indian ink drawing remained visible. I tried to do the same, but soon found that while the pastel could be wiped away, its tinting strength was insufficient for an orange glaze. Degas's pastels must, therefore, have been very soft and extremely rich in pigment. As mine would not give the desired result, I resorted to using an orange-coloured oil glaze. I applied it to the canvas using a rag soaked in painting medium with a circular spreading motion to produce a thin, even colouring. The result is a toned orange ground with a black ink drawing

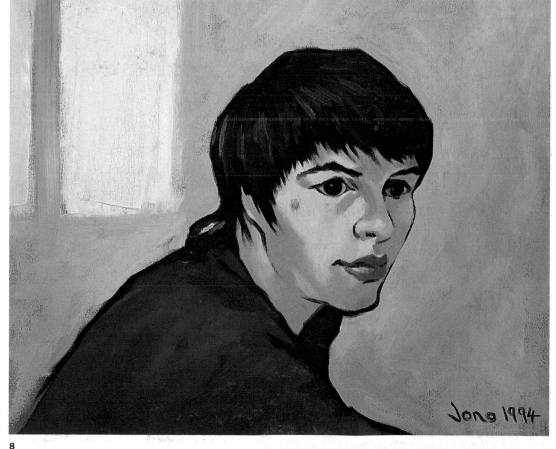

Jono 1994

8

2.5 PORTRAITS

Portrait of Tricia using the methods of Manet

MATERIALS

Canvas
A standard stretched cotton canvas with a white acrylic ground – primed a pale grey with artists' acrylic colours. Size 14" x 18" (35.6 cm x 45.7 cm).

Paint
Artists' quality oil colours.

Burnt Sienna
Cadmium Light Red
Cadmium Yellow
Lamp Black
Raw Umber
Red Lake (Deep)
Titanium White
Yellow Ochre

Brushes
An assortment of bristle brushes. Sizes 6 and 2 long flats accounted for most of the painting, but small rounds were also used. A crank-bladed palette knife was essential.

This portrait was inspired by two of Manet's works. His sketch *'Au Bal'* (*c.* 1875) suggested how I should paint the hair and his portrait of *Berthe Morisot with a Bouquet of Violets* (1872) prompted the theme – a head and shoulders portrait of a figure wearing black, lit from the side.

This example was a straightforward and natural piece of painting, but I did constantly consider what Manet would have been likely to do in the same circumstances. The method shown is probably very close to his. I began by acting instinctively and then reacted to what happened, letting a technique evolve as I painted. This is how you paint like Manet, allowing the success or failure of what you have just done to determine what you do next. The same simple elements of technique are used again and again, but the order of their employment is ultimately subject to chance. You keep on trying until you get a satisfactory result.

Manet would have painted each work differently. My demonstration is just one example of how to apply Manet's methods to create a portrait. Do not expect your attempts to follow quite the same path, but work according to the same general principles, judging for yourself what is necessary and, either by a longer or a shorter route, you will arrive at a finished painting.

FIRST SITTING

Firstly, I positioned myself and my subject, Tricia. She sat so that the light illuminated her face as I wanted it to and I stood where I could see her and the canvas at the same time. The lighting here is rather complicated – the face is lit strongly from the left by a window out of the pictorial space and there is also a window behind the figure that creates some soft highlighting around the contours of the shadow-side of the face. Some of you will find it easier to use a source of light coming from one side of the figure only. Always paint under conditions that both you and your model are comfortable with and only work in natural light.

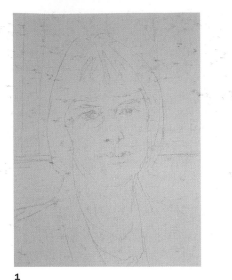

1

My choice of materials was, of course, conditioned by Manet's. Like his, my palette was dominated by earth colours, Black and White; to begin with, the only bright colour on it was Red Lake, although Cadmium Light Red was added soon afterwards. The pale grey priming of the canvas, the long, flat and round bristle brushes and the crank-bladed palette knife were similarly judged appropriate for Manet's methods.

1–4 I started with a light positioning sketch in Conté crayon done directly on to the canvas and then painted in the hair with broad strokes of Raw Sienna and, for the shaded areas, Raw Umber, both mixed with Red Lake.

I put the hair in first because I did not want to get White in it when I took it off again. I then use the palette knife to scrape down, leaving just a thin covering of colour over the pale grey ground. The effect of adding Red Lake to the earths was then apparent as a radiant deep red-brown was obtained. Immediately afterwards highlights were dashed into it with tints of Ochre and White from a long flat brush used on its edge. These blended into the red-brown as they were put in, producing a quite different colour. Traces of the original tint were also left showing to give sparkling, irregular highlights as the two mixed imperfectly.

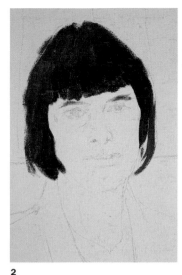

2

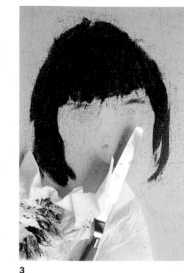

3

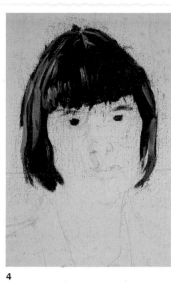

4

Looking at my subject determined which value to put where – however, my decisions may have been more conscientious than Manet's as he apparently considered a single tone sufficient for light areas and an abrupt change to shadow preferable to the careful representation of values that the eye does not instantly take note of. In my completed portrait the divisions of tone are simpler than they appear at this stage, but it is difficult to ignore what you see while you paint.

7 At the end of the first sitting I had a representation of the face made up of patches of colour and tone placed mostly with long flat brushes. When painting as Manet did, you must be able to judge your own work critically – I knew this was wrong. It was too fussily painted, was not a good enough likeness and the alignment of the features was incorrect. Even the best portrait subjects move as you paint from them and such errors easily creep in. A hazard of direct spontaneous painting, like that practised by Manet, is that you simply cannot keep everything under control, so do not be surprised if you stand back after a period of concentrated effort and discover that what you have achieved is not as good as you thought.

You can encourage this effect by controlling the loading of the brush and the lightness of the stroke. You only have one chance to do this right, so look at the subject, observe the highlights in the hair and place them accordingly. If it is wrong, either you can remove everything and start again from the beginning, or else you can continue with opaque tints, correcting your work as necessary to salvage some of the effect. If it goes disastrously wrong, just repaint it in opaque tints – there are no rules.

5–6 Next, I went on to the flesh tones which were mixed from Yellow Ochre and White with a little Burnt Sienna and either a touch of Red Lake, or Cadmium Light Red, or both. The exact mix varies from tone to tone. Raw Umber and Black were added into the shadows. I was using the bright reds to increase the richness of the flesh tones that were mixed from earth colours.

Working against a grey ground is very useful because it stands in for shadow and you can gauge the effects you are creating before they are complete. I started with the lightest parts of the face and placed tone against tone, meaning that the different flesh values were put on side by side, touching each other, but not worked together – Manet might have done the same.

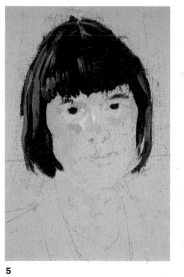

5

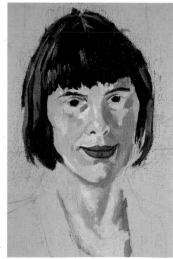

6

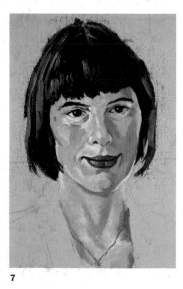

7

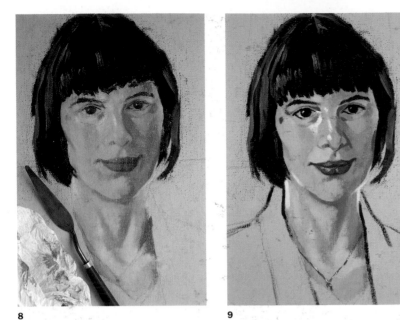

8

9

10 With the portrait head complete, the clothing was added. Cadmium Yellow was now put on the palette to mix with the reds and with White for the tangerine orange blouse. The brooch was painted with Yellow Ochre, and White and Black worked wet into wet. The black jacket was put in last. I began to paint it with pure Black for the folds and shadows and then with deep greys for the areas in between. White was painted into these with confident strokes to create the pale grey highlights around the shoulders and collar.

11 Finally, the background was added. A rough representation of the studio window behind the figure provided the firm edge to the head and the contrasts of tone that put what I had already completed into context.

The portrait palette

Portraits require an organized palette (opposite, top to bottom). Here mine was set out with only the colours needed to begin with. Next, you can see it at the end of the first sitting and at the end of the second. Between these stages the mixing area was scraped clean with a palette knife so that fresh, unsullied colours could be produced once more. Then it was scraped clean again before the background colours were mixed on it.

Note how the original line of colours was gradually extended as others were needed, although the blue in this instance was never used. The relative importance of the first colours laid on the palette is evident from the extent to which they have been employed. Note also the soft consistency of the White – fluid colours that handle well are necessary for Manet's methods.

8 I knew that if Manet was dissatisfied he would have scraped off the paint and started again, so that is what I did. As you can see the palette knife only takes off the paint that stands proud of the canvas and does not touch the paint embedded in its weave. If you have painted tone against tone, each colour will go right down to the ground, so a ghost image of what you have done stays in place when you scrape off. The presence of fast-drying earth colours in the flesh tones also increased the amount of paint that stayed in place in this instance. Note that I avoided scraping off the hair as well as the face, since I considered it to be satisfactory.

SECOND SITTING

9 Another shorter sitting the following day gave me a good likeness and a more impressive piece of painting. It is, of course, deceptively good because it looks as though it has been painted instantly and directly when in fact it was painted over the remnants of a previous attempt – repeating the good aspects of the original version and correcting what was wrong. Traces of the grey ground are also visible now as a result of

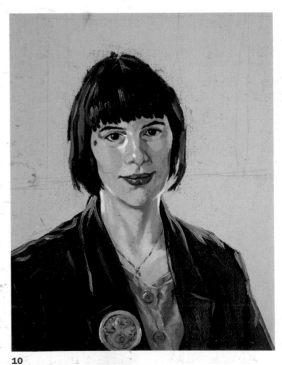

10

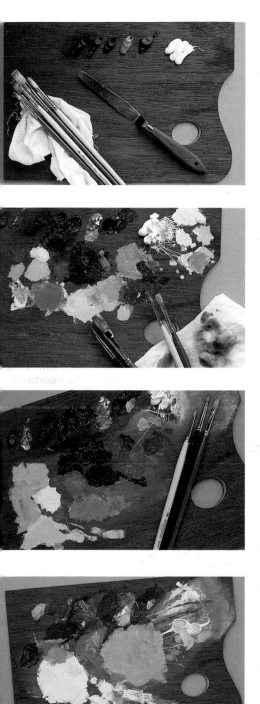

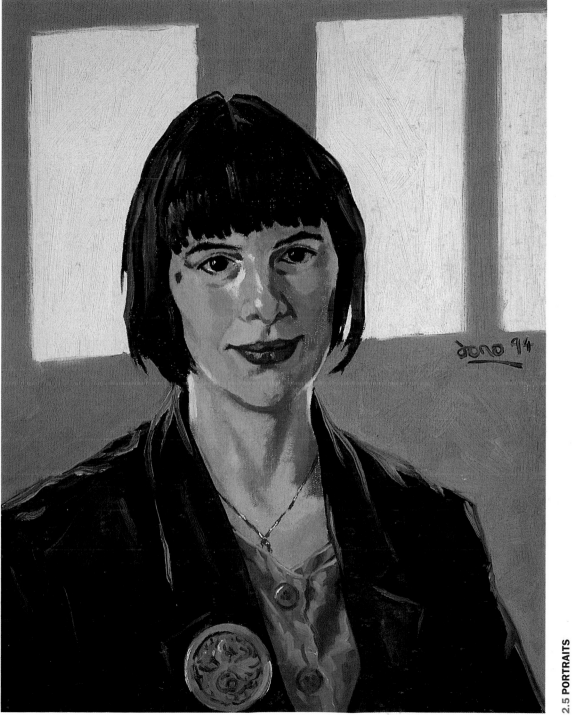

11

2.5 PORTRAITS

Portrait of Amy and Sophie using the methods of Renoir

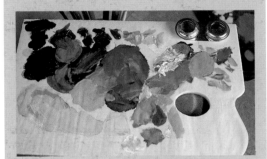

MATERIALS

Canvas
A standard stretched cotton canvas with a white acrylic ground. Size 20" x 24" (50.8 cm x 60.9 cm).

Paint
Artists' quality oil colours.

Cadmium Light Red
Cadmium Yellow
Cobalt Blue
Hansa Yellow Pale
Lamp Black
Phthalocyanine Green
Red Lake (Rose)
Titanium White

A double dipper containing painting medium and turpentine was used at all times.

Brushes
One size 6 long flat; several rounds in sizes 4, 2 and 1 – all in bristle.

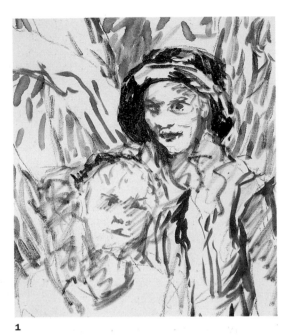

1

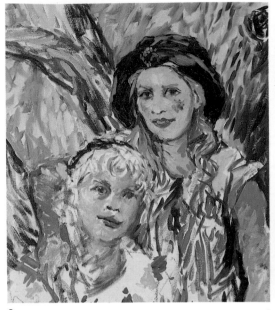

2

This double portrait in the manner of Renoir tackles the difficult topic of painting children. It began outside with the two girls posed against a tree as they appear in the finished painting, but proved impossible to complete under those conditions and was continued with formal sittings. It was still done directly from life and aimed to be faithful to the original impression, but the method was a compromise between practicalities and Impressionist principles. This is what Renoir would have done and you should be prepared to do the same – it may be the only way you will get a finished painting.

Renoir said he had no methods, but that is not strictly true. He painted without applying a definite technique, approaching his result by trial and error, but his paintings often reveal a sensible working process. This varied from the beginning to the end of his career and from painting to painting, but there are recurrent themes and my work is based on some of those.

Renoir appreciated traditional craftsmanship in painting and was capable of more subtle and advanced techniques than most of his fellow Impressionists. His works, especially his figure paintings and portraits, often have a light beginning, a central period of development and then some delicate finishing on top. This is quite a traditional approach, but Renoir merged these stages into a fast and slightly out of control process, where the vagaries of working from reality took over. The clear cut distinctions between the purpose and result of each session then become blurred.

FIRST SITTING

1 This portrait started with a very rapid and simple positioning sketch in charcoal immediately followed by the use of very dilute paint. A medium of sun-thickened oil and turpentine was added and further diluted with extra turpentine. At first I only used pure colours or pure mixed colours – that is to say with no White added. The paint was thinned down to the consistency of a wash and was applied with large strokes that took account of the background detail. The bark of the tree and the sky seen through the fluttering leaf cover behind it are already being suggested by the brushwork at this stage.

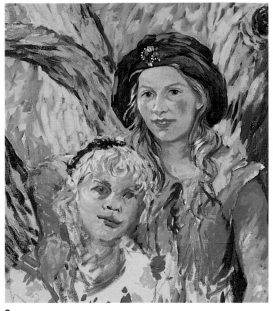

3

2 Continuing with very thin paint, still adding plenty of turpentine and just a little medium to it, but now putting White into the colours to make opaque tints as well. This process of capturing the impression went on until I had virtually covered the canvas and established the whole painting. This was the end of the first sitting.

SECOND SITTING

3 The following day I attempted to carry on painting this portrait direct from my subject at the same place and time, just as you would when doing an Impressionist landscape, but that idea did not work and I began to lose the beginning of the likeness from Amy's face. I was able to add some more carefully judged colouring to the trees and began to work up the values of Amy's pale blue dress on the right, now using richer paint with more medium and less turpentine in it.

This did not get me very far, except that it proved the need for a more controlled environment for portrait painting. I remembered that Renoir posed models in his garden and later in life did portraits in the studio, so I followed his

example. From then on I worked from each of my models separately, not re-creating the whole pose, but positioning the heads so I could study them properly. I was careful to paint under similar lighting conditions to those that had originally existed, not in precise detail, but in general concept. The light had been entering the pictorial space from the left to begin with, so I positioned my models with light falling the same way across their faces.

STUDIO SESSIONS

4 I worked on Amy's face first, progressing this far in one studio sitting. It was done entirely with narrow strokes from round bristle brushes in sizes 1 and 2 – not with slow, cautious movements of the brush, but mostly flicks of the brush tip or light sweeping gestures that touched the canvas and left it with a spring. They curve as if wrapped around the face, helping to describe its shape.

Adding medium makes the paint fluid so the brushstrokes mingle as they touch and, although not actually blended out, they become almost

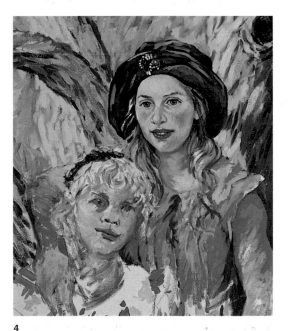

4

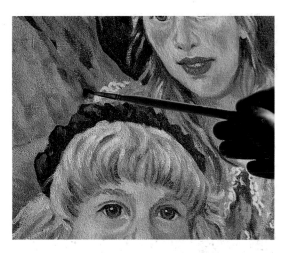

Holding the brush

The softness of Renoir's manner, as it is seen in some of his portraits and figure paintings, is very difficult to imitate. It is partly dependent on his use of fluid paint, partly on his use of colour and partly on the quality of his brushstrokes. It seems likely that he held the brush well back on its handle, aiming the stroke from a distance which encourages the making of a quick dab, or flick, and limits the tightness of control that the painter has over the stroke. Perfect accuracy is thus avoided and the cumulative effect of the many tiny vagaries of the imperfections introduced by such strokes is a shimmering softness of the overall image quality. For all of this painting, the brushes were held as seen here (above).

Adding medium

You should increase the concentration of medium in your painting as the layers build up. This obeys the important principle of working fat over lean. For this portrait I used sun-thickened oil diluted with turpentine as a medium to which extra turpentine was added. This is a fast-drying traditional version of stand oil that Renoir may have used and would certainly have read about in Cennini's Il Libro dell'Arte – an early text on painting that interested him. This soon becomes sticky and may not suit all of you, so I would suggest experimenting with different oil painting mediums to find one that you like. The palette shown (below) is laid for work on a face and carries a double dipper containing painting medium and turpentine.

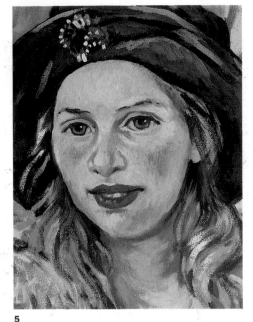

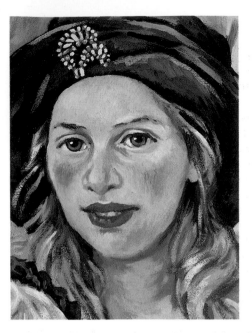

5

invisible. You may have to get quite close to a work by Renoir to see them. The gradual build up of fluid paint also fills the canvas weave and any roughness in the underlying paint, making repeatedly worked-on areas like this face smooth and enamel-like.

Renoir painted pale complexions, some of which appear to have been done or finished with very delicate pinks, possibly White barely tinted with Red Lake. I have used this idea here, but occasionally added tiny amounts of Cadmium Light Red as well, for a warmer, deeper tone. The shadows are purple – Red Lake, Cobalt Blue and White. As Renoir caused quite a sensation when he first shaded flesh with purple, it seemed appropriate to do the same in this example. Renoir tried to avoid deep shadow and exact contours, which are often necessary in portraiture, so this is a difficult principle to apply. I decided that it was more important to obtain a likeness than to follow him exactly.

5 Amy's face was not worked on again until it was dry and the painting was almost finished. The changes made to it were subtle, but

important. The highlights in the eyes were moved to match those in Sophie's eyes and the whites of the eyes were highlighted as well to confirm the light coming from the left – never paint the whites of the eyes pure White, then you can do this. In this painting they were originally a pale flesh tone tinged with purple.

The corner of the mouth on the left-hand side was softened at this stage and the jawline, cheeks and forehead were retouched with more light brushstrokes of fluid, medium-rich paint. The brooch on the hat was completed as well *(above)*.

6 Sophie's face was painted in two sittings followed by a series of final adjustments made without her to refer to. Sometimes, especially when painting children, it is better to limit the potential confusion caused by working from life. At each successive covering of paint the image becomes more refined. You can work over the previous layer without waiting for it to dry, but do not force the pace. On this painting and I suspect on many of Renoir's, sessions of working wet into wet or wet over wet are

alternated with working wet over dry. You can see Sophie's face after the final corrections and attempts at improvement had been made.

7 I thought this painting was finished and put my signature to it when both portraits seemed complete. A few days afterwards, I decided Sophie's face was not good enough and made some alterations. I also reworked the sky and added a few finishing touches with glazes – pure colours made very dilute by thinning them with a rich painting medium for a transparent effect. Renoir did not use glazes extensively, but they are a minor aspect of his technique and it made sense to add a few here. He applied them as separate brushstrokes and not as flat coverings of colour, which is a traditional way of using them.

Renoir's own paintings frequently show signs of alteration and ongoing changes or late corrections should be regarded as part of his method. It is always useful to look again at a portrait that you think is complete after a short interval, so that you can see it with fresh eyes and know whether it is really finished, or not. Renoir did not look for absolute perfection, though, and neither did I in this example.

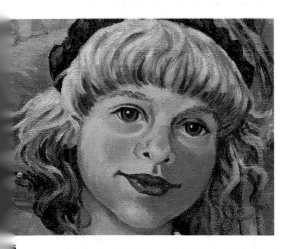

6

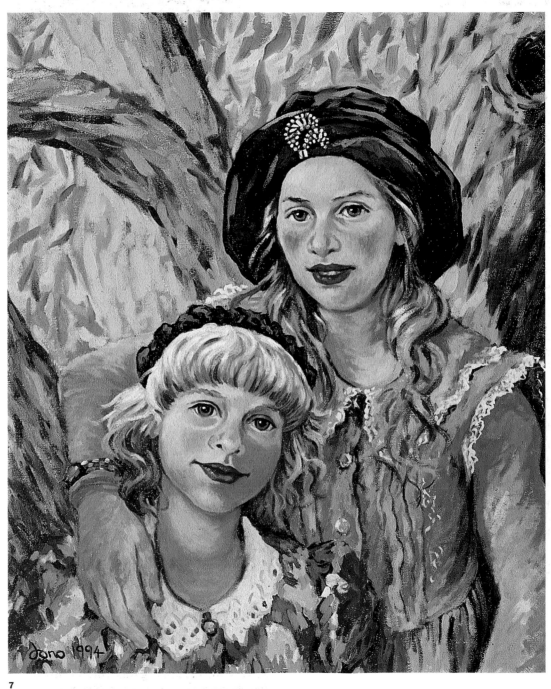

7

I should like to thank all the manufacturers and suppliers of art materials who either directly, or indirectly, helped with this book. My thanks are also extended to Ann Hickman, who transcribed and typed up my text, for her invaluable assistance.

LIST OF ILLUSTRATIONS

Measurements are given in centimetres, followed by inches, height before width.

2–3 Edouard Manet, *Music in the Tuileries Gardens*, 1860–62, 76 x 118 (30 x 46½). Reproduced by courtesy of the Trustees, The National Gallery, London

5 see p. 10; see p. 43

7 Claude Monet, *Rouen Cathedral, the portal and the Tour Saint-Romain, full sunlight. Harmony in blue and gold*, 1893, 107 x 73 (42⅛ x 28¾). Musée d'Orsay, Paris. © Photo R.M.N.

9 Claude Monet, *Field of Poppies, Giverny*, 1885, 60 x 73 (23⅝ x 28¾). Virginia Museum of Fine Arts, Richmond, VA, USA. Collection of Mr and Mrs Paul Mellon

10 Gustave Caillebotte, *Self-Portrait*, 1892, 40.5 x 32.5 (16 x 12⅞₆). Musée d'Orsay, Paris. © Photo R.M.N.

Pierre-Auguste Renoir, *Berthe Morisot*, 1892, etching

Pierre-Auguste Renoir, *The Engaged Couple* (detail), *c.* 1868, 106 x 74 (41¾ x 29⅛). Wallraf-Richartz Museum, Cologne

Camille Pissarro, *Portrait of Paul Cézanne*, 1874, etching, 26 x 20.6 (10⅝ x 8¼). Bibliothèque Nationale, Paris

Paul Cézanne, *Portrait of Camille Pissarro*, 1873, drawing, 10 x 8 (3⅞ x 3⅛). Cabinet des Dessins, Musée du Louvre, Paris

Pierre-Auguste Renoir, *Self-Portrait*, *c.* 1875, 85 x 60.5 (33½ x 23⅞). Sterling and Francine Clark Art Institute, Williamstown, Massachusetts

Pierre-Auguste Renoir, *Portrait of Claude Monet* (detail), 1875, 85 x 60.5 (33½ x 23⅞). Musée d'Orsay, Paris. © Photo R.M.N.

11 Henri Fantin-Latour, *A Studio in the Batignolles Quarter*, 1870, 204 x 273.5 (80¼ x 106¼). Musée d'Orsay, Paris. © Photo R.M.N.

Paul Gauguin, *Self-Portrait in front of an Easel* (detail), 1883/1884–85, 65 x 54.9 (25⅝ x 21⅝). Private Collection

Vincent Van Gogh, *Self-Portrait*, 1887, 44.1 x 35.1 (17⅜ x 13¾). Musée d'Orsay, Paris. © Photo R.M.N.

Gustave Courbet, photograph (detail)

Edgar Degas, *Self-Portrait* (detail), etching, 1857

Eugène Boudin, photograph

Mary Cassatt, *Self-Portrait* (detail), *c.* 1880, 33 x 24 (13 x 9½). National Portrait Gallery, Washington, D.C.

Camille Corot, photograph

12 Nadar's studio, *c.* 1890, photograph. Bibliothèque Nationale, Paris

Title-page of the catalogue of the first Impressionist exhibition, 1874. Bibliothèque Nationale, Paris

13 Pierre-Auguste Renoir, *La Loge*, 1874, 80 x 64 (31½ x 24¾). Courtauld Institute Galleries, London

14 Claude Monet, *The Bridge at Argenteuil*, 1874, 60 x 79.7 (23⅝ x 31⅜). Collection of Mr and Mrs Paul Mellon, © 1994 Board of Trustees, National Gallery of Art, Washington, D.C.

15 Frédéric Bazille, *The Artist's Studio*, 1870, 98 x 128.5 (38½ x 50⅝). Musée d'Orsay, Paris. © Photo R.M.N.

17 *Art Students and Copyists in the Louvre Gallery*, 1867, illustration after Winslow Homer from *Harper's Weekly*, 11 January 1868

18 Edouard Manet, *Roses in a Champagne Glass*, *c.* 1882, 32.4 x 24.8 (12⅞ x 9⅞). Glasgow Museums: The Burrell Collection

19 Engravings of easels from the Winsor & Newton catalogue of 1886